Paint Shop Pro 8

Paint Shop Pro 8

The guide to creating professional images

Robin Nichols

AMSTERDAM • BOSTON • HEIDELBERG • LONDON • NEW YORK • OXFORD
PARIS • SAN DIEGO • SAN FRANCISCO • SINGAPORE • SYDNEY • TOKYO

Focal Press is an imprint of Elsevier

Focal Press
An imprint of Elsevier
Linacre House, Jordan Hill, Oxford OX2 8DP
200 Wheeler Road, Burlington MA 01803

First published 2004

British Library Cataloguing in Publication Data
Nichols, Robin
 Pasint Shop Pro 8: the guide to creating professional images
 1 Paint Shop Pro (Computer file)
 I. Title
 006.6′8′69

Library of Congress Cataloguing in Publication Data
A catalogue record for this book is available from the Library of Congress

ISBN 0 240 51698 2

For information on all Focal Press publications visit our website at:
www.focalpress.com

Composition by Genesis Typesetting Limited, Rochester, Kent
Printed and bound in Italy

Contents

Picture Credits

David Nichols:
pages 115, 116, 117

Jim Nichols:
pages 23, 42, 64, 80, 81, 94, 133, 134, 135, 139, 140, 169, 182, 183, 184, 185, 186, 224, 225, 226

Amelia James:
pages 48, 128, 131, 171, 175, 177 ('july'), 219, 221, 231

Peter Eastway:
page 176

Introduction

What is digital imaging?

One revelation is that, five years ago, I'd probably never have written about digital imaging.

Five years ago, the digital picture-making process was barely past the front door. At best it was a clumsy and expensive process with dubious value to all but the manufacturer and retailer. Things are very different now.

Digital imaging, the process of recording, retouching, distributing and printing electronically created pictures, photos or graphics has come of age. Three factors have made this possible:

- many consumers now own sophisticated computers;
- many also own scanners and digital cameras; and, most importantly,
- digital imaging is now **eminently affordable**.

Using scanners and cameras we can create and digitise photos that are shot on film or we can snap our own digital pictures and load them into a computer with relative ease. What's more, we can also view these vibrant digital memories in our own home, our workplace, and even in a pressurized cabin 40 000 feet above the earth's surface (providing that our notebook batteries are charged!).

We can send pictures via the Internet to other computers using the seemingly limitless reach of the World Wide Web so that others, our friends and our families, can enjoy the experience at the same time as us. Well almost. And all this achieved with very little effort.

It's not surprising then that professional photographers and graphic designers have taken this technology to heart, converting entire photo studios and design businesses from film-based economies to that of the silicon chip, the powering platform upon which all computers and digital cameras rely. The expense of such changeover is high, as it is for all early technology adopters. The benefits, however, are now trickling down from the professional arena to the man and woman in the street, the consumer.

Consumers can now buy a 'digital capture device', a high-quality digital compact camera, for the same cost as a regular film camera. Amazingly, these point-and-shoot devices perform every function of a film camera while also boasting a wide range of impressive digital advantages, features we barely dreamed of five years ago.

For example, digital photos can be loaded onto home computers and viewed using photo-editing software such as Jasc Paint Shop Pro 8. Sometimes such a program is bundled free of charge when the camera (or scanner) is bought, a great bonus. Not only can we use this consumer software for viewing photos but, with a little skill, it can also be used to apply the most wonderful range of pictorial effects and enhancements to digital snaps. So powerful is its capability that we can create veritable works of art barely recognizable from the digital original – all with a few well-placed clicks of the mouse and a spot of free time.

These creations can then be printed (as if they were real photographs) on media that looks and feels like 'real' photo paper, only on a machine that's cheap enough to buy and install at home (the inkjet printer). There's now almost no need to trek to the nearest high street mini lab or to email files to a remote printing laboratory to get your prints done. In fact, the quality of new inkjet printers is so high it's no longer possible for a viewer to tell if the photo is a digital picture, an illustration, a painting or, indeed, made from an original film negative.

Digital imagers, as this new breed of pictorial entrepreneur are often dubbed, gain great benefit from not using film: there are no material costs to manage and certainly no laboratory processing hassles to encounter. Of course, the technology has virtually replaced the need for the commercial processing lab. Printing at home on a photo-realistic inkjet printer, though not always cheaper than a film lab (because of our propensity to print everything), is becoming increasingly viable. Besides which, the speed, creativity and, ultimately, the control over the final result is now in the hands of you, the image-maker, and not the lab, as it was five years ago.

Despite the fact that this art form is based around an entirely new technology (well, almost new), digital imagers still require the same **image-making skills**, **vision** and **manual dexterity** originally required when making pictures from film. The difference is that now consumers have at their disposal retouching and manipulation capabilities that far outweigh those available to the consumer using a film camera.

It's this overwhelming power to create, edit, manipulate and distribute photos that makes a book like this so essential.

About Jasc Paint Shop Pro 8

US-based **Jasc Software** has been in the business of producing photo-editing software from its inception in 1991. Its leading software product, **Paint Shop Pro**, is now in its eighth version and continues to provide digital photographers and photo enthusiasts with a thoroughly professional and diverse range of image-editing, manipulation, retouching, illustration, Web creation and picture distribution tools. As a top-of-the-range product in the consumer market, Paint Shop Pro no longer provides mere photo-manipulation capabilities. It's a lot more than that.

As the digital environment has developed over the years, the demand for more features has burgeoned. To its credit Jasc has reflected those changes in the evolution of its product to what it is today – a fully integrated multimedia imaging solution designed for all levels of expertise, from the

novice, 'I'm just back from the photo shop' type enthusiast, to the professional web designer, graphic designer, business user and even professional photographer.

Even though, as an imaging-based journalist, I have had many years experience with photo-editing programs, I'm a relative newcomer to Paint Shop Pro. When I first assessed the program I was amazed at its complexity, its sophistication and, above all, its street-smart capabilities. Here at last, I thought, was a real software package that addressed pretty much all of my image-making needs, plus a fair few that I had yet to discover. In this respect, Paint Shop Pro straddles the imaging market perfectly.

This completely rewritten version has a look and feature list to die for, yet it sells at a price that anyone can afford. It's intuitive, it's feature-rich and it can be integrated into a wide range of applications including photography, graphic design, web design, page layout, education, pre-press, advertising, research, printing and even web animation.

The strength of such a product lies in the duality of its design. It functions perfectly as a basic but effective digital photographer's retouching aid but it can also be used to create a staggering range of complex effects, manipulations and creative designs for a wider, more discerning audience.

However, Paint Shop Pro 8 is more than a photo-retouching program. It offers one of the best browsing engines in the business (sorry Photoshop!), it includes full animation capabilities for Web applications and can be used to create complex web graphics. It even has tools that allow you to create an entire website, from the ground up.

Paint Shop Pro 8 is also a design tool, containing a range of sophisticated vector-based tools enabling designers to move seamlessly from vector editing, to bitmap, print or web environments and back again with little effort, ensuring higher productivity and greater cohesiveness throughout.

1

Digital Image-making: The Basics

DIGITAL IMAGE-MAKING

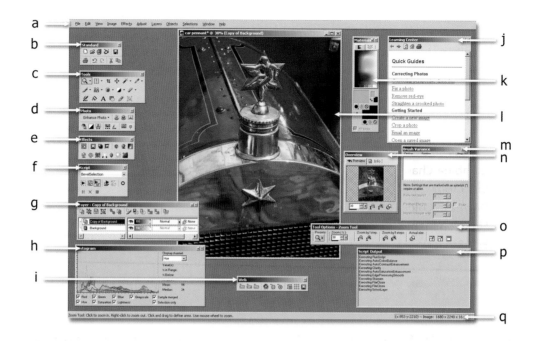

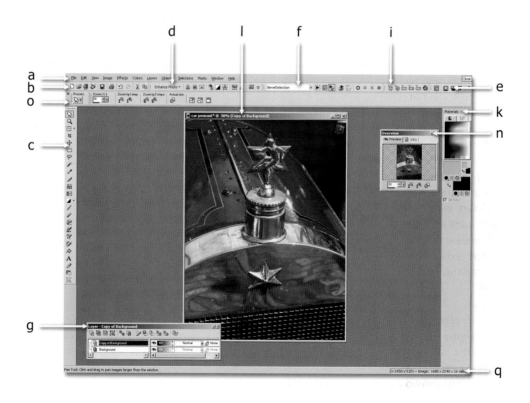

This chapter introduces Paint Shop Pro's basic and sophisticated picture editing features.

TOOLS USED IN THIS CHAPTER

Canvas Size	Fit to Window (command)
Combine Channel (command)	Grayscale
Crop tool	Increase Color Depth
Decrease Color Depth	Mirror (command)
Flip (command)	Rotate (command)
File Browser	Split Channel (command)
Full Screen Preview	View Full Size (command)

Figure opposite. Top frame: (a) Menu bar. (b) Standard toolbar that contains some of the most frequently used commands. (c) The Tools toolbar contains all the stuff you'd need to make physical changes to a picture. These include paintbrushes, erasers, selectors and more. (d) The Photo toolbar is biased towards the photographer, with tools specifically for enhancing digital photos or scans. (e) The Effects toolbar is, as the name suggests, there for applying special actions to an image or selection within that picture. (f) The Script toolbar plays pre-recorded scripts over whatever is currently open on the desktop. Use the Scripts toolbar for batch processing effects and for recording your own customized scripts. (g) This is the Layers palette. It displays essential information on the types of layer in a document, their order and status. (h) The Histogram palette displays the spread of tones captured in the displayed picture. Clicking the checkboxes brings up individual color channel information. (i) The Web palette is there specifically for web gurus. On it are a range of tools designed for getting the best quality and download performance from images destined for the Internet. (j) For those of you that are relatively new to Paint Shop Pro, use the new Learning Center to quickly find your way about PSP. (k) The Materials palette is used for selecting foreground and background colors for all the paint and drawing tools. You can also add texture and gradients to the color mix, just as if it were a painter's mixing palette. (l) This is the main picture window displaying the picture that is currently open on the desktop. (m) Brush Variance adds an incredible degree of behavioral control over drawing and paint tools. (n) The neat Overview palette indicates, at a glance, how much the current image has been enlarged and over what section the main picture window is displaying. Useful for when working at large picture magnifications. (o) Tool Options, the operational powerhouse of every tool in Paint Shop Pro. It controls how each particular tool works: its opacity, density, tolerance to change, and so on. (p) Script Output palette records everything that goes into or replays from the Scripts tool. (q) The Task Bar displays vital information on how each selected tool works, as well as data on the image that's currently displayed in the main picture window (l). **Lower frame:** Using the incredible customizable nature of Paint Shop Pro enables you to customize the interface entirely to suit a particular workflow, whether that be for print, the Web or for illustration. Save each specialist palette/toolbar combo as a PSP Workspace file.

Introduction: basic tools and functions

When Paint Shop Pro is loaded in Windows; it opens in a standard configuration. What you see onscreen is the **user interface (UI)**. Jasc has spent two years completely rewriting the code for this program – so it not only looks pretty new, it also behaves quite differently.

Take time to familiarize yourself with what you see onscreen. Everything displayed is customizable. This means that you can move the palettes and menu bars around the screen. Remove some and add others and you can change which tool icons appear on which menu bars using its 'Customize' function (right-click on any toolbar to access this feature).

Paint Shop Pro enables you to save and reload any palette/menu configuration through its workspace save feature ('File>Workspace>Load', + Save, + Delete, + Recent). So, if you work on the Web you might save one setting for the Internet and another for print applications. Default settings can be restored via the File>Workspace>Default menu command.

The Menu bar

Menu bars are standard throughout the computer world, whether in word processing, photo-editing or multimedia software. Paint Shop Pro's many keyboard shortcuts are listed alongside each submenu topic (where shortcuts are available). A keyboard shortcut, which we'll study in greater detail later, offers a fast left-handed way of accessing other parts of the program without the need for excessive right-handed mousing. Learning and using keyboard shortcuts will significantly increase the speed at which you can use this program.

Toolbars

The toolbars in photo-editing programs are, for many, the most important feature. Paint Shop Pro has eight of these, containing more than 70 different photo-editing features between them (not including obvious tasks like 'File Open' and 'Save As'), plus there are many more effects filters. Most tools and filters are arranged on the three main toolbars (Tools, Photo and Effects). All can be floated, or docked, according to their groupings or requirements.

Tool or filter effect?

A **photo-editing tool** has a specific cursor-driven function such as painting or drawing. The term applies mostly to manual, mouse-driven operations, whereas **filters** refer to preset visual processes. For example, click an icon once to open a filter from the Effects toolbar, hit the 'OK' button and check the result. If you don't like the preset effect, further customize or refine it using the controls in the filter's dialog window. Like the filter effects, tools are also fully customizable though their **options** palettes. All tool or filter effect dialogs (the window that appears with all its controls) can be sized

Each menu header has a submenu that appears when the mouse is positioned over it. Submenus contain more tools and actions that are pertinent to that header. For example, under the File header you'll find commands for creating a New file (New), opening an existing file (Open), looking for a file using the thumbnail search (Browse), saving the file (Save), and saving the file under a different file name or format (Save As). Though there are dozens of actions to choose from, if you consider the action required first and use your common sense, you'll find the system quite intuitive to use. For example, I want to open an existing file (or document) so look under the File menu. If you want to apply a special effect to the picture, look under the Effects header. If you need to improve the look of the snap, look under the Adjust header.

to suit the application, screen or taste. They also remember where they were when previously used and reposition accordingly when used again. All dialogs have a 'before' and an 'after' preview window which can now be switched off if required.

'Standard' toolbar

This contains all the usual housekeeping style tools familiar in most software programs. These include: (create) 'New File', 'File Open', 'File Save', 'File Browse', 'TWAIN acquire' (which allows you to import a scanned picture directly) and 'Print'.

'Tools' toolbar

The **Tools** palette displays 17 photo-editing tools, with another 20 lurking beneath those marked with tiny black arrow symbols (click and hold to see what's underneath; click once and slide the cursor across to select any 'hidden' tool).

This toolbar is the Paint Shop Pro editing powerhouse. Here you'll find a tool, or sets of tools, that will enable you to do pretty much anything to a digital photo or scanned picture file, from retouching to repairing.

Tools are loosely divided into 17 groupings that include:

'Zoom/Pan', 'Deform/Straighten/Perspective Correction/Mesh Warp', 'Crop', 'Move', 'Selection/Freehand Selection/Magic Wand', 'Eye Dropper/Color Replacer', 'Paintbrush', 'Airbrush', 'Warp Brush', 'Clone Brush/Scratch Remover', 'Dodge/Burn/Smudge/Push/Soften/Sharpen/Emboss', 'Lighten/Darken/Saturation/Hue/Change to target', 'Eraser/Background Eraser', 'Picture Tube', 'Flood Fill', 'Text Tool', 'Preset Shapes', 'Pen tool' and 'Object Selection tool'.

Though there are plenty to discover, most tools are fairly self-explanatory and can be mastered with a little practice.

Tip

Each tool has a unique set of options that give the user greater control over how it operates on the picture. Most have up to ten (different) options. Each option might have a sliding scale of up to 100 variations, so you are looking at an infinite variety of creative possibilities for each tool.

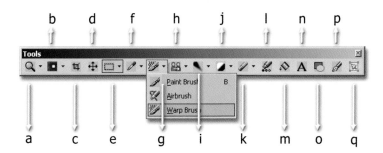

Tools include: Pan + Zoom tool (a), + Deform + Straighten + Perspective Correction + Mesh Warp (b), Crop (c), Move (d), Selection + Freehand Selection + Magic Wand (e), Dropper + Color Replacer (f), Paintbrush + Airbrush + Warp Brush (g), Clone tool + Scratch Remover (h), Dodge + Burn + Smudge + Push + Soften + Sharpen + Emboss (i), Lighten/Darken + Saturation Up/Down + Hue Up/Down + Change to target (j), Eraser + Background Eraser (k), Picture Tube (l), Flood Fill (m), Text tool (n), Preset Shape tool (o), Pen tool (p) and the Object Selection tool (q).

Tool presets

Another powerful feature is the ability to record a favorite tool action as a 'preset'. For example, you might have spent ages fine-tuning one particular brush look. By clicking on the **Preset** tab in that brush's options palette (and then 'Save') you can give it a name and save it for later use. Presets can be built up over time so that you have a customized library of user presets for different applications, like painting, web, print and layout.

'Photo' toolbar

If you deal with scanned or digital photos, this is **the** toolbar to get friendly with. The principal tool is the all-in-one Enhance Photo filter that applies six different actions to the picture. These are: Automatic Color Balance, Automatic Contrast Enhancement, Clarify, Automatic Saturation Enhancement, Edge Preserving Smooth and Sharpen.

At the bottom of this drop-down is the Red-eye Removal feature. Also on this toolbar are three new lens correction filters (Barrel, Fisheye and Pincushion), 'Fade Correction', Black and White, 'Manual Color Correction', 'Histogram Adjustment', 'Adjust HSL', the JPEG Artifact Removal filter, and the Unsharp Mask filter.

Most of the photo tools are concerned with fixing-up digital snaps or scans. Try the auto Enhance Photo command first. Often, this is all that's needed to make an ordinary digital snap jump off the page.

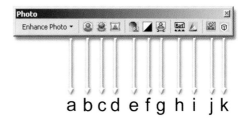

The Photo toolbar contains a number of highly useful tools that include the new all-in-one Enhance Photo tab (a), three new lens distortion filters: Barrel, Fisheye and Pincushion (b–d), a Fade Correction tool (e), a Black and white tool (f), a Manual Color Correction dialog (g), the Histogram Adjustment dialog (h), the Hue/Saturation/Lightness adjustment tool (i), the neat JPEG Artifact Removal tool (j) and the Unsharp Mask tool (k).

Tip

If it doesn't work first time, run the same filter effect again till it does!

'Effects' toolbar

If you have had no experience using PSP but are curious how its effects might look when applied to a picture, click the tab on the far left side of the Effects toolbar. This loads and displays the **Effects Browser**, a sophisticated program that displays all 142 filter effects (or one at a time, depending on where you click in the file hierarchy).

This is quite an eyeful, even for a seasoned image-maker! Double-click the effect you like the look of in the Browser and Paint Shop Pro transfers it to the photo on the desktop. In this way you can preview the filter effect and save time by only trying effects that you like the look of. Other programs provide a list of effects but little clue as to how long or how effective any, or each, might be on the opened picture file.

What else is there on the Effects toolbar? 'Buttonize', 'Drop Shadow', 'Inner Bevel', 'Gaussian Blur', 'Hot Wax', 'Brush Strokes', 'Colored Foil', 'Emboss', 'Lights', 'Fur', 'Polished Stone', 'Sunburst'

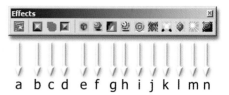

The Effects toolbar includes the new Effects browser (a), Buttonize (b), Drop Shadow (c), Inner bevel (d), Gaussian Blur filter (e), Hot Wax (f), Brush Strokes (g), Colored Foil (h), Emboss (i), Fur (j), Lights (k), Polished Stone (l), Sunburst (m) and the Topography filter (n).

and 'Topography'. All are preset filter effects that can be applied to a selection, or globally, depending on application. All can be infinitely customized through the displayed options window. Customized filter sets can also be saved in the same way that customized tools can be preserved for imaging posterity.

'Script' toolbar

Scripting is new to PSP 8 and, while strictly not a tool as such, it offers incredible power to anyone with a bit more than the most basic of photo-editing requirements. What's scripting all about? As the name might suggest, a script is a file of instructions that produce a series of actions or effects –

much in the same way that a play's script, when followed by a group of actors, produces actions that result in a play (hopefully!).

Paint Shop Pro ships with a small range of pre-recorded scripts but the fun really begins when you start to record your own. The tool is set up just like a video recorder. Press 'Record'; perform the actions you want on the selected picture (i.e. rotate + change contrast + save). It's that easy. Once saved, the script can be run on other pictures on the desktop. It's a great way to automate, and thus perfect your working style and throughput, so important in jobs that

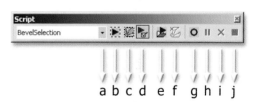

The Script toolbar has a number of features that include: Select saved scripts (a), Run selected script (b), Edit selected script (c), an interactive script playback toggle (d), Run script (e), Stop script (f), Start script recording (g), Pause script recording (h), Cancel script recording (i) and Save script recording (j).

require repetitive actions applied to multiple pictures (for example, in website design). This is an extension of the filter tool's preset concept. Perform an action that produces a likeable result and record it so that it can be rerun on other pictures, or parts of a picture, when needed.

'Web' toolbar

Put together specifically for web designers, this small toolbar contains an 'Image Slicer' tool, an 'Image Mapper' tool, 'JPEG', 'GIF' and 'PNG' image optimizers plus a 'Web Browser Preview' feature, 'Seamless Tiling' and a 'Buttonize' feature. Most of the tools, in fact, needed to make and run your own website.

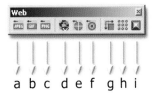

The Web toolbar contains a number of productivity-enhancing tools, including JPEG Optimizer Wizard (a), Gif File Optimizer Wizard (b), PNG File Optimizer Wizard (c), Preview in Web Browser tab (d), Image Slicer tool (e), Image Mapping tool (f), Offset filter (g), Seamless Tiling filter (h) and the Buttonize filter (i).

Palettes

While the toolbar houses the program's main tools, it's the **palette** that displays all the options, in a window for each specific tool. Palettes don't have to be visible all the time and they certainly don't have to be accessed every time a tool is used. If you don't, Paint Shop Pro uses the settings from the previous time it was used. If that proves to be wrong, for whatever reason, you can reverse the process ('Edit>Undo' or keyboard shortcut 'Ctrl Z'), open the palette and make adjustments to its controls before proceeding forward.

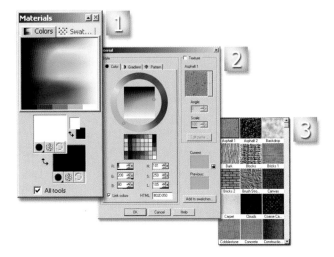

The Materials palette is used for selecting foreground and background colors for all the paint and drawing tools in Paint Shop Pro. You can also add texture, patterns and gradients (2 and 3) to this color mix, creating a palette that's more powerful than a painter's mixing palette.

Browser

Most of us have reasonable memories but, when it comes to computers, we often find that our gray matter refuses to work as reliably as the disk on which we have stored those precious memories! The proliferation of digital cameras and scanners throughout the consumer market means that we are flooded with more pictures than before. Remembering where we put everything remains an uphill battle.

PSP's browser ('File>Browse') makes this seek-and-open task significantly easier. It allows you to peek into your computer for a look around. The left-hand side of the browser window shows the Windows file hierarchy: the 'C' Drive, any other subsequent hard drives or disks plugged into the computer. Click any of the '+' symbols to open that drive, or folder, to display the subfolders within. In this way you can explore what's in every nook and cranny of the computer and associated discs. Paint Shop Pro only opens files that are readable by the program – so you won't see word files in the browser window – but you will see just about every picture file type imaginable displayed as a thumbnail picture. I like this browser because it's fast to display the pictures to begin with and, once it's logged the files for the first time (and left a small text document in the folder recording what's in it), this process is significantly faster the second time you visit. PSP automatically updates this file if pictures have been added or removed since it was last used. You can also use this utility to rename, remove, replace, print and email pictures.

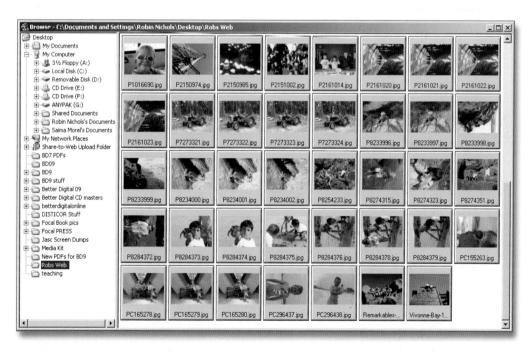

The Browser allows users to search for pictures visually – much easier than having to remember what certain files were called. Click on a folder from the Windows hierarchy at left to reveal the contents.

Multiple image printing window

This is another all-new feature of Paint Shop Pro 8 and contains some useful printing 'helpers' designed to make quality inkjet printing easy with little, or no, previous experience. (We deal in greater detail with this tool in Chapter 8.)

Paint Shop Pro 8: advanced features

Tonal controls

Most of the processes mentioned in the previous section deal with single-button operations that perform a logical, but not always controllable, function. These are often good for the bulk of your photo-editing tasks, like simple color and contrast corrections. However, there'll come a time when you need to make detailed changes to a photo – this is where Paint Shop Pro's advanced tools save the day. Most are simply expanded versions of the one-button-does-all tool sets discussed previously.

One of the most versatile is the **Histogram Adjustment** feature, found under Adjust>Brightness and Contrast>Histogram Adjustment menu. With this you can set shadow and highlight values, as well as all the tones in between (called the 'midtones'). A step up the sophistication scale is the **Curves** tool. Again, designed by professionals to get the maximum out of camera and scanned files, Curves is one of my favorites as it has almost limitless possibilities for tone control and creativity.

Paint Shop Pro would go nowhere without a range of sophisticated **color controls**. The program has enough of its own to satisfy all professional demands, and then some. These include: a **Manual**

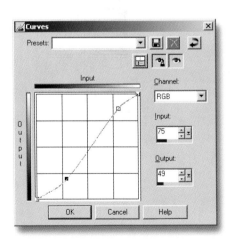

Curves offers tremendous tonal control over any digital picture.

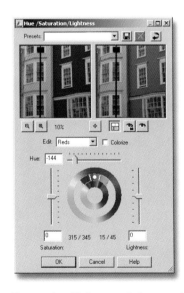

The Hue/Saturation/Lightness dialog provides an incredible range of color changing options, from black and white through to subtle color tints and dramatic colorizations.

Color Correction tool, a **Hue/Saturation/Lightness** tool, and more. Like all quality photo-editing programs, Paint Shop Pro offers several different tools that perform a similar job. Some are better at doing things than others, and this is where experience comes in handy. Judging what tool works best for your picture(s) takes some getting used to.

Other simple yet sophisticated enhancement tools include filters for **sharpening** and **blurring** the picture, a tool for copying one part of the picture over another to remove scratches and surface damage (the **Clone tool**) and a wide range of selection tools.

Once you have got your head round the idea that all digital pictures require at least some tonal fix-ups, you'll begin to appreciate the power of **selections**. A selection allows you to isolate part of a picture so that you can then apply a change or filter effect to that selected area only. Paint Shop

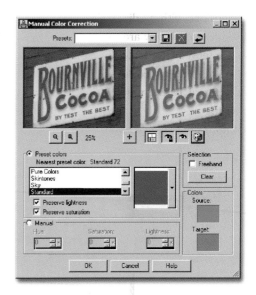

The Manual Color Correction dialog gives you the ability to change colors to match a wide range of presets.

Pro not only has a wide range of selection tools but also a comprehensive range of modifier features (under **Selection Edit mode**) that are so good as to shame most other photo-editing programs.

Perhaps, after tonal fix-ups and learning about selections, you'll move onto **layers**. Layers offer the digital image-maker incredible editing capabilities. You can add disparate picture elements to a 'master' picture file, move them about, change their colors and contrast, and then move them some more to make the weirdest montage effects imaginable. The reason you'd keep all these elements on layers is that you can move everything else in the frame even after it has been saved in a layered format. Once saved, in a flattened, non-layered format, you lose all editability. Layers can also be radically changed using layer masks or individual **adjustment layers**.

An extension of the layers concept brings us to the use of **Text**. Paint Shop Pro has an all-new text engine which allows you to add text, as a separate vector layer, to any document. Again, the advantage of this is that you can return to the picture at any time and edit the text layer, changing the size, font, kerning or other text-specific characteristics. Because this is done using a special vector layer (not pixel-based) there's no loss of quality. Vector text introduces us to the creation of vector shapes and art.

All digital scans and photographs are bitmap or raster files; they are made up from pixels which explains, in some part, why a bitmapped image requires so much computing power to manipulate. An A4 photo contains more than 20 million pixels! **Vector images**, on the other hand, are made from mathematical calculations: dots and points on the canvas that are filled with flat or graded colors. An A4 vector illustration might only be a few hundred kilobytes at most. Besides a small file size, the beauty of vector art is that it's scaleable. You can increase or decrease vector shapes to almost any

dimensions with no discernible loss of quality. Enlarge a bitmapped file too much and it begins to look distinctly fuzzy around its edges. Vector images are created and edited using the **Pen** tool, one of the most sophisticated of all the tools.

Other advanced features of Paint Shop Pro 8 include the use of layer and image **masks**, **adjustment layers**, **gradients**, the **picture tube**, sophisticated **warping** tools, a range of very cool printing aids, framing assistants, GIF and JPEG **image optimizers**, **image mapping**, **image slicing** and even an **animation wizard**.

Not new but one of the favorites, Paint Shop Pro's Picture Tube can be used to spray images in the form of a continuous paint stream.

Web designers will be able to use Paint Shop Pro's many sophisticated web optimization tools like this Image Slicer tool.

The JPEG Optimizer is designed so that you get the most from web quality and download speeds.

Animations? Yes, Paint Shop Pro can even be used to create interactive web animations using its (freebie) plug-in, **Animation Shop v. 3.04**. Use this program to create, edit and design a range of very cool-looking stuff for use on the Web in seconds!

Paint Shop Pro: features new to version 8

Auto actions

Auto actions enable PSP to perform operations to make a command available (when it wasn't in version 7), change color depth, float a selection, etc.

Background Eraser

Used to seamlessly remove the background pixels surrounding an object.

Balls and Bubbles filter

Places one or more balls or bubbles on the photo for surreal effects.

Black and White Points

Correct the color of a photo by adjusting a highlight, midtone or shadow value.

Blend modes

There are four new Blend modes: Hue (True), Saturation (True), Color (True) and Lightness (True).

Continuous paint option

With continuous paint mode on, all input counts as a single stroke regardless of how many times the mouse moves up and down.

Crop tool

The Crop tool has support for cropping to standard photo sizes and can optionally update the resolution value of the image to force output to match desired size.

Drop Shadow

This dialog has an easier-to-use control system and can optionally create the shadow as a new layer.

Edge Seeker

A new Freehand Selection tool mode similar to Smart Edge but better at following weak edges next to strong ones.

Effect Browser

Generates default thumbnails for all effects. Apply the preset directly or launch the specific dialog and edit further. As presets are saved they automatically become added to the browser.

File New

Supports presets and the ability to use any material as the background of a new picture. It's also possible to create a new image with a vector layer instead of a raster layer.

File formats supported

AutoFX (AFX), Brooktrout Fax (BRK), CALS Raster (CAL), Microstation Drawing (DGN), AutoCAD Drawing (DWG), JPEG 2000 (JP2), Kofax (KFX), Lazer View (LV), NCR G4 (NCR), Portable Document File (PDF), Scalable Vector Graphics (SVG), Wireless Bitmap (WBMP), X Windows Bitmap (XBM), X Windows Pixmap (XPM), X Windows Dump (XWD), Postscript Level 2 support has been upgraded to Postscript Level 3.

PSP 8 supports reading/writing of lossless JPEG files.

In addition, EXIF data is read and written to file formats that support it. The PSP file format now supports EXIF data, so you can open a JPEG file from a camera, edit it, and save as a PSP file without losing the EXIF data.

Halftone filter

Simulates the halftone process used in printing.

Info tab

The info tab displays both general information about the picture and information specific to the active tool.

Layer Groups

Allow common elements of a picture to be lumped together, and viewed, moved or hidden as a single unit.

Learning Center

This new HTML feature greatly increases the ease at which you can learn about PSP 8 and a range of techniques. Quick guides can use scripts to automate some or all of the steps in the guide.

Lens distortion filters

New tools for correcting, or adding, pincushion, fisheye and barrel distortion effects.

Magnifier palette

When enabled the magnifier palette shows an enlarged view of the pixels under the cursor.

Materials palette

Replaces the PSP 7 color palette. Texture controls have been combined with the style controls, and the flyouts for switching between solid, gradient and pattern are no longer needed.

Mesh Warp

Warps a photo by distorting a mesh laid over the top of the picture.

Offset (filter)

Used to shift the image on the canvas, typically wrapping pixels around to the opposite edge as they go off canvas.

Page Curl (filter)

The Page Curl filter now supports setting the area behind the curl to transparent.

Pen

The line tool and node edit tools have been combined into the Pen tool.

Perspective tool

Designed to fix perspective errors in a picture.

Print Layout

This new dialog makes it easy to print single or multiple photos at a specific size or scale anywhere on the page. Supports (multiple) print templates for standard paper sizes. You can use predefined templates or create your own.

Polar Coordinates (filter)

Transforms pixels by mapping them from Cartesian to polar coordinates or vice versa.

Retouch tool (redesign)

Each of Paint Shop Pro 7's **retouch tools** are now separate. Left/right mouse-clicking works with the inverse retouch tools (i.e. Darken/Lighten, Dodge/Burn).

Seamless Tiling (filter)

Produces surreal but somewhat crude kaleidoscope-type effects for fun and background applications.

Selection Edit mode

In this mode, all of the raster painting/drawing tools and effects can be used to modify the selection marquee.

Selection Modifiers

All Selection Modifiers have been significantly reworked and now support the standard proof/preview/preset controls on the dialog.

Scripting

PSP 8's productivity-enhancing scripting engine, based on the Python programming language, allows you to record, pause, save, play, edit or cancel scripts for increased productivity.

Soft Focus (filter)

Simulates the effect of a glass photographic soft focus filter.

Spherize (filter)

Alters an image as if it were wrapped around (or into) a sphere.

Straighten tool

The Straighten tool is designed to straighten a scan or tilted photo.

Tablet support

Tablet users can take advantage of varying parameters by altitude, azimuth, twist, z-wheel, finger wheel, and pressure. All of the standard brush parameters can be varied by any of the variables list above. In addition, jitter can be used to introduce random fluctuations in any value, which is useful in attempting to create a natural look.

Text

The Text tool is completely redesigned. Most controls are set on the options bar, and text entry is done on a floating window. The text tool uses the materials defined in the Materials palette.

Tools

Paint Shop Pro's tool options bar is separated into bands. Each can be rearranged and resized to suit your working style. Almost all tools now support presets so you can quickly use saved settings. All of the brush tools (Paint Brush, Airbrush, Clone Brush, Eraser, and all retouch tools) have completely new internals.

Buildup brushes	Non-Buildup brushes
Airbrush	Paint Brush
Eraser	Dodge
Smudge	Burn
Push	Soften
Color Replacer	Sharpen
Picture Tube	Emboss
Lighten	Darken
Saturation	
Hue	
Change To Target	
Clone	

User interface (UI) customization

PSP 8 supports extensive customization of the user interface. Move, add, or remove buttons on toolbars and menus. Create your own menus and toolbars. Assign your own hot-keys.

- All menu icons are new.
- With the exception of file open/save dialogs, all dialogs remember their last used size and position.
- All effect dialogs can be resized, and the preview panes shown or hidden.
- With a few exceptions for simple effects, all effect dialogs have the ability to save/load presets or to randomize parameters.

Warp Brush

Distorts a photo almost as if it were made of rubber – stretch, shrink, twist, push, etc.

Zoom by percentage

PSP 8 now supports zooming at arbitrary percentages making it possible to size an image to fit your screen. The resembling method at scales of less than 100% is less likely to lose small details.

Additional considerations for the digital darkroom

A range of photo-quality inkjet papers is essential for all photo-editing enthusiasts.

Digital image-making is not a cheap alternative to creating pictures with film. However, the added control and increased creativity that it brings to the photographer far outweighs its higher adoption cost.

At a basic level you'll need to buy gear to capture digital pictures, a device for storing and viewing those pictures, software (of course!) for retouching the pictures and some form of printer so that you can enjoy the fruits of your labor. (At worst, you can rely on your local photo-finishing service to scan your film and supply commercial CDs.)

Digital cameras come in all shapes and resolutions although, to be fair, many offer remarkably similar features. The big differences lie more in the camera's resolution capabilities, the scope of its zoom lens and the capacity of its accompanying memory card. How you judge what resolution to buy is easy: look at your requirements and work backwards. For example, if you are only ever likely to use the camera for emailing and web illustration, you'd only need a 1.3

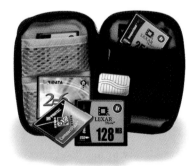

Digital photographers will inevitably need more than one memory card on which to store their digital camera snaps prior to loading them into a computer for manipulating in Paint Shop Pro.

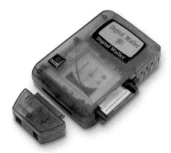

This is a product called the Digital Wallet – the ultimate method of storing lots of digital camera images on the road. Each Wallet can hold up to 40 Gb of images. You can also use Wallets as essential data backup for your computer hard drive.

million pixel camera (or similar) as this is an ideal resolution for displaying work on a computer monitor, and that's all that's necessary for web work. A higher resolution will therefore be wasted.

If you want the highest quality from your photography with a view to lithographic printing, look for a camera with the highest resolution that your budget can afford. Other factors such as lens (glass) quality, image sensor dimensions (CCD), software processing capabilities (color and contrast) and physical handling characteristics also affect the results.

Of course, no one would go far in this business without a good quality computer on which to store, view, manipulate, print or email digital pictures.

Computers are somewhat easier to understand. Buy a computer that has a fast CPU (processor or 'brain'). Because digital photos are information-heavy, they contain a lot of data so need a bit of power to shift. That said, what's almost as important is the computer's active memory or RAM (Random Access Memory). You need RAM to operate programs and you need more RAM to open pictures onscreen. It's not always necessary to buy the fastest processor, but it is important to load the computer with as much RAM as your (now depleted) bank balance might stomach. Also consider installing a fast(er) graphics card (for brilliant color reproduction onscreen), a second hard drive (for additional storage – digital photos take up heaps of space) and a good quality color monitor. With the latter, though costly, you get what you pay for.

Seventeen-inch monitors are now 'standard', although a 19-inch monitor will provide a significantly better viewing area for pictures, and a 21-inch monitor is the best (but considerably more expensive). It's worth paying the few extra dollars required to get a flat-screen version. This dramatically reduces annoying reflections, displays pictures more accurately and is generally easier on the eyes, an important consideration if you plan adopting this hobby full time. A flat-screen LCD display is even better.

■ Software is available in a range of different types, from free giveaways to high-end products specifically designed for industrial strength commercial printmaking applications. Most perform an adequate job, although digital image-makers, with even a small amount of experience, discover that user-friendliness is as important as a program's feature list. While some are specific in their function, more are designed with a total package concept in mind, and it is into this latter category that Paint Shop Pro falls.

The consumer inkjet print is fast becoming another imaging essential, as picture quality is both exceptional and long lasting.

■ Desktop inkjet printers are also economical enough for anyone to buy. Having enough money to keep the ink tanks topped up is another matter. However, as a device for producing photo-realistic prints that last, in some notable examples, longer than real photo paper, this is a small price to pay, especially when compared to the advantages of immediacy, control and creativity.

Add to this the increasingly large range of digital printing services offered by commercial and professional photo labs for those who don't have the time or inclination to print at home and you have an attractive package for all requirements.

More accessories

Accessories for the digital image-maker are numerous and should be purchased to make your life simpler.

I'd always advise digital camera users to buy a **high-capacity flash memory card** (128 Mb+) and third party **card reader**. Extra memory allows you to shoot and store more pictures on one card while the reader is permanently connected to the computer to make the job of downloading digital snaps quicker and more convenient (more convenient than having to connect the camera to the computer every time).

Also consider an extra **removable memory disk**, such as a CD-R, CD-RW burner or DVD-R, so that photos and other data can be stored off-computer, a range of **inkjet papers** to cover a variety of printing jobs, from business cards to high-quality digital photos, and of course, a **fast email connection**, such as cable, ISDN or ADSL, so that you can monitor and send pictures over the Internet with the minimum of fuss, delay or frustration.

If you spend a lot of time making selections or creating digital art using a photo-editing program such as Paint Shop Pro, you'll find a graphics tablet essential in providing ease of use and incredible accuracy.

Creating pictures using film, digital cameras and scanners

There are dozens of ways to get digitised or 'digital' pictures: shoot them with a digital camera, scan them from black and white and color prints or even scan them directly from film. You can also open them directly from your own computer hard drive (if there's anything there) and you can copy them from another computer, if connected. You can also get them from a variety of removable media (such as free CDs, DVDs, floppy and Zip disks) and, of course, you can get them from the Internet.

Digital cameras are now an essential part of the image-makers toolbox. Even some of the cheaper consumer products produce image quality that's hard to pick from regular film.

You can even make digital pictures from scratch using Paint Shop Pro 8 and nothing more.

Scanning has been the prevalent method of digitizing a print into one that can be viewed and manipulated electronically. Two types of scanner are used for this task: regular desktop **flatbed scanners** that are designed to digitise flat artwork and photos, usually up to A4 in size, and **film scanners**. The latter are usually more expensive – and limited to scanning film only. Several different types of film scanner are available, the most common being those designed for 35 mm film – although many now ship with adaptors as included extras.

Professionals favor the more expensive film scanners designed for medium and even large format film formats. Interestingly, most desktop flatbed scanners can also scan film, although not to the quality and resolution of a dedicated film scanner. These have a small light box built into the scanner lid that provides enough illumination to scan transparent materials (like film and overhead transparencies).

The advantages of the scanner as a digital recording device is that it's relatively cheap to buy when compared to a digital camera and its resolution is variable so, if having already made a scan, you realize a higher resolution is required, rescan the original at a higher setting. A digital camera, on the other hand, though often capable of recording details more accurately, has a fixed resolution ceiling. This can be set to a lower pixel value but never to a higher (pixel) value, as there are only so many pixels in the CCD or imaging sensor to go round. If you need a higher resolution than a digital camera can supply you must **resample** (or **interpolate**) the image to a higher resolution. This

Desktop scanners, whether film or flatbed, are also becoming part of the landscape, producing impressive results.

process adds more pixels to the canvas, a task that can easily be done using PSP. The downside is that some image quality loss is suffered in this process.

Paint Shop Pro can also be used to create pictures from the ground up. Start with a blank canvas and use its many paint, drawing or vector tools to create an illustration from nothing. It's as varied or as powerful as your creativity allows.

Pictures for nix

The Internet has thousands of sites and tens of thousands of web pages dedicated to giving away free pictures: web art, clip art, print art, you name it, it's there! All stuff that's useful in some context, but often useless in others. Free pictures tend to be the ones that no one else requires, the sort of stock that top image libraries have thrown out because they now have better quality. Even so, some stuff is still 'OK' and, with a little help from Paint Shop Pro's magic tools, most can be converted into impressive multi-image artworks.

Establishing reliable picture sources is one matter, being able to open and view everything is another! Digital files come in all shapes and sizes. Some, like the **JPEG** file format, are common and readable by almost every photo-editing program you'd care to mention, others are not so hospitable.

Thankfully, Paint Shop Pro 8 doesn't suffer from file-opening limitations. In fact, you can use it to read and open a staggering array of file formats from a wide range of sources. Too many to go into here, suffice to say that pretty much all bases are covered so that, even if great uncle Rodney is still saving files to that now obscure amiga '.iff' format, Paint Shop Pro 8 will open and display them just as easily as if it were common JPEG, .DOC or '.txt' files.

Using the file browser

TOOL USED

Browser

Opening and viewing digital pictures is done in one of two ways: either by using the standard 'File>Open' command directly off the menu bar (and then scrolling through the Windows file hierarchy to find the errant picture) or by using its easy-to-operate **file browser**.

What's this? Choose 'File>Browse' from the main drop-down menu. The browser provides the PSP user with a visual glimpse into the computer's innards. In fact, it can be used to view what's on any type of hard drive, floppy disk or removable media. Whatever's connected to the computer. If you can't remember where on earth a scan went, chances are you'll remember what it looks like. If this is the case, use the browser to view what's in the folders and storage areas on the computer hard drive until that scan resurfaces as a visual reminder.

Clicking on the '+' symbol in the left-hand Windows hierarchy opens a folder. Alternatively, just double-click the folder icon to open it. Clicking the '–' symbol closes it. Users of **Windows ME** and **XP** will find this a familiar process because both programs display pictures as thumbnails (and 'film strips'). Paint Shop Pro remembers what it has seen in any folder and leaves a tiny data file behind so that, next time you peek, it displays the contents faster. If something has changed in the meantime it's best to right-click and select 'Refresh Tree' so that the browser can update its file log. This takes no time.

Browsing in this manner is a fast and reliable way to remember where files went! But that's not all. The browser has a range of other features that make it one of the best in the business for tracking, managing and logging digital pictures, whether there are ten or 10 000 to cope with.

Right-clicking brings up the browser features that include:

Copy To

Transfers and copies pictures from one place to another.

Delete

Removes that file to the recycle bin.

Move To

Transfers pictures to another folder or file location. No copy is made.

Rename

No need to open the picture – use this to change the name of the file.

JPEG Lossless Rotation

Rotate pictures with no loss of quality (other programs can lose quality when the image is rotated).

Information

Displays all the dimensional details of the picture selected.

Send

Use this feature to resave any type of file in the JPEG file format so that it becomes small enough to be emailed. The program opens your default email software and drops the picture into it as an attachment.

PhotoSharing

This is a function that uploads the selected photo to the ShutterFly website with the idea that it can then be shared with family and friends, wherever they may be.

Open 'Print Layout'

Opens the Print Layout dialog so that the contents can be printed.

'Open' file in PSP

Use this simply to open and edit the picture selected. If more than one is selected, all are opened (shift-click to select multiples).

Tip

If you ever need to send more than one picture in an email, use the **Send** feature in the browser (not from the file menu) as this will send as many pictures as your ISP can stand.

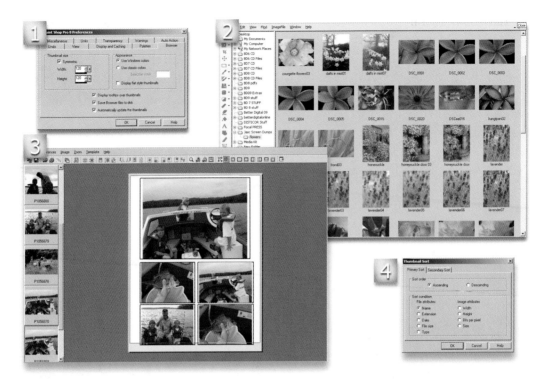

(1) Use the Preferences dialog to alter the thumbnail window size (and style). (2) Standard browser displays the Windows file hierarchy to the left of the thumbnail images. Click a folder icon once to display what's in it. Non-picture files are not displayed. (3) Printing directly from the browser is another powerful feature to be found in Paint Shop Pro. This is the Print layout dialog. (4) The file browser also gives you a wide range of ways to organize, sort and find files stored on the computer hard drive.

File formats

Paint Shop Pro can read (or 'open') a wide range of different digital file types. But why would we need so many, what are the good ones to use for photos and what should we do if one's saved in an unrecognizable format?

Saving a **file format** is the term given to the way software stores digital data. There are dozens of file formats to choose from and most have specific characteristics.

Many file formats can be read by a wide range of software programs. A few might even be termed **universal** because they can be opened by any program, on any operating system. Well, almost.

A **native** file format can be opened only by the software that created it. A typical example would be Paint Shop Pro's '.pspimage' file format or Adobe Photoshop's '.psd' file format.

The reason for a native file format is so that it can record specific details that other formats cannot, such as vector data, blending modes, layers, channels and selections. If you save a file in a format other than its native state, most of this data will be discarded.

Normally you'd keep the picture in its native file format file as a **Master** file and it's this that you refer back to whenever further retouching or editing is required. If you need to print or distribute that file over the Internet, you'd save it under a different name, in a more widely accessible file format, such as a '.jpg' (JPEG) file. Despite the fact there are dozens of formats to choose from, most are not necessary for the digital image-maker. In fact, the fewer you use the better.

The following is a description of some of the more popular file formats and what they are used for.

Photoshop ('.psd')

As the name suggests, this is a file format designed specifically by Adobe and is similar in character to PSP's native '.pspimage' format. Adobe Photoshop 7 files can be recognized and opened by Paint Shop Pro 8. What's more, they retain all channel, layer and color profile information.

Tiff ('.tif')

The Tiff format is readable by a wide range of photo-editing programs. It's a good format for saving or storing digital photos on a hard drive, CD-Rs or other removable media. Tiff files can be compressed slightly to make more files fit into a smaller space with no loss of quality. Its **LZW** compression is lossless and reduces storage size by 20–30%. Other file formats can be compressed to higher ratios, but with significant loss of quality (see 'JPEG files'). Their disadvantages might be that they can be slow to open and they are physically large to store. If you want to preserve the maximum quality in a photo, however, a Tiff file is a good choice.

EPS

If you work in desktop publishing you'll be familiar with the Encapsulated PostScript ('.eps') file format. These, like the JPEG file, are cross-platform (i.e. they can be read on a Mac and a PC) and are particularly suited when using pictures or graphics destined for Level 3 PostScript printing devices (commercial offset litho printing). Page layout programs such as Quark XPress, Adobe InDesign and Adobe PageMaker support the EPS file format, as does Paint Shop Pro 8, and others. Files can be saved with ASCII, Binary or JPEG encoding (depending on the platform) and can include other information such as a **halftone screen** and **ICC profile**. If the file is purely photographic, stick with the Tiff or JPEG format.

PDF

The Adobe Portable Document Format or '.pdf' file is incredibly versatile. Using Adobe's Acrobat Distiller, you can create PDF files from any kind of publishing document. Acrobat Reader, the mini software program used to open and display PDF files, is available everywhere as a free download.

PDFs are ideal for transmitting comprehensive documents over the Internet. You can use them to notate and edit documents, articles and books, before returning them to a publisher or pre-press house for changes and final printing.

RAW

The RAW file format is a proprietary format used by Canon and Kodak, among others, for storing high-bit-depth photos before bringing them into smaller-bit-depth photo-editing programs, such as Paint Shop Pro 8. Once converted to a Tiff or JPEG file, there's some quality loss, although this always produces a 'cleaner' quality than if it were shot in a lower bit depth. There is little advantage in resaving that data back to the RAW format, as the quality lost is never regained.

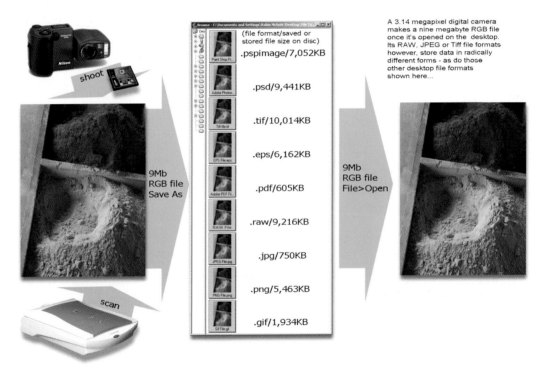

A 3.14 megapixel digital camera makes a nine megabyte RGB file once it's opened on the desktop. Its RAW, JPEG or Tiff file formats however, store data in radically different forms - as do those other desktop file formats shown here...

shoot

9Mb RGB file Save As

scan

(file format/saved or stored file size on disc)

.pspimage/7,052KB

.psd/9,441KB

.tif/10,014KB

.eps/6,162KB

.pdf/605KB

.raw/9,216KB

.jpg/750KB

.png/5,463KB

.gif/1,934KB

9Mb RGB file File>Open

This illustrates what happens when the same (scanned or shot) 9 Mb file is saved in different file formats. Note that, though these files vary widely in size once saved to disk, when opened again, all revert to their previous pixel dimensions: 9 Mb.

Internet file formats

JPEG

The JPEG (Joint Photographic Experts Group) or '.jpg' file is the most common format used for saving and displaying photos on the Internet. The overwhelming advantage of this format is that a picture

can be compressed so that it occupies a smaller physical space on the hard drive. Once a JPEG file is opened (again) for viewing or editing, it is rebuilt to exactly the same dimensions it had before it was compressed. For example, a 9 Mb Tiff file occupies about 9 Mb of space on the computer. If this is saved as a JPEG file it can be compressed to anything between 2.5 Mb, to less than 200k, depending on the compression level set. However, once reopened, it reverts back to its original 9 Mb! This seemingly fantastic format is marred only by the degree of damage that compression causes. The more compression applied, the poorer the result once it's opened again. As most photographs on the Web are saved as JPEGs, those disadvantages clearly don't outweigh the advantages.

PNG

The Portable Network Graphics format ('.png') looks similar to a JPEG file, though produces higher (picture) quality and has more features plus support for transparency. Against this is its lack of support for many older, pre-version 4 web browsers, the production of larger files and (therefore) a slow public uptake. I'd only advise using this format if you are sure that your audience is up to date with technology (hard to judge), otherwise you might lose some viewers by default.

Gif

This is another web standard – Gif files can be saved as incredibly small files and are very quick to load in a web page. Ideal for graphics rather than photos.

About color space

TOOLS USED	
Increase Color Depth	Split Channel
Decrease Color Depth	Combine Channel
Grayscale	

When you use a computer to view digital photos you do so in a particular **color space**. A color space is a viewing environment that has a specific displayable range of colors. For example, Paint Shop Pro displays color primarily in the RGB color space. Other spaces include **HSL**, **CMYK** and **Web** color (although only RGB is actually used for editing here).

For all standard viewing, retouching and editing tasks you'd opt to use the **RGB** ('Red', 'Green', 'Blue') color space. This typically reflects the capabilities of an RGB computer monitor as well as most inkjet or other non-lithographic printing devices (e.g. Kodak LED, Durst Lambda and Fuji Frontier printers). Note that though inkjet printers contain CMY inks, they are not strictly CMYK devices – which is why they print RGB files so perfectly.

HSL is a color space used for representing color more for the human eye than for the benefit of a computer screen. Color is measured in Hue, Saturation and Lightness values only.

In stark contrast, **CMYK** is a color space devised to represent onscreen what you'd see in a commercially printed publication like this book or a magazine. Of the three, CMYK is the hardest to work with simply because it's a subtractive color process, so what you see on an excited phosphorescent screen (the monitor) is very different to what happens when ink hits the paper in a pre-press business. Paint Shop Pro doesn't allow you to convert RGB files to this format other than by separating them into the four (black and white) plates which can then be exported for printing. Adobe Photoshop, on the other hand, **can** convert RGB to CMYK and present, onscreen, an approximation of how those colors change. If you are working with Paint Shop Pro in the pre-press environment, it might then be better to let them make the conversions (from RGB) for you.

You can increase and decrease the color depth of the images displayed in Paint Shop Pro simply by accessing the feature from the 'Image' menu ('Image> Increase Color Depth' and 'Image> Decrease Color Depth'). Increasing color depth allows you to add more sophisticated color effects to pictures that were previously only black and white or downloaded from the Internet.

Reducing colors is a little more complex. You'd normally do this, for example, before optimizing images for the Internet. As the Web can only display a limited

Use these dialogs to reduce or restrict the range of colors displayed in the photo. The original is pictured at the top with a restricted color gamut version at the bottom.

color gamut, it is essential that you do not try to use too many colors. If this occurs the browser estimates colors, which sometimes leads to misleading color representation – disastrous if it's a company logo, for example. The dialog that appears has a Standard/Web-safe checkbox that eases the problem. Diffusion can also be added in order to blend some of the less friendly tones to give the impression of something that's smoother than it really is (because there aren't enough colors present). Choose error diffusion for photos – this often works well.

In Paint Shop Pro you can check and 'OK' all these reduction actions in the preview window.

You can **Split** a color photo into component RGB/HSL or CMYK plates so you can check noise levels in individual channels – allowing you to apply noise-reducing filters singly rather than to three or four channels. This produces a better result (note: some channels exhibit more noise than others). This is also handy for experimenting/editing masks (a mask is really only a black and white channel). When finished you can reassemble the split channels into a single, combined RGB file.

There's a facility for reducing the three-channel RGB image to a single-channel **Grayscale** picture. However, if you want to make hand-colored effects you must retain

Paint Shop Pro permits you to 'deconstruct' the color image into its RGB, CMYK or HSL printing elements or plates. Do this to clean up unnecessary noise in a channel (using filters) or to alter tones. Once this is done, simply reassemble the elements to their original color state.

the RGB color information by desaturating the picture using the **HSL** slider and then adding color back using any of the global or brush color tools.

Image resolution

TOOLS USED

Image>Resize

Image resolution is one of the hardest aspects of digital imaging to understand. In layman's terms, resolution can be described as the ability of digital data (i.e. the pixels in the image) to resolve or represent a certain degree of image detail. Pixels are the smallest unit of digital capture and could be compared, very approximately, with the grain you often see in film.

If you print a 10 in × 8 in (25.4 cm × 20.3 cm) portrait that has been shot at full resolution with a three-megapixel digital camera, you might clearly see all the strands in the subject's hair. In this example, it might be reasonable to assume that the photo displays 'a good resolution'. If the portrait is printed larger, say to A3 proportions (11.6 × 16.5 in or 42 cm × 29.7 cm), it might begin to look out of focus or soft, indicating that the amount of data in the original file is not sufficient enough to be printed at that magnification. In this example, a file containing more pixels (higher resolution) is required to hold similar detail.

Resolution in print is measured as a numerical value denoted as 'dots per inch' (or **dpi**). This number describes the arrangement of pixels across the set page size – it's not a fixed value nor is it finite, although the mechanical restrictions of the CCD sensor or printer device do control how high the resolution can go. Once a picture has been snapped or scanned, its resolution can be changed (within reason) to suit its application. In the photographic world, the figure of 300 dpi is regarded as the best resolution (or concentration of pixels) that's required to produce a picture that appears to have **continuous tone**, just like a real photo.

Anything lower than this value might look soft or out of focus once printed larger than its recommended size. Resolutions above this value will be wasted because they go beyond the physical capabilities of most consumer printing devices. However, inkjet technology is so good it's possible to get continuous tone, photo-quality results from pictures saved to lower resolutions than this, but more on this later.

Digital photo data, the pixels that make up picture detail, can be arranged in any resolution and quantity up to and including the physical maximum captured by the image sensor (or 'digital film').

For example, a three-megapixel digital camera has a CCD sensor containing approximately 3.34 million pixels. What manufacturers don't tell you immediately is that not all these pixels are used to make the photo. Only the more centrally located pixels on the CCD chip are actually used to record

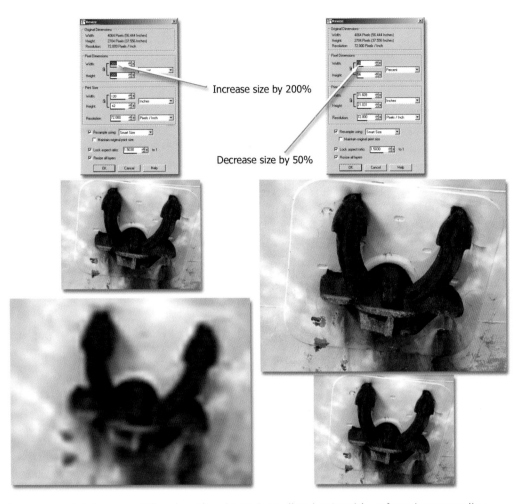

Increase size by 200%

Decrease size by 50%

Increasing print size, especially when the picture is small to begin with, softens image quality; however, decreasing image size has little detrimental effect.

the picture. For the number crunchers, this amounts to 2048×1536 pixels, or a total of only **3.14 megapixels**! This data is then (usually) saved in a 72 dpi resolution format on the camera flash memory card or a computer hard drive.

Because this data is stored in relatively low 72 dpi resolution, you might be fooled into thinking that this is no good for much other than use on the Web. However, if you have a close look at the file details once it's opened in Paint Shop Pro, you'll notice that the physical dimension of the photo is huge. The photo contains three million pixels, it's just that they're spread out over a large printable area, in this case $40\,\text{cm} \times 50\,\text{cm}$! Obviously way too big for most printers!

You can use Paint Shop Pro to reshuffle these pixels so that you get more into a smaller space. Doing this increases the resolution but reduces the physical, printable, dimensions (because there are more pixels per square inch).

For example, if you open a three-megapixel digital camera image in PSP and select the 'Resize' dialog window ('Image>Resize'), you'll be able to see how large the picture will print at that set resolution. In this example, if it's set to 72 dpi then the approximate print size will be 28 in × 21 in (or 72 cm × 54 cm).

To see how large this is at the correct continuous tone setting of 300 dpi, uncheck the 'Resample Type' checkbox and change the resolution setting in the New Size field to 300 pixels per inch (which is the same as dpi); notice that the size reduces radically to a more manageable 6.8 in × 5.1 in (or 17.3 cm × 13 cm). This, theoretically then is the largest the file can be printed before it begins to look a bit soft. However, as we now know, inkjet printers do such an amazing job, we can probably reduce that resolution further to 200 dpi or even 175 dpi and still get a print that looks fantastic. By reducing the resolution from 300 to 200, or 175, we make the print bigger because the pixels are spread thinner. The file size remains at 3.14 Mb throughout this process. Changing the resolution like this has no detrimental effect on the quality of the photo whatsoever (other than making it physically smaller).

Recap

You can change the density of the pixels in order to increase or to decrease the clarity of the printed output. Increasing the resolution reduces the printable dimension of the file.

What's the best resolution?

This depends heavily on your requirements. As a general rule it's best to work at an image resolution of 72 dpi if the work is destined for the Internet and at 300 dpi if your work is destined for print (at a photographic minilab or on a desktop inkjet printer).

Working on digital pictures that have been resized or scanned to a higher-than-needed resolution is not always a good idea because the quality benefits are negligible and the huge files this creates cause a problem for the speed of the computer. If you scan a photo at 600 dpi, the file will be twice the size of a 300 dpi scan, fine if you plan to print pictures twice the size of the original but a waste of time if it's going to be printed the same size, or smaller. Most scanners have a sliding (resolution) scale that allows you to enter the final (desired) print output size. This then scales the resolution to suit the degree of enlargement, thus minimizing the scan time and optimizing the file size. Don't try to copy the resolution of your inkjet printer. Most have a (so-called) resolution of 1440 dpi. Scan an A4 print to this resolution and you'll end up with a file several hundred megabytes in size! Far too big for most computers to open, let alone to manipulate! Stick to a maximum of 300 dpi. (If you are enlarging a print from, say, 4 in × 6 in to 8 in × 12 in you'd need to set a resolution of 600 dpi to handle the enlargement. For a same-sized print, leave the resolution at 300 dpi.)

The definition of resolution doesn't rely entirely on the amount of pixels present in the picture file. Resolution can be influenced by a number of other factors. These include:

■ The size of the pixels (consumer digital cameras have small pixels while pro SLR digital cameras have large pixels).

■ The lens or glass quality.

■ The software algorithms that convert the camera sensor's signal to displayable photo information.

Having said that, the **number of pixels** used to capture that data in the first place remains the most critical of all factors influencing picture resolution.

Resizing the picture canvas

'Image>Canvas Size'

You can add to the size of the **Canvas** by using the 'Image>Canvas Size' dialog. What this does is simply add, or subtract, pixels to or from the existing document, as if you had stuck a piece of backing card to the picture for a frame effect. Use this feature particularly if you are working on multi-layered documents and need extra room to accommodate new layers.

Enter the **New Dimensions**, center the canvas (you can add this extra real estate to one or other sides, to the top or bottom). Lock off the aspect ratio (if required) and click 'OK'. Using this dialog also allows you to add a different colored background to the picture, in a similar way to the Add Borders tool.

Photos that have a lot of white tones in them tend to bleed off the page, annoying if the page also happens to be white! Paint Shop Pro has an **Add Borders** feature ('Image>Add Borders') that can help. Choose the dialog and simply dial in the border width required for each edge, choose a border color, check 'Symmetric' if you want to lock the borders to the same thickness all round and click 'OK'.

Easy.

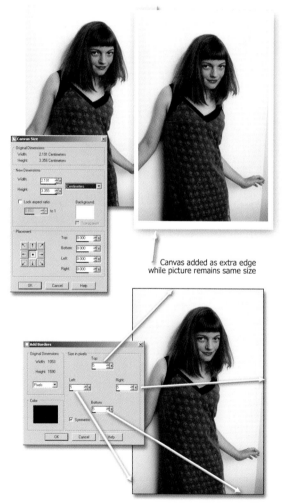

Canvas added as extra edge while picture remains same size

Use the Canvas Size dialog to add pixels to the entire document. Many pictures also benefit from having a colored border added to contain the composition. In this example use the Add Borders function.

Cropping the picture

Not all scans or photos arrive on your computer in exactly the right proportions. Scans in particular have a habit of not being on the level. Use the new **Straighten** tool (Tools toolbar, shared with the Deform tool) to fix this. Select the tool and it places a straight line through the middle of the frame. Grab a handle at either end and crank the angle up, or down, to match the horizon or the frame edge. Double-click to effect the change.

We have just discussed how to change the physical size in relation to the print resolution, but you might at some stage also need to cut bits off a picture to make it fit a frame, a particular format or window in a website. To do this you have to crop or cut pixels out of the picture using the **Crop tool**.

Crop marquee

This 9Mb file reduces to less than 8Mb after cropping

Although cropping an image reduces its overall pixel size (and therefore its resolution), sometimes it's necessary to attain better picture balance/composition.

Open a picture and choose the Crop tool from the Tools toolbar. Left-click the picture and, holding the mouse button down, drag the cursor across the image. Note the crop marquee that appears. Release the button, move the mouse inside this marquee and double-click to crop the image. The inside section of the marquee remains while the pixels on the outside are discarded. Care must be taken so as not to crop off too much! If it is not right, choose 'Edit>Undo'.

If you know the dimensions that the picture is to be cropped to, click the 'Specify Print Size' checkbox and enter the dimensions in the Width/Height and Units fields provided. The marquee automatically appears in the correct proportions for the desired crop. If you have many photos to be cropped for, say, a web gallery, this is a very productive tool. Click-drag any of the corner 'handles' or edges to expand or contract the crop dimensions while maintaining proportions.

You can also snap the Crop tool to a previously made selection in the image, its layer opaqueness or a layer's merged opaqueness. Double-click to make the crop.

Tip

If the 'Specify Print Size' box is not checked you can drag the sides of the crop marquee in any direction to make final adjustments to a freehand crop selection. Click 'Maintain Aspect Ratio' to keep the height the same as the width measurements when the crop marquee is enlarged or reduced.

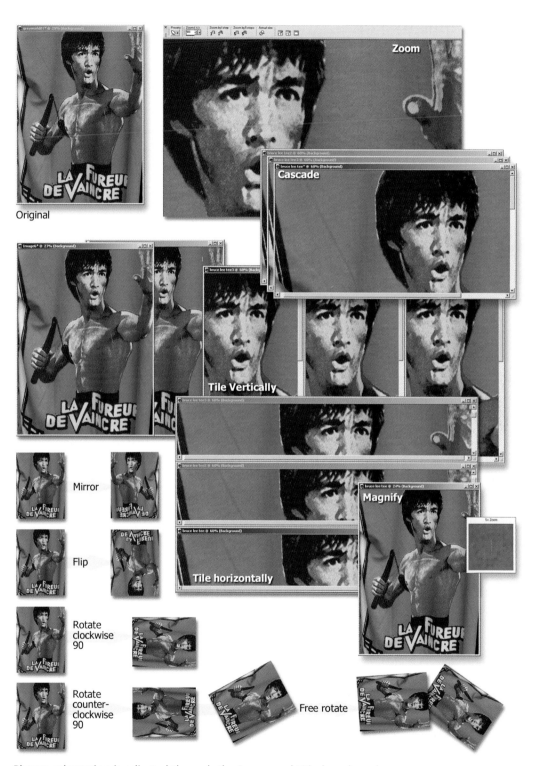

Original

Zoom

Cascade

Tile Vertically

Tile horizontally

Magnify

Mirror

Flip

Rotate clockwise 90

Rotate counter-clockwise 90

Free rotate

Picture orientation is adjusted through the Image and Window drop-down menus.

Adjusting picture orientation

TOOLS USED

Preview in Web Browser	Flip
Fit to Window	Mirror
View Full Size	Rotate
Full Screen Preview	

Paint Shop Pro has several important picture orientation tools. These include: Rotate, Flip, Mirror, Zoom, Fit to Window and Full Screen Edit.

Choose **Rotate** ('Image>Rotate>Free Rotate') and note the small dialog that appears. Use this to rotate the picture left, right, through 180 degrees or the full 270 degrees if needed. You can also use this dialog to make a free rotation of only a few degrees.

Flip merely turns the picture on its head over the horizontal axis, while **Mirror** turns the image on a vertical axis. Note that all the while you can use the central mouse wheel to increase or decrease the picture size in the editing window (if you don't have a three-function mouse, this is a good reason to get one!).

The **Zoom** tool is used to enlarge or reduce (left/right-click) the size of the image. If you need more control use the Zoom by one or Zoom by five steps for accelerated zooming. You can also click the **Full Screen Edit** to temporarily hide the Status and the Title bars ('Shift+A'), repeat to bring them back or **Full Screen Preview**, which places the active picture in a black border, removing all the palettes and menus ('Ctrl+Shift+A').

Web hounds can also preview the current file in the default Web Browser ('View>Preview in Web Browser'). If you want to see two pictures side-by-side, choose **Tile Horizontally** (or Vertically) from the Window menu. There are also features to let you **Cascade** more than one picture, fit the current image to the window size (Fit to Window) plus **View Full Size**, which fills the frame with the current pick.

2

Simple Picture Manipulation: Improving the Look of Your Digital Photos

This chapter shows how to fix up tones in digital photos and scans using Paint Shop Pro's auto function tools.

TECHNIQUES COVERED

Adjusting color saturation	Fixing underexposure
Adding soft focus effects	Fixing red-eye
Adding impact to photos	Making photos appear sharper
Controlling picture contrast	One-button photo fix-ups
Correcting color balance	

TOOLS USED IN THIS CHAPTER

Automatic Contrast Adjustment	Hue Map (tool)
Automatic Color Enhancement	Levels (tool)
Automatic Saturation Enhancement	Manual Color Balance (tool)
Black and White Points	Noise reduction filters
Color Balance tool	One Step Photo Fix (multiple filters)
Colorize tool	Red-eye Removal (tool)
Clarify (filter)	Stretch (filter)
Fade Correction (filter)	Sharpen (filter)
Gamma tool	Sharpen More (filter)
Histogram Adjustment (tool)	Soft Focus (filter)
Highlight/Midtone/Shadow	Saturation brush
Hue/Saturation/Lightness	Unsharp Mask (filter)

One-button digital photo fixes

TOOLS USED

One Step Picture Fix	Clarify
Automatic Contrast Adjustment	Automatic Color Enhancement
Stretch	Automatic Saturation Enhancement
	Fade Correction

Pictures shot with a digital camera, when viewed in a photo-editing program, often appear dull, flat, boring or lifeless. There are two reasons for this: firstly, it might just be that you have taken a dull, boring and lifeless photo but, more than likely, it's because the camera has captured the picture data in a lower-than-normal contrast mode, either because its processing software has made a mistake or because that's the way it was programmed. Some cameras save photo information in flatter-than-normal contrast in order to capture maximum detail from subject highlights and shadows.

Paint Shop Pro's **One Step Photo Fix** applies six different filter actions designed to increase the quality of any dull or lacklustre photo...

Use Paint Shop Pro's new One Step Photo Fix feature to improve the look of a digital picture file or scan.

Paint Shop Pro 8 has several 'instant fix' remedies to make photos appear 'snappier'. These are found under the 'Adjust' drop-down menu or on the 'Photo' toolbar and can be used as a one-click solution or customized for better results through its dialog window. The best place to start is using Paint Shop Pro's new **One Step Photo Fix** tab – this applies a selection of image enhancements to the picture file, including auto contrast and clarify. This is normally enough to make even the dullest of photos appear snappy.

Automatic Color Balance

This is a versatile tool for removing stray or odd color casts from digital photos. In the film world, casts are caused when film is exposed under a light source that's not recommended for that film brand. Daylight film exposed under incandescent lighting produces a strong yellow/red cast. Incandescent or tungsten film is blue-biased and is designed specifically to negate this yellow/red cast, although if shot in daylight everything turns blue. Regular daylight film shot in fluorescent tube lighting goes green.

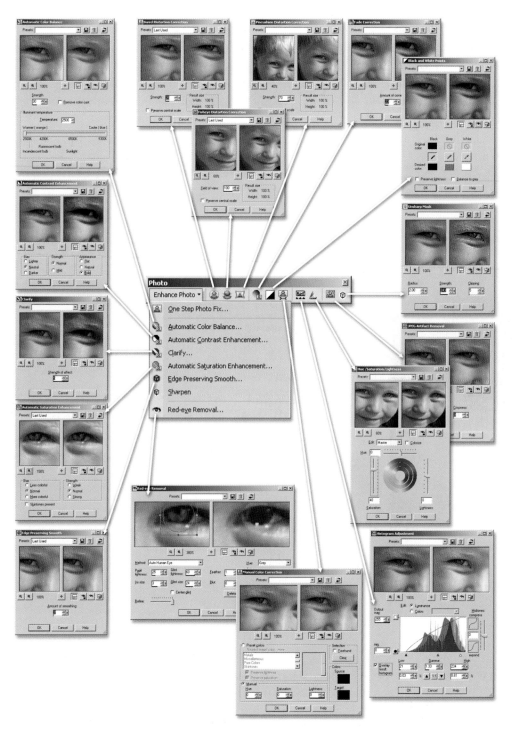

The Photo toolbar is really a powerhouse of image editing potential, from the One Step Photo Fix through a range of auto functions to Paint Shop Pro's Clarify and Sharpen filters. Little is left out. If it is, check what's offered on the Tools and Effects toolbars.

Though similar casts occur with digital cameras, their **Automatic White Balance** settings usually fix any color discrepancy. When this doesn't work, you'll need to make a software adjustment.

Here's how: ensure that the 'Photo' toolbar is visible on the desktop. If not, right-click the menu bar and select 'Photo' from the toolbar's contextual menu. In default mode these sit under the Enhance Photo submenu ('Automatic Color Balance', 'Automatic Contrast Enhancement' and 'Automatic Saturation Enhancement').

Click the first button to open its palette or 'dialog' window. Although it's simple enough to click the 'OK' tab here and accept the result Paint Shop Pro serves, it might not always be the **right** result.

For this reason all tool dialog windows have a range of options that allow you to view changes **before they are applied to the picture**. This is a more economical way of operating because it permits you to test numerous versions before committing to one effect.

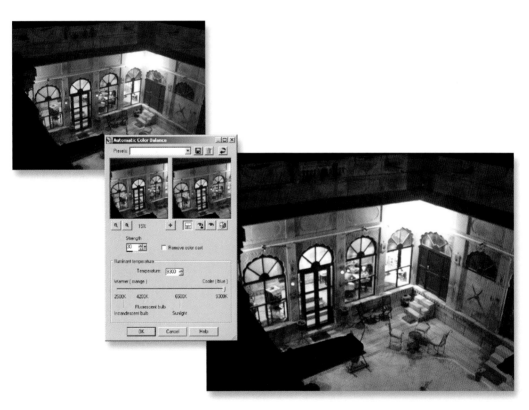

The **Automatic Color Balance** tool is built for photographers. The sliding scale that runs horizontally through the middle of the dialog is film-based, referring to the color temperature of light and its relative hue (represented in degrees Kelvin or 'K'). All you need to know is that if the slider moves to the left the picture becomes warmer, if it's moved to the right it becomes cooler. If the picture has a blue tint, slide the handle to the left, and if it's 'warm', drag the handle to the right. Some might use this to add a color cast. The red end of the spectrum conjures up a wealth of emotions connected with cosiness, happiness and contentment. A blue house interior is less inviting than one that's filled with a warming, yellow glow.

Click the 'Automatic Color Balance' button on the Photo toolbar and check out the dialog window that appears on the desktop (alternatively, open it via the 'Adjust>Color Balance>Automatic Color Balance' menu; to help, the symbol in this submenu for this tool is the same as the one on the Photo toolbar). Each of these filter tools has a similar dialog window, although obviously some have more controls in them than others, depending on the job they are designed to perform.

Display options

At the top of the dialog are two preview windows, 'before' on the left and 'after' on the right. You can switch these off if you prefer. (Click the 'Show/Hide Previews' tab, under the left-hand preview window to do this. Click again to make it reappear.)

Everything you do in terms of picture adjustments using this tool appears in the right-hand preview window. The larger the file size, the longer this might take to action. You can also make changes appear live on the desktop display by pressing the **Autoproof** or **Proof** tabs. Autoproof displays all changes made in the dialog, Proof displays the last change only.

If you are unsure about what you are looking at in these windows because it's magnified too much, there are two things to do. Click anywhere, in either window, and, using the hand tool that appears, push the preview till it's in a more suitable position. If it's greatly magnified you might have to either reduce the magnification by clicking the '−' tab or by using the **navigation** button to relocate the source of the preview. Click, hold and move the mouse to relocate the preview source point.

All dialog windows are resizeable so that, if you feel the default size is not big enough to view changes properly, you can mouse-grab the bottom right-hand corner and stretch it to fit the monitor. Paint Shop Pro 8 'remembers' where the dialog sat last time so reopens in the previous position and with the last settings.

A final point to make about dialog windows is the **Randomize** feature. If you don't understand what all the adjustments might, or might not, do to the photo, click the Randomize button and let Paint Shop Pro decide for you. There are no guarantees, but at least this feature gets you out of old habits by presenting combinations that you might never try. Continue randomizing till you hit on one that you like.

The **Automatic Color Balance** tool is built for photographers. The sliding scale that runs horizontally through the middle of the dialog is film-based, referring to the color temperature of light and its relative hue (represented in degrees Kelvin or 'K'). All you need to know is that if the slider moves to the left, the picture becomes warmer, if it's moved to the right, it becomes cooler. If the picture has a blue tint, slide the handle to the left, and if it's 'warm', drag the handle to the right.

Some might use this to add a color cast. The red end of the spectrum conjures up a wealth of emotions connected with cosiness, happiness and contentment. A blue house interior is less inviting than one that's filled with a warming, yellow glow.

Automatic Contrast Enhancement

Like the Auto Color Balance feature, Paint Shop Pro's **Automatic Contrast Enhancement** dialog requires at least one mouse click. It offers an instant contrast boost, ideal for any photo that's a bit dull. Open the photo and select 'Adjust>Brightness and Contrast>Automatic Contrast Enhancement' or click the relevant button on the Photo toolbar.

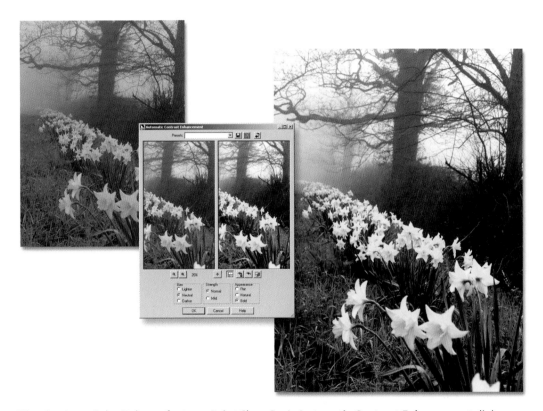

Like the Auto Color Balance feature, Paint Shop Pro's **Automatic Contrast Enhancement** dialog requires at least one mouse click. It offers an instant contrast boost, ideal for any photo that's dull. Open the photo and select 'Adjust>Brightness and Contrast>Automatic Contrast Enhancement' or click the button on the Photo toolbar. Dialog options include a tone Bias ('Lighter', 'Neutral', 'Darker'), Strength ('Normal' and 'Mild') and an Appearance setting ('Flat', 'Natural' and 'Bold'). Clicking the default 'Neutral, Normal, Natural' setting is usually enough to improve the look of most photos. If a snappier result is needed, select the 'Bold' setting.

Dialog options include a tone **Bias** ('Lighter', 'Neutral', 'Darker'), **Strength** ('Normal' and 'Mild') and an **Appearance** setting ('Flat', 'Natural' and 'Bold'). Clicking the default 'Neutral, Normal, Natural' setting is usually enough to improve the look of most photos. If a snappier result is needed, go for the 'Bold' setting.

Automatic Saturation Enhancement

Paint Shop Pro's easy-to-use **Automatic Saturation Enhancement** tool ('Adjust>Hue and Saturation>Automatic Saturation Enhancement') is just that: simple to use and especially effective on pictures that are dull. Dialog options include 'Less Colorful', 'Normal' and 'More Colorful' buttons. However, it's the 'Strength' settings that you need to watch. Ensure that you preview the shadow areas in the picture because that's where changes will be most evident. Use the Automatic Saturation Enhancement feature on faded or overexposed photos (too bright) or pictures that have lost color through poor scanning and inexperience.

There are a few more features on the Photo toolbar that can be used to improve the appearance of a dull picture. These are 'Clarify', 'Stretch' and the 'Fade Correction' tools.

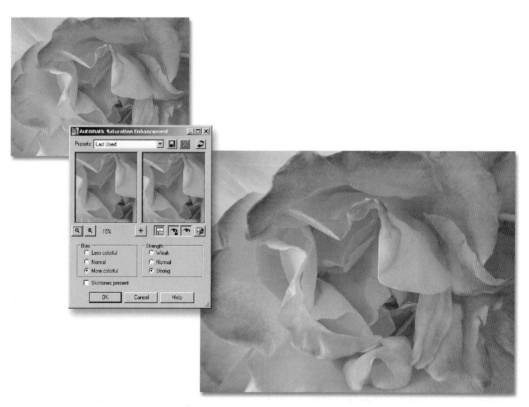

Automatic Saturation Enhancement. Providing that the contrast in the photo is OK, this tool can transform a picture from 'plain old dull' to a punchy and attractive color in one mouse click. Dialog options include 'Less colorful', 'Normal' and 'More colorful' buttons. However, it's the 'Strength' settings that you need to watch. Ensure that you preview the shadow areas in the picture because that's where changes will be most evident. Use the Automatic Saturation Enhancement feature on faded or overexposed photos (too bright) or pictures that have lost color through poor scanning and inexperience.

Clarify is well termed because that's exactly what it does to a slightly unclear picture. It adds contrast and color so it also appears to have been slightly sharpened and brightened.

Stretch adjusts the tone histogram in one hit. If you choose Levels you have to do this manually. Stretch does it in one go. Maybe it works, maybe it doesn't. If not, choose 'Edit>Undo' and try another tool.

Fade Correction is designed for restoring photos that have suffered the ravages of time. Options for this tool are limited: strength from zero to 100. That's it! Again, if the filter effect doesn't work, try another function like 'auto contrast' or 'auto saturation'. A combination of the two might work better than one.

Controlling picture contrast

TOOLS USED

Histogram Adjustment	Black and White Points
Levels	Equalize
Highlight/Midtone/Shadow	Stretch
Gamma Adjustment	

One of my favorite enhancement tools is also one of the most powerful; it's called the Histogram Adjustment tool and is used for making tonal improvements to pictures, or selections within those pictures. These can be subtle or quite radical, depending on your requirements. While most one-button tone fix-up tools tend to rip the guts out of the pixels every time they are used, Paint Shop Pro's contrast tool subsets preserve the picture integrity, so there's never any lost quality, important if you plan to edit or re-edit pictures more than a few times.

If you are a casual image-maker, losing a bit of quality mightn't worry you a jot, especially if you're in the habit of working from copies. However, for the digital purists, the sanctity of the pixel is often paramount, which is why the Histogram Adjustment toolset is an ideal choice for making the most of tonal changes.

In Paint Shop Pro, contrast adjustment appears in several guises, principally as the **Histogram Adjustment** tool ('Adjust>Brightness and Contrast>Histogram Adjustment'). All other tools in the subset are variations of the same: the **Levels** tool ('Adjust>Brightness and Contrast>Levels'), the **Highlight/Midtone/Shadow** adjust tool ('Adjust>Brightness and Contrast>Highlight/Midtone/Shadow'), the **Gamma Correction** tool ('Adjust>Brightness and Contrast>Gamma Correction'), **Black and White Points** ('Adjust>Color Balance>Black and White Points'), the **Histogram Equalize** tool ('Adjust>Brightness and Contrast>Histogram Equalize'), and the **Histogram Stretch** tool ('Adjust>Brightness and Contrast>Histogram Stretch') tool. Roughly in that order of effectiveness.

Choose **Luminance** to affect all the picture. Click the Colors tab to add tone changes to selected RGB color channels only

The **Shadow** slider increases contrast in the shadows by reducing shadow detail

Click here to see the **Before** and **After** spread of tones in the photo (highlighted in ruby-red)

Highlight slider. Use this to increase contrast in the highlights

Midtone or **Gamma** slider. Use this to brighten or darken the frame without affecting the contrast

Click the Floppy icon to save a particular setting as a Preset for use later on other pictures

Push the Gamma slider to the right to brighten tones in the picture. Push to the left to darken picture brightness

Not sure which way to go with the tones? Click the Randomize tab and let Paint Shop Pro try a few versions!

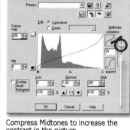

Expand the Midtones to flatten contrast in the photo

Compress Midtones to increase the contrast in the picture

The perfect combination is when you slide shadow and highlight sliders towards the center of the Histogram map (move them only slightly till the slider touches the base of the tone histogram mountain area) and then give the Gamma slider a tweak to compensate for any ensuing lightness or darkness.

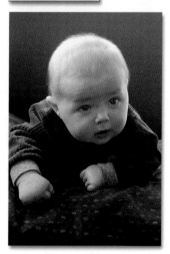
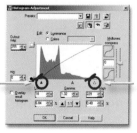

Move shadow tab in till it touches edge of the tone histogram. This should be enough to display a radical improvement in picture contrast. Repeat the process with the highlight slider if necessary...

Most digital camera pictures suffer from low contrast – a shot in the arm from the Histogram Adjustment tool is usually all that's needed to change a boring snap into one that literally jumps off the page.

The Histogram Adjustment tool is the most honest of this entire toolset – the rest are simplified or slightly watered-down versions of the same process although, that said, each has its own distinct place in the hierarchy of tonal change.

Get to grips with the Histogram Adjustment tool and you'll be able to walk through the rest with your eyes shut. Begin by opening a picture. Choose the Histogram Adjustment tool from the 'Adjust' menu. The first thing you'll notice is the odd-looking 'mountain range' sitting bang in the

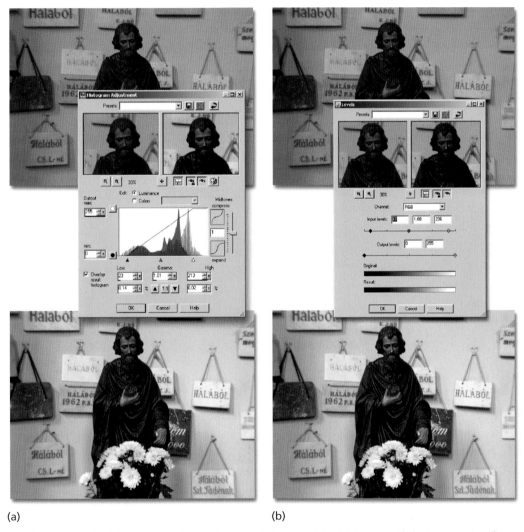

(a) (b)

Check the spread of the tones in the Histogram Adjustment tool (a) to see if there's any significant flattening at the shadow or the highlight end of the tonal mountain range. Push the appropriate slider across the flat toneless area till it hits the edge of the 'mountain' range. This is normally enough to fix the contrast, darken the shadows and put enough 'oomph' into the highlights. The Levels tool (b) works in almost exactly the same way – although you don't have the benefit of seeing the tones in a histogram to help guide you.

middle of the dialog window. This mountain range, or histogram graph, represents the distribution of the tones within the photo. The 'range' to the left represents the shadows while the 'range' to the right represents the highlights. If there's a bit of flat 'beach' either side of the mountain range, this indicates that picture contrast is not as wide as it could be, even if you can't see anything wrong with the picture.

The three small triangles along the base of the tone mountain (one black, one gray and one white) represent the shadow, midtone and highlight values, respectively. The two at either end of the scale can be physically repositioned to stretch or compress the tones in the picture. Stretch them and you decrease the contrast (PSP adds more tones to the histogram), compress them and you increase the contrast (PSP reduces the number of tones present in the histogram).

If you want to make the picture look brighter or darker without changing the contrast, grab the middle slider and move it right or left. The beauty of this tool is that it shows you, in the most precise fashion, exactly what's happening to the tones in the picture. Simple enhance contrast or 'enhance brightness' tools don't always show what happens and can often make mistakes, often resulting in pictures that don't look much better than before.

As a rule you can make the best tone improvements by shifting the shadow and highlight sliders across any flat, beach area to the beginning of the mountain range (see figures (a) and (b) on page 49). Not all histograms have a beach, while others might have a beach on one side only. Making these basic adjustments should bring significant improvements to the picture contrast, as well as to its overall visual impact.

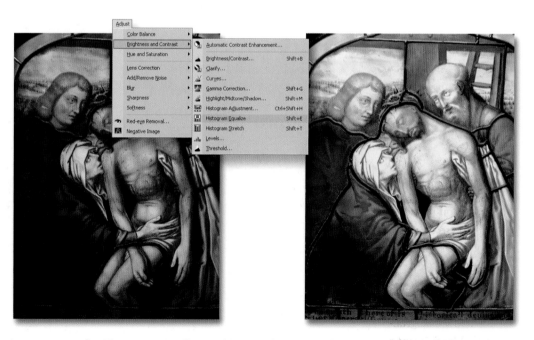

In some cases the Histogram Equalize tool is enough to smooth out the tones in a digital file. If it has no effect, try the Histogram Adjustment tool.

Increase or decrease the brightness in the picture using the Gamma Correction tool.

Die-hard image-makers can look at the histogram and make numerical changes in the fields provided, without even seeing the graph. For the time being I'd suggest sticking to the proven click-and-slide technique described.

What else can this tool do?

- Change the gamma (a mixture of contrast and brightness) of the image, bringing it in line with the specific gamma of a PC or Mac screen.
- Create extreme color effects by radically compressing the shadow/highlight values.
- Create film-like cross-processed effects by radically compressing the midtones.
- Apply any of these tonal effects to individual color channels only (Red, Green or Blue) by clicking the 'Color' radio button below the 'Luminance' button.

A summary of how other histogram subset tools work is given below.

The **Levels** tool is a simplified version of the Histogram Adjustment tool. Its chief controls are the input and output scales. The former affects the contrast and brightness in the picture in exactly the same ways as the Histogram Adjustment tool. The central slider influences the image brightness. Use the output scale to reduce the contrast in the shadows or the highlights. It's a neat, fast and mostly effective method of controlling the tones in your photos.

The **Highlight/Midtone/Shadow** tool performs the same job as the Histogram Adjustment and Levels tools, only the adjustments have been wrapped neatly into a linear scale rather than as tones represented in a histogram. I can't say that this is better, or worse, than other tools. It's just a similar tool in a slightly different package. You might find this easier to use than the Histogram Adjustment tool, so give it a go.

PSP's **Gamma Correction** tool is used to alter the gamma (or brightness) in the picture. Again, in much the same way as you'd increase/adjust the gamma using the Histogram Adjustment tool – but that's all it will do. Link the three color channels to make this a uniform adjustment. Unlink and use the channel sliders to make colorized monotone effects.

The **Black and White Points** adjustment feature allows you to specifically target tones in the picture and to change them from black, white or midtone to an adjusted shade of those tones. Adjust the original shades using the eyedroppers provided to the desired color. The tool has a 'Balance to Grey' and 'Preserve Lightness' checkboxes.

Another slant on the image brightness theme is to use this tool – the Highlight/Midtone/Shadow tool can be used to direct a brightness increase to specific parts of the picture, without the need for making any selection.

The **Equalize** feature does the same as the Stretch feature with the addition of spreading the midtones evenly across the width of the histogram. This produces an 'averaging' effect throughout that might prove too much for some pictures. Try it first on overly bright or contrasty pictures.

The **Stretch** tool is the simplest contrast adjustment tool of the lot. It (invisibly) drags the highlight and shadow ends of the 'beach' to the beginnings of the tone 'mountain' for you, thus spreading the tones (more) evenly across the tone range. It's a true one-button tone fix-up with absolutely no user control. Try it on average or low-contrast photos.

> **Tip**
>
> You can apply any of these histogram adjustments to selections. Make the selection first, save it and then run the tone adjustment, as described.

Correcting color balance

TOOLS USED

Color Balance	Manual Color Balance
Fade Correction	

Color is one of the most difficult subjects to get 'right'. What one might think is 'a nice color', others might hate.

Despite current digital camera technology offering fantastic image capture potential, few cameras ever produce truly realistic color. While the end result will always be better than if we used film, digital snaps still require fixing up to make them look similar to the scene as the shutter button was pressed. Though this might entail just a simple contrast boost, more often than not, the print is going to need some 'tweaking' to get the color reproduction near perfect. Paint Shop Pro has a wide range of color correction tools, some basic and some quite sophisticated, with which to achieve this. The trick really is to recognize which of these tools work best with each different picture.

If you suspect a picture requires a color boost, try the **Automatic Color Balance** or **Fade Correction** tools (as mentioned in Chapter 10). If this doesn't do the trick, you'll need to reach for the big guns: the first, and probably the best, one to try is called the **Color Balance** tool ('Adjust>Color Balance>Color Balance').

RGB, or Red, Green and Blue, is a description given to the range of colors used by all computer monitors. This is also called the **color space**. Other spaces include **CMYK** (Cyan, Magenta, Yellow and Black) and **HSL** (Hue/Saturation/Lightness). The Color Balance dialog has two scales: RGB and CMY, the colors that are physically opposite to RGB. If you have ever tried darkroom color printing, you'll recognize these terminologies. If you have never had the pleasure of any darkroom work, all you need to know is that if you increase the yellow values, for example, you'll reduce its opposing color (blue). Increase the green and the magenta reduces, increase the red and cyan decreases. The trick is in being able to recognize any rogue colors in the picture first and to make the necessary adjustments, which is where experience working in a color lab comes in handy.

The nice thing about digital is that if it doesn't work immediately, you can try more of the same color or use the **Restore to Default** button that sits on PSP's tool dialog window. Once the image is restored to the previous version, go for a different color combination. While Paint Shop Pro's

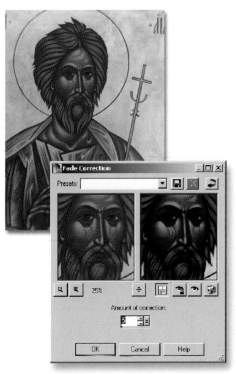

Use the Fade Correction on any pictures – not just those that have faded through age. Expect a dramatic improvement in picture clarity and contrast.

automated correction tools make some of these decisions for you, not everything works properly first time! The manual adjustment nature of the Color Balance dialog allows you greater control and therefore a better chance of attaining the precise effect you are after.

The powerful nature of the Color Balance tool means that all shifts are infinitely variable – they can even be applied to three separate tonal areas in the picture: the shadows, midtones and the highlights. This is like having your own selections built into the picture.

- Use the 'Preserve Luminosity' checkbox to preserve some of the detail in the picture. If this is clicked 'off', you'll get a harder and denser color result.
- By sliding two of the three color sliders fully left and fully right (one each), for all three tonal areas, you can convert a full color picture into a flashy two-color illustration. Try using the color balance sliders in extreme positions to make heavily atmospheric color effects.
- Use color changes in these three tonal areas to create colorized effects in black and white pictures.

If the Color Balance tool looks a bit scary, try the **Red/Green/Blue** feature. This is a pared-down version of the Color Balance tool and allows you to simply dial in numerical values for additional red,

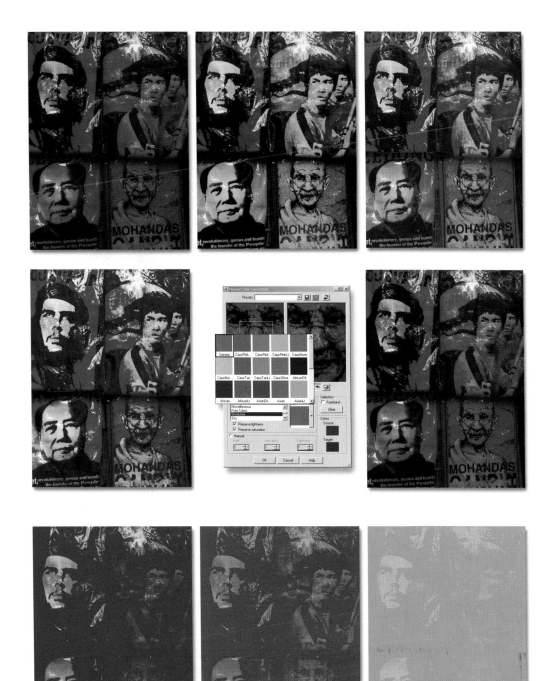

Paint Shop Pro's Manual Color Balance dialog has a wealth of possibilities – using either the preset color channels (for example, skin tones) or by flicking to its manual color adjustment settings.

green and, you guessed it, blue, where needed. It's a pretty straightforward tool to use. Again, having some knowledge of what these wayward colors look like would help. If the picture has a slight color cast it'll be most obvious in the neutral-gray tones.

Another tool packed into Paint Shop Pro is its rather esoteric **Manual Color Correction** tool. Esoteric? More like plain old weird! This dialog works on the principle that you can isolate a 'Source' color and change that to a 'Target' color. The Source can be a single pixel or group of pixels, chosen using a standard marquee or freehand selection tool. For example, to make the picture darker, select light gray as the source color and set dark gray as the target color. All the light grays in the frame darken to the same hue as the target color. There is a range of unusually described preset colors supplied in the dialog designed to cover a wide range of possibilities. Colors include: hot dog, brussel sprouts, white bread and light beer. Does that explain my 'esoteric' comment?

Aside from changing the source to the target colors, the tool also changes all the surrounding tones proportionally. In the gray example, the image simply darkens. If another color is chosen, you'll get another result entirely. The idea behind this tool is to include color subsets that users are likely to remember, i.e. beer-colored or pizza-colored scenes. Very Simpsons!

Adjusting color saturation (intensity)

TOOLS USED	
Hue/Saturation/Lightness	Colorize
Automatic Saturation Enhancement	Hue Map

While it's simple enough to change contrast and color in a photo using the histogram and color balance tools, not all picture-makers take the time to adjust the color hue and its intensity or 'saturation'.

Paint Shop Pro's Hue/Saturation/Lightness or 'HSL' tool ('Adjust>Hue and Saturation>Hue/Saturation/Lightness') is a specialized feature that encompasses controls to change specific color values within a picture, rather than by simply increasing or decreasing its color shades.

What this means, in English, is that you can choose the yellow values and shift them to blue. When this is done, all other colors shift the same amount. So reds shift to green, blues to yellow, and so on. The outer color circle in this dialog represents the original color while the smaller inner color circle represents where that original color has been shifted to.

This tool can be used to remove slight color casts in a picture or to add specific color effects that you mightn't be able to achieve using one of the color balance tools. For my money, the real power in this feature is its ability to shift color values in individual color channels. On some pictures this works as if you have custom-made selections built into the picture.

For example, if it's a snap of a green-colored car, you'll be able to select 'Green' from the 'Master' drop-down menu, change the Hue values so that **only** the car color changes. How neat is that? If

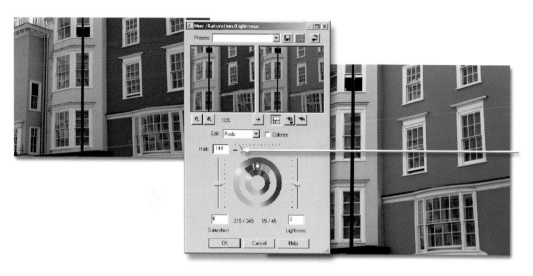

By matching a subject color with one of those displayed under the 'Master' drop-down menu and then shifting the Hue values you can radically change the color in one part of the picture while **not** affecting anything in the rest of the picture.

there are other green objects in the frame, these will also change color proportionally; while the selection concept works OK, it's important to note that it's color-specific, not pixel-specific. Options include 'Reds', 'Greens', 'Blues', 'Cyans', 'Magentas' and 'Yellows'.

What else can be done using this tool?

While hue is an expression of color values within a picture, saturation refers to the intensity of those colors. Saturation is often where we come unstuck! If a photo looks a bit dull you might naturally reach for the Auto Saturation Enhancement tool ('Adjust>Hue and Saturation>Automatic Saturation Enhancement' or from the Photo toolbar) and crank it up fully in an attempt to make the photo more attractive (set to 'More Colorful' and 'Strong').

Superficially this might work quite nicely and will certainly produce seriously attractive colors onscreen. However, the trouble with radical saturation increase is that often it becomes unprintable because so much color has been added to the image it's impossible to match using regular inkjet printer inks. The machine will keep firing ink at the paper without any apparent color change. Care must be taken at all times so as not to overdo the saturation and make an unprintable result.

You can also use this dialog to change the lightness of the image – although I'd leave this well alone and choose the Levels dialog to perform these actions. The only exception to this rule might be if you are using the tool to make backgrounds – in which case the picture integrity is not paramount. Another neat effect is to colorize the picture by clicking the tab. What does this do? Colorize essentially applies an old-fashioned tinting effect to the picture by reducing its saturation, almost to monochrome, and adding a specific single color hue. The result is a beautifully tinted light blue/red/yellow/green picture. You see this type of effect a lot in advertising, as it's particularly effective in evoking a mood or specific period in a picture. Click the 'Colorize' tab and move the Hue

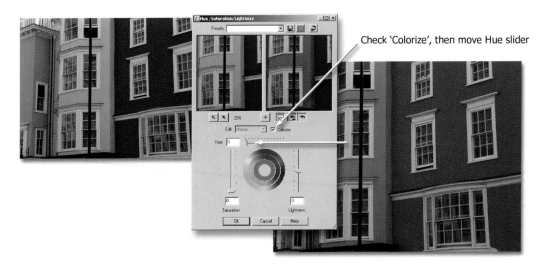

Check 'Colorize', then move Hue slider

With the Hue/Saturation/Lightness dialog open, check the Colorize box and watch as Paint Shop Pro tints the entire image. Use the Saturation slider to temper the effect.

slider, noting how the color in the tint changes. Move the Saturation slider more to increase or reduce the intensity.

If colorizing as a special effect is all you are after use the Colorize dialog ('Adjust>Hue and Saturation>Colorize'). This is faster and less complicated than the full-on HSL tool, plus it has the additional benefit of having vari-colored 'amount' sliders that display the part of the spectrum that the sample is taken from. This is a nice touch.

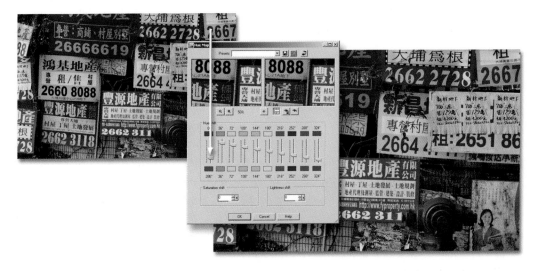

The Hue Map looks a bit scarier. Match a color with one of the colors displayed in the dialog and shift them, using the provided slider to another value. Fine-tune the effect using the two fields at the base of the dialog for Saturation and Lightness shift.

The Hue Map is another slightly off-center tool used to change specific colors within a picture. This is similar to applying a color change using the HSL tool on a specific channel, as just described. You can elect a particular color, move the appropriate slider to choose another hue for that only and check the results live. If you then want to change that second color, you must remember to go back to the original slider to make the change, rather than selecting a color that matches the changed state. Paint Shop Pro used the original color information as the source for its changes. Check the preview window to locate the (original) color source.

Other tools to consider: try the Color Replace tool to get a similar result.

Making photos (appear) sharper

TOOLS USED

Clarify	Sharpen
Unsharp Mask	Sharpen More

Sounds too good to be true? While it's acceptable to change color, contrast or saturation in a digital file, changing the sharpness is a little trickier.

For some this might seem a Godsend, along the lines of changing water into wine. However, Paint Shop Pro has several tools designed to make pictures appear sharper than when they were scanned or shot using a digital camera. It's important to note that you can never really change an out-of-focus picture to one that looks as though a top advertising shooter did the job, but you can certainly make it look better!

How does this magic work? Most sharpness tools act on picture contrast. You might have noticed this using the histogram tools. A general contrast boost usually makes a picture appear sharper.

Paint Shop Pro has four sharpness filters. **Clarify** is a one-button filter used to add a quick bump in contrast and image sharpness. Most times this works well; however, for total control you have to use the perversely named **Unsharp Mask** filter. What this does is apply a selected contrast boost, at pixel level, to parts of the picture with varying lightness levels.

The reason that this is the best picture-sharpening tool is that it has three adjustable controls written into the equation: 'Radius', 'Strength' and 'Clipping'. Radius selects the number of pixels around the point of contrast difference. Strength controls the amount of contrast added to those pixels while clipping affects the lightness of the chosen pixels.

One of the disadvantages in sharpening digital pictures is that the filter is non-discretionary; it has a habit of sharpening the bits you don't want to sharpen as well as the bits you do. This includes any digital noise, film grain or other electronic imperfections that have been added to the file along

The Unsharp Mask filter can be adjusted to extract the maximum (sharpness) from all types of scan or camera snap. Increasing the percentage or 'Strength' value alone is not always enough to produce satisfactory results every time. Radius of 1 and a Strength value of 100 produces slight improvement. Increasing the Strength to 300 (center dialog) produces a marked improvement – though this needs to be tempered using the Clipping values (see lower dialog).

the way. So, the more it's sharpened, the more noticeable the imperfections (the digital noise) becomes. Help is at hand though, because the main reason for the dialog controls is to help in minimizing this inevitable noise increase.

■ Too much radius creates a nasty-looking whitish halo throughout the high-contrast sections of the picture.
■ Too much strength adds an equally fiendish grittiness that looks particularly bad once in print.
■ Too much clipping makes the picture appear soft, destroying the sharpness effect entirely.

Like all sophisticated photo-editing tools, Unsharp Masking requires practice to get right. There's no 'perfect' setting because some pictures need more sharpening than others.

The picture's application also has a profound impact on how you sharpen its pixels; inkjet prints need less sharpening than those designed for newsprint. If you are submitting pictures to a third-party publication, call the relevant art department first to check on that publication's specific material (sharpening) requirements, if any.

As a general rule start with:

■ A radius of one or two pixels.
■ A strength of between 100 and 200.
■ A clipping value of 'zero'.

If nothing seems to improve in the picture with these settings, increase the strength value. Then try increasing the radius value (a bit at a time). If the Unsharp Mask effect is applied to a high-contrast picture, you'll need to dial-in a small clipping value to soften its impact. The beauty of this is that you see what you are getting instantly and can make changes live before applying them to the full resolution version.

Paint Shop Pro comes with two other no-brainer sharpen tools: the **Sharpen** and the **Sharpen More** filters.

The Sharpen filter is a good place to start; it applies a preset contrast boost to a selected range of pixels. This might be enough to give most digital snaps a nice sharpen. For a stronger filter effect, try the Sharpen More filter. This is slightly more radical, though still by no means as radical as the Unsharp Mask filter can be. The good thing about these effects is that they are repeatable. If the effect isn't strong enough, repeat it using the keyboard shortcut 'Cntrl+Y' till it is.

Tips for making digital files appear sharper

■ If using a digital camera, make sure that the picture is exposed correctly and that the focus is correct for the subject. It's possible to enlarge the image on the camera LCD screen to check this focus closely. If you think that there's a problem, erase that frame and reshoot.

SIMPLE PICTURE MANIPULATION

■ In Shutter (Tv) or Manual (M) shoot modes, pick a faster shutter speed (a higher number) to 'freeze' action, essential if the subject is fast-moving.

■ Learn to use the **AF lock** in the camera. This works by half-depressing the shutter button that activates the AF system. Once the in-camera audio 'beep' confirmation sounds you can then either press the shutter fully or reframe to position a subject off-center and then take the picture. The most obvious cause of out-of-focus snaps is from the subject not being in the camera's AF focusing area when the shutter button is pressed.

■ Scans normally require unsharp masking to compensate for the scan process, which can make things appear slightly unsharp.

■ Most scanner software comes with inbuilt unsharp mask filters to compensate for quality loss. Most will not be as good as Paint Shop Pro's sharpen tools. You might want to leave that feature switched 'Off' and sharpen the files using PSP later. It's always preferable to have an untouched 'Master' file on your hard drive. Once an effect like unsharp masking has been added to a file, it's impossible to remove.

■ The same can be said for in-camera sharpen functions. Switch this 'Off' and apply it using your software.

■ Use PSP's Overview palette to move the view around the preview picture. Sharpening never has the same effect across all sections of a picture, so it pays to check the important bits up close.

■ If you just don't have a clue where to start, try the **Randomize** tab. It's a good starting place and one that's likely to come up with an answer in a matter of a few clicks.

Adding soft focus effects

TOOL USED

Soft Focus

In a digital file, regular blur filters never produce as nice a result as you'd get using film and real glass soft focus filter screwed to the front of a lens.

Paint Shop Pro addresses this problem with a new **Soft Focus** filter. The difference between this and the straight 'blur everything' filter set (Blur, Blur More, Average, Gaussian Blur) is that the former actually applies more blur to the highlight rather than to the other tones. This produces an effect frighteningly similar to the effect that you'd get using a regular glass photographic filter – only Paint Shop Pro offers a wealth of controls over how you can influence the way that the blur looks.

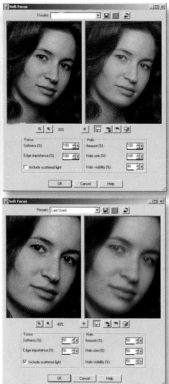

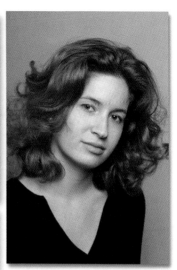

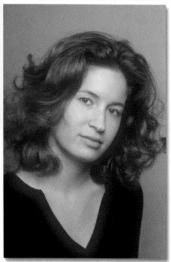

The new Soft Focus filter has an incredible range of possibilities to suit most photos. Increase or decrease the halo amount to match the highlights in the original photo. Too much and the eyes might take on a Satanic quality of their own. Checking the 'Include scattered light' box radically softens skin tones.

You can vary the overall softness of the filter, as well as the edge importance (edge sharpness), plus there are three controls for adjusting the blur halo (Amount, Size and Visibility).

Much time has been put into creating this filter and it works extremely well, emulating the precise look of a glass filter costing more than Paint Shop Pro itself. As with most filters, it's possible to try a combination of effects using the **Randomize** tab. You can also save a particular combination for use any other time via the preset tab.

STEP-BY-STEP PROJECTS

Technique: creating photo impact

TOOLS USED

Auto Contrast Enhancement Automatic Saturation Enhancement
 Saturation brush

More digital pictures than not require tonal fix-ups, despite the technology used to make them. Because of this, contrast and color never looks quite as good as it could be. The trick is to learn to recognize when a picture needs help and, if it does, how to do it quickly and efficiently.

Simple tonal fix-ups can be added using any of the tools on the Photo toolbar. Try these general enhancements first:

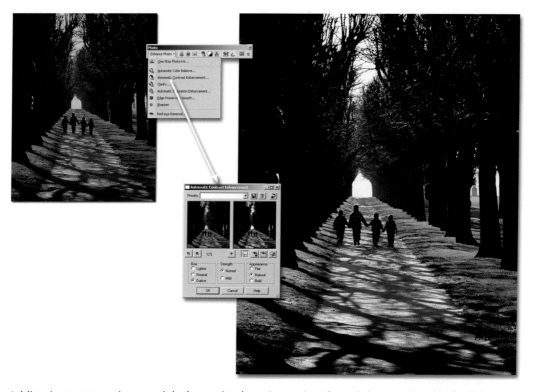

Adding impact to an image might be as simple as increasing the existing contrast levels in the photo. Use the Auto Contrast Enhancement feature to do this and check the results. If it's not enough, repeat the filter action as many times as required.

Step 1. Open the picture. Evaluate if it's the contrast or the color that needs increasing (or both).

Step 2. Choose the **Auto Contrast Enhancement** filter from the Photo toolbar. Press its 'OK' tab.

Step 3. If the contrast change is minimal, apply it again. If little change occurs, try resetting the command in the dialog to 'Darker' and 'Bold', then run the filter a third time. For some pictures this is usually the best way to increase picture impact; however, some photos change little. This is either because there's not enough information in the frame (because it's a low-resolution file or because it requires heavier adjustment using Levels or the Histogram Adjustment tools).

Step 4. You might want to increase the saturation of the color. Choose the **Automatic Saturation Enhancement** filter from the Photo toolbar, click on 'More colorful' and 'Strong', and click 'OK'.

Local enhancements

The previous tonal changes apply to the entire image. Some actions will work well for the picture, while others might produce unprintable over-the-top results. Local impact can produce more interesting results using Paint Shop Pro's Saturation brush.

Step 1. Open the picture and choose the **Saturation brush** from the Tools toolbar. Note that this has a range of options that include brush 'size', 'hardness', 'step' and a useful 'opacity' level.

Step 2. Once you have adjusted the brush to fit the job, set the opacity level to a low value and draw over the subject. Note that left-clicking this tool increases the saturation while right-clicking reduces the saturation.

Add impact by reducing the saturation of the background and increasing the saturation in the subject. It's a simple task yet produces incredibly powerful visual results.

Technique: fixing underexposure using tone adjustment

TOOLS USED	
Histogram Adjustment	Noise reduction filters

Underexposure happens to all photographers at one time or another. The lighting is wrong, the action too fast or the camera malfunctions. The result is often a film negative that has very little detail. For the darkroom worker, correcting this often disastrous problem involves careful hand-printing techniques.

If the picture is digital we have similar problems to deal with, although, in the digital darkroom, options are less messy, faster to achieve and more predictable.

An underexposed digital picture looks very dark and gloomy, with little or no visible detail. At a glance, it's 'unsaveable' and certainly not worth printing. Or is it?

Paint Shop Pro comes to the rescue, literally. It can be used in a number of different guises to fix up the problem of underexposure so that the resulting file not only looks great, but can also be printed with minimal loss of original quality.

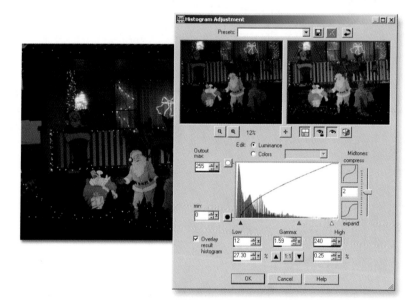

Step 1. Open the photo and choose the **HistogramAdjustment** tool. Have a close look at the histogram tone map. This odd-looking 'mountain' shows you the distribution of tones in the file. Underexposed files usually have everything bunched up towards the left-hand, shadow end of the histogram. If this is the case it's simple enough to mouse-drag those erring tones across the entire contrast range in an attempt to bring everything back into line with 'normal'. Drag the gamma slider (the tab in the middle) to the right and check the resulting brightness in the preview window. Try dragging the highlight slider to the left as well. This might have a more radical effect on the tones. Keep moving the sliders till you have a result that appeals. In case you've not already discovered this, try checking the 'Overlay result' box. What this neat feature does is to show how the tones might look if stretched correctly across the entire width of the tone scale (displayed in pink). Switching this on makes it easier to see what you might be doing by moving various sliders to the left or right. You might be pleasantly surprised to see the volume of information that's visible once you have opened up the tones in an otherwise underexposed and supposedly 'unsaveable' picture.

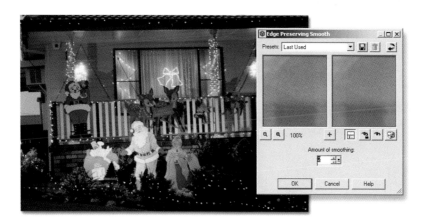

Step 2. Once happy with the brightness and the contrast in the new-look image, you might notice some noise. This is normally a sign that the CCD recording device has been heavily underexposed. This too can be minimized using one of Paint Shop Pro's **noise reduction filters**. Choose between the following:

- JPEG Artifact Removal.
- Salt and Pepper filter.
- Despeckle.
- Edge Preserving Smooth.
- Texture Preserving Smooth and Median filters.

Each behaves quite differently and can do too much, or not enough, depending on the nature of the original picture and how underexposed it is.

Try the soft-acting Salt and Pepper filter first, as this is adjustable. Despeckle isn't. Try others if this doesn't work.

Tip

Remember noise reduction filters soften the picture, no matter how sophisticated they might appear. Care must be taken not to overdo the effect and ruin the picture!

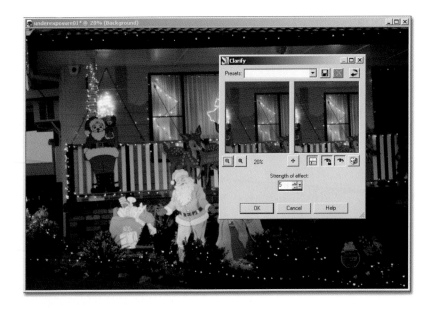

Step 3. Another filter to try here is Clarify – this has the dual effect of brightening and sharpening the picture in one hit.

Step 4. This is the final result, with the original (inset) for comparison.

Other techniques to use

You can also use the **Layers palette** to save disastrously underexposed files. Duplicate the background layer and change its blend mode from 'Normal' to 'Lighten'. In a similar vein, for hopelessly overexposed files (too bright), duplicate the layer and apply a 'Darken' blend mode.

Other blend modes like 'Overlay' and 'Hard light' might also do the trick. Blend modes are a little unpredictable, so it pays to play around with a range of blend styles to get the look just right. You might still have to run a noise reduction filter through the file for the best results.

Technique: fixing red-eye

TOOLS USED	
Saturation brush	Materials
Hue brush	Red-eye Removal

The incidence of red-eye is less of a hassle for digital photographers because, as technology improves, so the chances of this ugly flash-induced imperfection happening are becoming less. But happen occasionally it does. How do we get rid of red-eye? As you'd expect, there are several ways to rid yourself of this scourge.

Red-eye removal: method 1

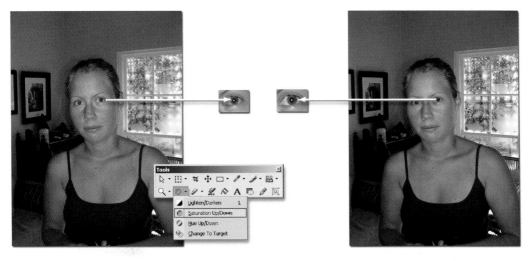

Use Paint Shop Pro's Saturation Up/Down brush to rescue the redeye color strength. This turns the redeye effect into 'dark eye' – a quick and mostly satisfactory result for all but the most extreme redeye-affected portraits.

Open the offending picture and choose the **Saturation brush** from the Tools toolbar.

This tool increases and reduces saturation (color intensity) in the subject, depending on whether you left- or right-click, respectively. Enlarge the picture so that you can clearly see the red-eye-damaged area. Set the brush size close to the subject pupil size and set brush opacity to a low figure so that the desaturation process acts slowly. Run the brush over the red-eye areas, right-clicking all the time to desaturate the red color. Don't do this too much, otherwise the red-eye becomes black-eye. Stopping halfway produces a gray-eyed result that's often more than acceptable.

Red-eye removal: method 2

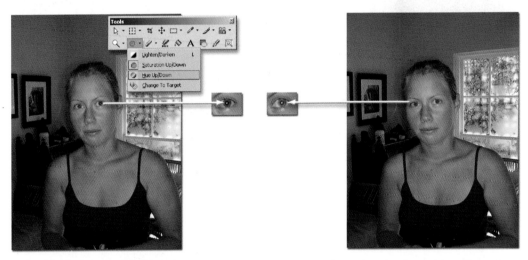

Use the Hue Up/Down brush to fix redeye. This changes the color values in the redeye affected area – in most examples, you can get a closer match to the original color but care must be taken not to overdo the degree of color change . . .

Repeat the brush process but use the **Hue brush**. This changes the color values from existing to a **target color** value. Choose the target value from the **Materials** palette and run the brush over the red-eye area.

Red-eye removal: method 3

The first two techniques are quick to try and work well in most situations; however, if the problem persists or the eye is enlarged to become an important part of the picture, choose the **Red-eye Removal** dialog from the 'Adjust' drop-down menu.

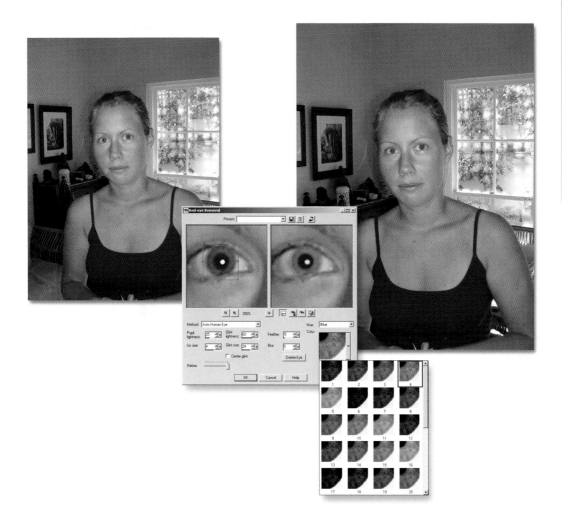

Step 1. There are several options: open the photo, choose the tool and drag the cursor over the pupil in the left-hand preview window. The mouse draws a circular outline that can be repositioned exactly over the red-eye-affected pupil. Use the Navigate and Zoom tabs to get the enlargement and positioning just right. The easiest way to use this dialog is to choose **Auto Human Eye** from the 'Method' menu and see if it produces the desired result.

Step 2. The new, corrected eye version appears in the right-hand preview window. If it looks fine, click OK and save the file.

Step 3. If the red-eye is not fixed, adjust the tool parameters. Choices under the Method drop-down menu include 'Auto Human Eye', 'Auto Animal Eye', 'Freehand' and 'Point to point'. Choose human eye or animal eye for obvious reasons. Freehand and Point to point are there to give you

greater influence over eyes that don't match the regular templates supplied by the first two options. These selections can be further fine-tuned to give the sort of results that make this one of the best of all red-eye reduction tools. These include varying the iris and pupil sizes, lightness, feather values and a blur. Altogether, these controls make this one of the most sophisticated red-eye removal tools around.

3

Simple Picture Manipulation: Moving Past the Basics

In this chapter, we look at tools designed for removing digital noise and scratches from scans, plus dust specks from scanned film and how to restore old photos to new glories. We also learn about using Paint Shop Pro's powerful Clone Brush, its new Warp brushes and how to convert a color picture to black and white.

TECHNIQUES COVERED

All about scripting

Creating black and white pictures

Creating color overlay effects

Controlling digital noise

Creating hand-coloring effects

Making surreal color effects

Removing blemishes from scans

Retouching using the Clone tool

Restoring tones in faded photos

Tinting black and white photos

Using the Warp tools

TOOLS USED IN THIS CHAPTER

Automatic Small Scratch Removal filter + other noise reduction filters

Automatic Contrast Enhancement

Automatic Color Balance

Automatic Saturation Enhancement

Burn tool

Clarify (filter)

Curves

Clone brush

Colorize

Channel Mixer

Color Balance

Despeckle filter

Dodge tool

Edge Preserving Smooth filter

Fade Correction (filter)

Flood fill (paintbucket tool)

Gray World Color Balance

Grayscale (conversion)

Histogram Adjustment

Hue/Saturation/Lightness

Levels adjustment

Manual Color Balance

Median filter

Posterize (filter)

Red/Green/Blue adjust tool

Salt and Pepper filter

Scripts

Scratch Remover tool

Solarize (filter)

Warp Brushes

Zoom tool

Removing scratches and blemishes from scans

TOOLS USED	
Zoom	Scratch Remover

No matter how careful you might be when scanning film or prints, dirt always gets in the way and inevitably ends up on the scan. Paint Shop Pro has a good range of filter-based tools designed for cleaning up or removing these problem areas, however bad they might appear.

Dirty scans? No, it's not a rude movie, in fact you might never realize quite how dirty scans can be unless they are magnified to a size that reveals the mess. If you only enlarge your snaps to about 6 in × 4 in, only the worst dust blemishes will ever become apparent. If you print to 20 in × 16 in, however, you might get a shock when you see the dirt and surface scratch marks picked up by the scanner!

The first thing to do is rescan the print or negative. Clean the flatbed scanner's glass platen, the place where the print is positioned. Use a mild window cleaner and a soft, lint-free cloth (i.e. linen). Finger grease, however minimal, is a great dust attractant so don't forget to gently wipe the surface of the print as well. If scanning film, use an appropriate film cleaning solution and soft cloth.

Once the scan is made, open the file in Paint Shop Pro and enlarge the file to between 200% and 400%. Do you see dust specks that weren't there in the original? They probably were there, but were just too small to be noticed. If you are planning to enlarge and print to A3, or bigger, you might need to run one, or more, of Paint Shop Pro's clean-up filters over the file to improve the quality.

Here's how: open the picture and crop to suit. Many scanners are more than generous with their flatbed scan areas, adding extra 'real estate' to the edges of the print or transparency. Select the Crop tool from the Tools toolbar, marquee the areas not required and double-click inside the marquee to perform the crop. (To maintain the aspect ratio, use the 'Maintain Aspect Ratio' checkbox in the tool's options palette).

Assess the damage. Enlarge the file to 400% or 500% by clicking on the picture with the **Zoom** tool (keyboard shortcut 'z') and, using the **Pan Tool** (keyboard shortcut 'a' – it sits under the Zoom tool), move the picture around the screen for a closer inspection. Increase or decrease the magnification according to the amount of detail you might want to retouch. If it's a high-resolution scan (i.e. scanned for A2 output), you'll have to zoom in on the image further, say up to 400%, to see the same (scratch) detail as if it were scanned to A4 and magnified only to 200%.

Tip

Never use filters to remove large blemishes. Use the **Clone** or **Scratch Remover** tool for this.

Tip

Do not try to remove all dust spots or scratches in one filter action as this might result in an over-application of the filter (and therefore an overall softening of picture details).

A quick way to remove dust spots blanket fashion is to run a filter over the entire picture. Select the **Automatic Small Scratch Removal** filter from the Adjust>Add/Remove Noise menu ('Adjust>Add/Remove Noise>Automatic Small Scratch Removal') and try a couple of the settings provided in the dialog window. The result appears in the right-hand preview window.

Try the normal settings first. The reason there are many variants is to cover the multiple quality situations scanning introduces. Note that there are checkboxes for 'light' and 'dark' scratches, a contrast inhibitor (pull the tabs to the center to limit the contrast range), as well as three filter strength settings. It's important to remember that, with this, and most of Paint Shop Pro's other filter-based tools, the dialog window offers multiple options so that you can customize all actions to suit whatever image you have open on the desktop.

This includes an **Auto Proof** and **Proof** tab, a **Randomize** tab, a **Save Preset** tab and a **Stretch** window tab that allows you to resize the dialog window (mouse-click the bottom right-hand corner and drag to enlarge). If the filter effect doesn't work fully first time, try another combination. Alternatively, use the 'Randomize' to get the program to make that decision for you.

Scratch removal filters apply their effects **globally**. For specifically difficult or large blemishes, use a local scratch removal brush first. This is a more effective technique because you can limit the filter's softening action to a small area of the scan only. No point in softening the entire picture to remove one or two scratches.

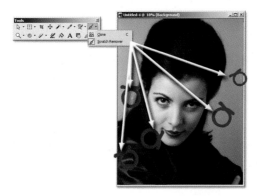

The Scratch Remover tool is best for fixing numerous scratches and scanned blemishes in a print, regardless of size and shape.

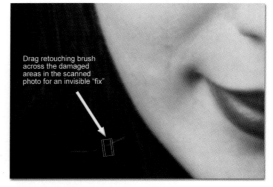

Choose the tool, click and drag across the damaged area. Use the Tolerance values to blend the repaired section with the background.

Salt and Pepper filter. As you can see from the actions of this and the filters in the following two figures, while some might introduce an aesthetic smoothness to the skin tones, removing all the blemishes globally in one hit can also wipe out much of the detail, something that's not always desirable.

Median filter.

Edge Preserving Smooth filter.

This is the best result – a combination of the retouching brush and several slight filter actions.

Choose the **Scratch Remover** tool from the Tools toolbar and drag the cursor over the blemish to remove or to soften it. Paint Shop Pro clones/blurs out the damaged pixels. This is quite a fast tool to use and, like most of the tools in PSP, it has a preset save function allowing you to create your own custom scratch remove brushes. If you hit on a good shape/width combination, save it for later use.

Once satisfied that PSP has removed/diffused enough of the small scratches to make the scan appear credible, save the file under another name before continuing with further editing (always keep the original file untouched, where possible).

Other smoothing filters to try

- Salt and Pepper filter.
- Despeckle filter.
- Median filter.
- Edge Preserving Smooth filter.

(All of which are found on the 'Adjust>Add/Remove Noise' menu.)

Controlling digital noise

Digital cameras suffer from a phenomenon called digital **noise**. This is electrical interference that appears as spotty grain in the picture. Generally, the more that you pay for a digital camera, the less likely you are to suffer from this picture defect.

Digital noise occurs mostly during longer-than-normal exposures (i.e. more than a second) and appears as speckly discoloration in the shadow areas of the photo. Some cameras have a **noise reduction mode** to help reduce this. Many don't.

Most digital cameras produce noise, invisible to the eye unless the exposures are unusually long, the ambient lighting is dark, the camera is poorly designed or all three. Some noise is quite obvious to the naked eye; other instances have to be greatly enlarged, like this example here.

Paint Shop Pro has several noise reduction filters that are ideal for minimizing digital noise. This is called the Deinterlace filter.

Median filter dialog.

Automatic Small Scratch Removal filter dialog.

Salt and Pepper filter
dialog.

Texture Preserving
Smooth filter.

Moire Pattern Removal
filter dialog.

In this finished example
and inset I have used
PSP's Edge Preserving
Smooth filter to clean up
the noise in the
shadows.

Paint Shop Pro has several noise reduction filters that are ideal for minimizing this problem. These are: Automatic Small Scratch Removal, Deinterlace, JPEG Artifact Removal, Moire Pattern Removal, Despeckle, Edge Preserving Smooth, Median, Salt and Pepper filter, and the Texture Preserving Smooth filter.

It also has a filter that is ideally suited for adding noise (Add Noise). Why add noise to a digital photo? Several reasons.

Adding noise can transform a regular photo into something quite special. Here I have drawn an elliptical selection.

The next stage is to apply a feather to this selection to soften the edges (in this example, by 143 pixels).

I now use Levels to brighten the center of the picture (i.e. the bit that's selected). You could at this stage invert the selection and, still using Levels, darken the edges of the frame for effect.

Now it's time to add some digital noise.

The final stage involves the adding of a motion blur type effect to the outside of the selection (i.e. invert the selection if you have not already done this). This adds the blur to the outer section of the photo so that the boy is preserved in relatively sharp focus.

The result, which can be made in a matter of a few minutes, is quite pleasing to the eye.

All retouching, whether you are using a filter effect or a specific retouching tool (like the Clone or Scratch Remover tools) smooth out textures. This is an excellent result for portraits, glamour, fashion and any other applications where flattery pays.

However, if one area of the picture has had too much retouching, it's going to appear smoother than the rest of the image. In this example, it's better to add noise to the retouched section to make it appear more like the rest of the photo rather than attempt to smooth out the entire picture.

You can also add noise to increase the grittiness and overall impact in a picture (see illustration).

There are several ways to do this:

- Add noise to the retouched section using one of the supplied textures from the Materials palette.
- Copy the background layer, make sure that the new layer is selected and use Paint Shop Pro's 'Add Noise' filter to add a suitable quantity of noise to match the rest of the image. Then, using the 'Eraser' tool, rub out the bits of the top layer that have had no retouching done to them. It's a longer way to do things but negates the need to make a selection first.
- Apply noise using a selection.

Retouching using the Clone Brush

TOOL USED

Clone Brush

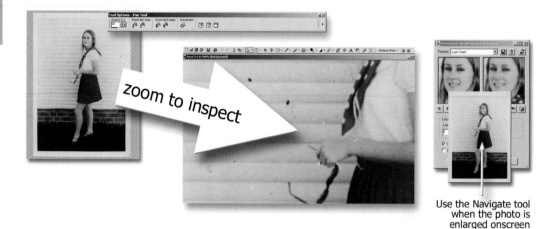

zoom to inspect

Use the Navigate tool when the photo is enlarged onscreen

Enlarge the image first to see if there are scratches worth removing. Use the Zoom tool to inspect for possible damage done to the print and for dust and dirt picked up by a scanner that is too accurate. At 400% the quality viewed is radically different to what is seen at 200%.

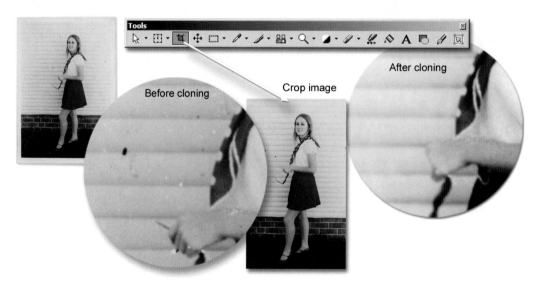

After cloning

Crop image

Before cloning

The first step is to crop the excess scanned material from the picture. This cleans up the file, reduces its overall size and improves your chances of making a better color assessment.

The **Clone Brush** is possibly the most useful of all Paint Shop Pro's retouching tools because it can be used for repairing both damaged pictures and for glamorizing existing photos, especially portraits. Learn how to use this tool with skill and it'll open up potential you never thought possible with your current photo-retouching skills.

There's no big mystery to the Clone Brush. What it does is simply to copy one part of a picture into the clipboard or temporary memory (this is called the '**Source**') and paste it over another part

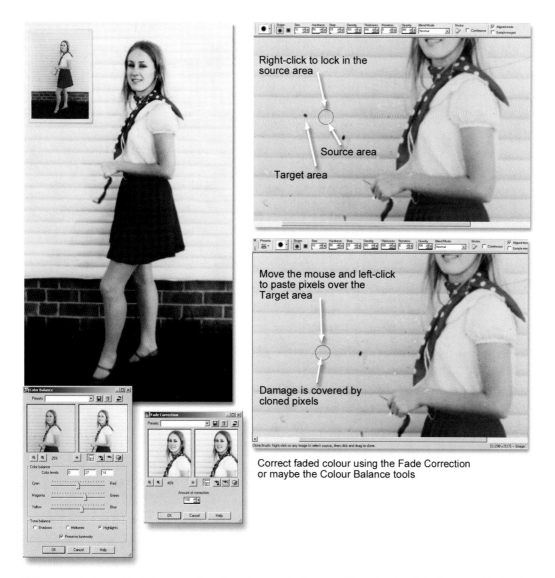

Right-click to lock in the source area

Source area

Target area

Move the mouse and left-click to paste pixels over the Target area

Damage is covered by cloned pixels

Correct faded colour using the Fade Correction or maybe the Colour Balance tools

This example has a high degree of surface damage to it, as well as plenty of dust scanned into the file from the glass platen. The color has also faded considerably – leaving a ghastly magenta cast. Clone the damaged areas first and then attend to the color deficiency second using the Color Balance and the Fade Correction tools, as illustrated.

of the picture (called the 'Target'). Typically this tool is used for repairing damaged prints: tears, scratches, blemishes, dust spots picked up by a scanner can all be things of the past using the Clone Brush. Where the Clone Brush has a distinct advantage over dust and scratch removal filters (discussed earlier in this chapter) is that the Clone Brush has a local effect. You only retouch the bits that need retouching. Filters, on the other hand, apply a blanket effect, softening the entire picture rather than just the blemishes. You can, of course, apply a selection to limit the action of the filter's softening (effect) but this is time-consuming and not always practical.

In use

Choose the **Clone Brush** from the **Tools** toolbar. This is shared with the Scratch Remover tool so you might have to click the latter's icon and reselect 'Clone' from the drop-down menu. Make sure that the tool Options palette is also open on the desktop by right-clicking on the Menu bar and choosing 'Tool Options' from the palette's submenu.

To make the Clone Brush work properly you must select a **Source** area. If repairing an old, scanned photo, you'll need to use this tool to cover up dust specks, tears and other damage. First off, find a spot in the picture that is tonally close to the tone in the damaged section. There's no point in trying to copy a dark patch over a light patch. The light patch goes dark with the copied pixels and ends up looking unconvincing.

Move the brush over this area and right-click once with the mouse. This sets the **Source** point and copies the pixels that are under the brush. Move the brush to the damaged section of the picture and left-click. This pastes the copied pixels over the damaged pixels. You should see the damaged section disappear or, at least, reduce in intensity. (Note that this is just like your copy and pasting sections of a Word document from one section to another.)

The Clone Brush has several options designed to fine-tune the brush performance. These include brush 'Size', brush 'Shape', brush 'Step', brush 'Density', brush 'Thickness', brush 'Rotation', brush 'Opacity' and 'Blend mode'. The most important controls to try first are the brush **Size**, its **Opacity** and, finally, the **Blend mode**.

Setting brush size is important. If there are huge scratches, large fade spots or ripped sections in the picture, choose a brush size that's smaller than the damaged areas. Do this because building up the repair gently is preferable to trying to do it with a single brush stroke, and besides, there might not be enough of the Source area to copy from. Several softer brush strokes always produce a smoother finish and inevitably a more convincing result.

Change the brush size during the retouching operation as well as the Source area. So many novices copy-and-paste with such enthusiasm that they don't notice the tell-tale step-and-repeat tracks left across the print surface because they have not reselected the Source area. This is something to be avoided. Moving the Clone Source point often is the best way of avoiding these tell-tale marks and (usually) produces a more convincing retouched result.

The Options palette also offers an **Opacity** setting. This affects the brightness of the pixels copied from the Source area. Effectively, this slows the retouching process noticeably as you end up by trying to cover damaged areas with less dense pixels (reduced opacity). Several mouse-clicks might

have to be made to achieve the same as one set at 100% opacity. However, it's always better to reduce the opacity to get a smoother tonal result. Top fashion retouchers use this technique to dramatically soften skin tones even if the model appears 'perfect'. Setting the opacity to a low value, say about 10–15%, and cloning again and again can produce a surreal, almost porcelain-like effect on skin tones, especially if the contrast is kept quite high (using the Levels tool for this).

Another control to experiment with is the **Blend mode**. Blend modes, which we discuss in detail in Chapter 5, influence the way copied pixels react with the underlying, original, pixels. For example, click the default 'Normal' drop-down menu in the Options palette and try cloning using **Burn** (darken), **Dodge** (lighten) or the **Color** blend mode.

Other tools for fixing up damaged pictures

- Scratch Remover tool (to remove blemishes locally).
- Small Scratch Remover tool (to remove small blemishes only).
- Clarify filter (to make a picture sharper and clearer).
- Fade Correction (to rejuvenate contrast and color).
- Histogram Adjustment tool (to increase the contrast).

Restoring faded photos

TOOLS USED

Fade Correction	Automatic Saturation Enhancement
Clarify	Burn
Automatic Contrast Enhancement	Dodge
Automatic Color Balance	

How long do you think photo paper, the sort we get family snaps printed on, lasts? The truth is, **not long!** Commercial photo papers, of the type used in high street processing labs, only last about 15 years. Some last longer, while others don't get that far. The bottom line is that if you don't look after family snaps, they'll fade quickly. Inkjet prints also have a propensity for vanishing without warning, although some brands are now claiming a fade-free life as long as photo paper. Some, like Epson, claim a longer life in some instances.

The sad truth is that photos, digital or silver halide fade in our lifetime and often require restoring, especially if they make up part of our valuable family history.

Paint Shop Pro has a number of powerful photo-editing tools designed for restoring these faded memories to their former glories. The simplest of these are the one-button-does-all type filter effects found on the Adjust menu: **Fade Correction**, **Automatic Color Balance** ('Adjust>Color Balance'), **Clarify**, **Automatic Contrast Enhancement** ('Adjust>Brightness and Contrast') and **Automatic Saturation Enhancement** ('Adjust>Hue and Saturation'), roughly in that order of relevance to

this topic. Click an icon on the Photo toolbar and press the OK tab to see if it makes an improvement to the picture.

How you know which tool to use for the job is part of the skill that comes with experience. However, most of these tools are simple and fast to use, so it's not a problem to try the lot. Start with Clarify or Fade Correction first, or perhaps the Automatic Saturation Enhancement feature, taking care that the 'Skintones Present' button is checked first because this reduces the amount of yellow added to the correction.

If these tools aren't strong enough to fix the faded tones of an old photo, go for the big guns: the Curves or Levels tools ('Adjust>Brightness and Contrast>Levels/Curves'). These can be used to

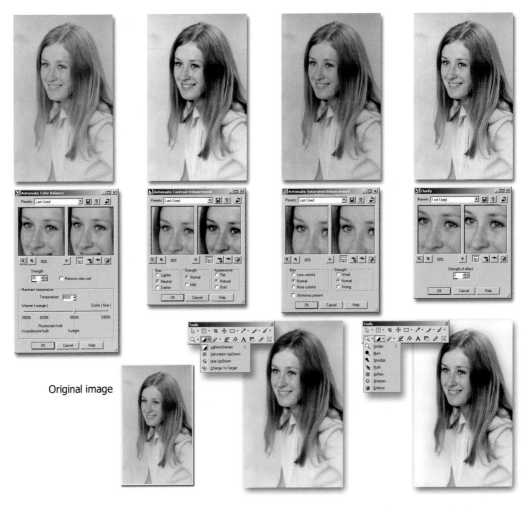

Original image

Restoring tones in old and faded photos is a relatively simple operation, but one producing considerably different results depending on the type of tool used to do the job. Note that all these tools have their own unique sets of controls, enabling you to customize the results to a high degree of accuracy.

make radical contrast changes to any picture. If you need to make slight color enhancements, do this using one of the individual color channels in the Curves or Levels dialog windows.

All the tools mentioned so far apply changes in blanket fashion, all over the picture surface. Paint Shop Pro also has a range of tools that work like brushes. In fact, they are brushes! Old photos inevitably fade unevenly. In fact, more than likely, you'll end up picking up spots and blotchy areas from all over its surface. Use the **Lighten/Darken** brush tools to work over the faded or miscolored tones in the old photo. This is one of the more understated of Paint Shop Pro's retouching tools. A left mouse-click lightens any pixels located under the brush. Right mouse-clicking darkens the pixels. It's a good tool, fast and accurate, especially if you use the options supplied. For example, you can select the 'brush type', 'brush size', 'hardness', 'step', 'density', 'thickness', 'opacity' and even brush 'shape' and brush 'rotation'. There's little you can't do with this retouch tool. They also have a buildup characteristic. Each brush stroke adds to the previous, underlying brush stroke.

Other tools to try

You could also try using the **Burn** and **Dodge** tools, again selectable from the Tools toolbar. These perform similar actions to the Lightness/Darkness tools but have non-buildup characteristics; if the brush stroke covers a previous stroke it doesn't get any lighter/darker. The Lightness/Darkness, Burn and Dodge tools are hard to use correctly without leaving tell-tale brush marks. To make it a bit easier to achieve a smoother result, reduce the opacity of the brushes. Start at a setting of, say, 10–25% and work up from there. Better still, use a **graphics tablet** – this emulates the action of a brush on a canvas with the additional benefit of having a pressure-sensitive tip. The harder you press the stylus, the faster the tool operates.

Damage, print blemishes and other photographic imperfections set in the print or the film can be removed using Paint Shop Pro's Clone tool.

Creating black and white pictures

TOOLS USED

Hue/Saturation/Lightness	Color Balance
Grayscale	Red/Green/Blue
Colorize	Manual Color Balance
Channel Mixer	

When it comes to converting color to monochrome, digital image-makers have several choices. The easiest is to capture the pictures in black and white by setting 'monochrome' in the camera preferences (usually found under **special effects** in the main mode menu).

However, I'd advise doing this in-computer and not in-camera because it's always better to have a neutral, raw or 'Master' file so that you can work on the basic data. Besides, if you only have the one shot in black and white, you can't turn it into a color shot. You can convert color to black and white though.

Paint Shop Pro has two techniques to convert a full color picture into a black and white snap. These are:

- The **Hue/Saturation/Lightness** tool. Reduce the saturation to a minus '100' value to remove all color in the image.
- Choose **Image>Grayscale** as a way to convert the picture from color to monochrome (called 'Grayscale').

Note, however, that desaturating a color photo doesn't convert it to another color space. Converting a color file to Grayscale does. The advantage of doing the latter is that a Grayscale picture is a small file because it only has a single channel. The desaturated color file remains in the RGB color space with three color channels – these simply display no color data so it appears monochrome.

If all you are ever going to use is a monochrome image, go for the Grayscale option, but if you think that you might want to add a bit of color back into the desaturated picture, like an old-fashioned chemically tinted silver halide photo, choose the desaturate option.

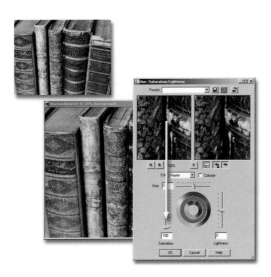

Use the Hue/Saturation/Lightness tool to reduce the color values in a file to zero. This turns it black and white.

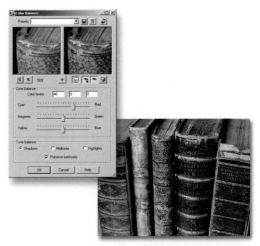

Use the Color Balance tool to add a tint to the shadows, the highlights and to the midtones. Try adding a different color to the highlight (than the one added to the shadow) to create a split-tone effect, i.e. red in the shadow and yellow in the highlight.

To add color back to the original RGB picture, choose from the following:

- Option 1. Choose **Colorize** from the 'Adjust' drop-down menu and slide the Hue tab to change the color values dialed into the image.
- Option 2. Choose the **Hue/Saturation/Lightness** dialog from the 'Adjust' menu and click the 'Colorize' box. Repeat the same Hue adjustment as in the Colorize dialog. It's a similar tool.
- Option 3. Choose the **Color Balance** dialog from the 'Adjust' menu and dial in the color that you want using the appropriate sliders.

Tip

You can also use the Red/Green/Blue or the Manual Color Balance tools. All do the same job but in slightly different ways.

Advanced tools for fine-tuning contrast in a desaturated black and white picture include the **Levels** feature and the **Channel Mixer**.

The **Channel Mixer** ('Adjust>Color Balance>Channel Mixer') is completely different – this allows you to increase or decrease any, or all, of the values in the picture's three color channels. (Remember that this is only possible if the file has been desaturated first. If the photo has been changed from RGB to Grayscale mode, it's not possible to use the Channel Mixer.) Click the 'Monochrome' checkbox and slide the tabs to the right to increase the contrast abruptly.

Tip

Shifting these channel tabs can produce an effect similar to what you'd get using a dark red filter with black and white film: greatly increased contrast and heavier shadows.

Tinting black and white photos

TOOLS USED

Grey World Color Balance Histogram Adjustment
Colorize Levels
Color Balance

In the last section we described ways to use Paint Shop Pro to convert a color picture to black and white and how to make that photo look punchier using the Histogram Adjustment tool. This section

shows you how to color-tint a black and white photo. Why color-tint? Most black and white pictures reproduce only a limited tonal range, 256 tones to be exact. The addition of color, albeit in subtle amounts, produces a print apparently much richer in tonal scale.

This process is sometimes called a **Duotone**. Adding two colors to a black and white photo in the same fashion is called a **Tritone**. Adding a third color makes this a **Quadtone**. Aside from increasing tonal depth, making a duotone can be a cheaper way of introducing color to commercially printed jobs (because adding a second color is cheaper than producing the full four-color print process).

Note: You can achieve a similar effect in Paint Shop Pro using a feature called **Colorize**, although this is limited to color photos that have not been entirely desaturated.

How it's done

Open a photo in Paint Shop Pro ('File>Open' or 'File>Browse' to display thumbnails). Choose an RGB color picture. If it's recorded in single-channel grayscale only, it must be converted back to a three-channel RGB color file, otherwise you'll not be able to display color! Do this by choosing 'Image>Increase Color Depth>16 million colors (24-bit)', from the main menu bar.

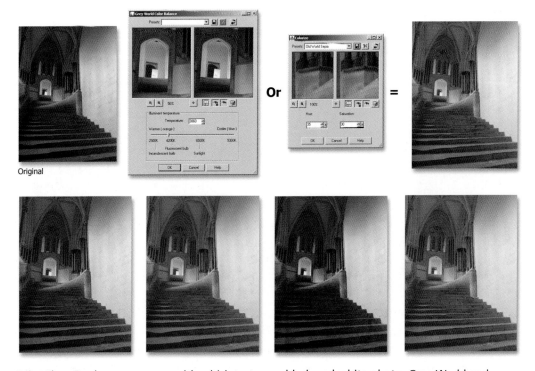

Original

Paint Shop Pro has many ways with which to tone a black and white photo: Grey World and Colorize are two of the best. Adding a tint like this increases the apparent tonal range in the photo, giving it the appearance of deeper and richer tonal qualities.

Once completed, you'll not see any tonal change because all you have done is increase the photo's color mode from 8-bit grayscale to 24-bit color. Also, you'll note that once this is done, Paint Shop Pro's Color Balance features are no longer grayed out. (If the menu is grayed out it's usually because it is in the wrong color mode.) If the photo is in RGB color, proceed to the next step. Duplicate the layer ('Layers>Duplicate' or click the layer duplicate icon in the layer palette).

Option 1

Choose the Grey World Color Balance tool from the 'Adjust>Color Balance' drop-down menu. Use the warmer/cooler slider to add a color tint to the picture on the desktop. It's quick to make simple duotone-type effects from black and white RGB color photos. 'Warmer' on the scale adds yellow and red to the picture, while 'cooler' adds blue.

Tip

Although you have no brightness control in the Grey World Color Balance tool, when you click 'OK', use the Histogram Adjustment or Levels tools to make your additional contrast changes.

Option 2

Alternatively, open the **Color Balance** feature ('Adjust>Color Balance>Color Balance'). The dialog window has tabs for adding color to the shadow, midtone and highlight areas only. Default for this tool is always 'midtones', so maybe try this first.

To create a sepia toned effect, enter values of '30 red' and '−20 yellow' in the fields provided. Sometimes this can look more effective if the red is added to the shadows (click the 'shadow' button first) and the yellow to the highlight values. Note that adding one color to the shadows and a contrasting color to the highlights reproduces the type of split-tone effects previously only attainable by immersing sheets of black and white photo paper in chemical toning baths. Using Paint Shop Pro is faster and far healthier!

Use a duplicate layer so that you can turn that layer 'off' to view the original, non-toned version (switch a layer off by clicking the corresponding eye icon in the layer palette). It's a simple way to judge how well the tone process has worked.

Create a second duplicate layer from the original (mono) layer and try another color combination. Build a collection of duotone-, tritone-, and quadtone-type effects in the same document as a 'Master' file. Note that layered files have to be saved in Paint Shop Pro's native, layer-friendly '.pspimage' format. You can also save different versions by turning layers 'on' and 'off' ('File>Save Copy As') and blend the original layer with a toned layer for another stylish image effect.

Creating color overlay effects

TOOL USED

Color Balance

Create a simple color overlay effect using the **Color Balance** tool. Do this by firstly duplicating the layer ('Layers>Duplicate'). Then choose the Color Balance tool ('Adjust>Color Balance>Color Balance'). Apply the same color adjustment (i.e. '+10 Red') to all three tone areas. For example: '+10 Red' to the shadows, '+10 Red' to the midtones and '+10 Red' to the highlights.

Increase or decrease the brightness ('gamma') in the file using the Brightness/Contrast dialog ('Adjust>Brightness and Contrast>Brightness/Contrast'). Add significant brightness to create a 'ghosted' image suitable for use as a background. Save the file.

These two features can make dramatic tonal changes to the way the color overlay looks and, ultimately, to the way it's used.

Uses for a color overlay effect are:

- As a special design effect.
- To create an interesting background for print/magazine layout.
- Use as a web background.
- Use as a picture frame.

Tip

When working with this tool dialog, ensure that the 'preserve luminosity' tab is not checked. If checked, you might find the color overlay effect a bit harsh. Unchecking the box softens this effect considerably.

Tip

You might also need to add a contrast boost using the Histogram Adjustment tool after creating a color overlay. Use this tool to bring the contrast into line or to create a forced (surreal) tonal effect, depending on how the picture is to be used. Firstly, check the histogram and drag the shadow (at left) or highlight (at right) sliders to the base of the tone mountain. If there's no space to do this (i.e. if there's no 'beach' either side of the histogram), try compressing or expanding the midtones (the gamma) using the sliders at the right of the histogram window.

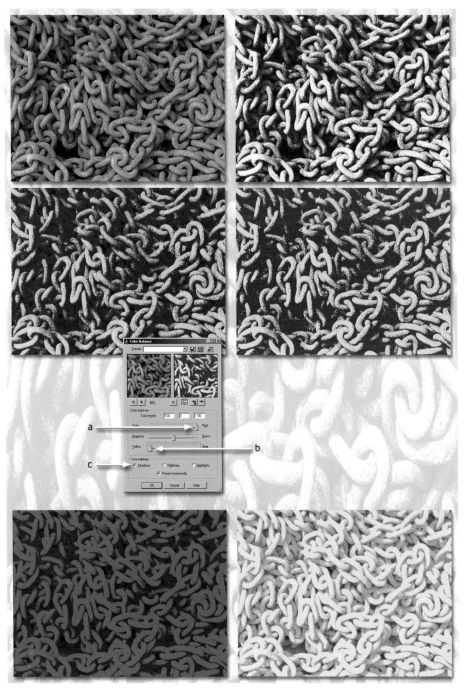

Besides being able to tint a mono picture quickly, the Color Balance tool can be used to smother an original with a single hue to produce a strong, graphic effect. Set the radio button to Shadow (c) and add 100% red (a). Check the midtones button and add the same value in red. Repeat for the highlights. Then work in reverse adding another contrasting color (e.g. yellow – b) to the three tone levels to produce this strong, poster-like illustrative effect.

Using the Warp tools

Paint Shop Pro has several powerful brush tools that can be used to radically bend and distort the pixels in a photo. These are the Warp brushes.

Why use a Warp brush?

- To create zany, surreal pictorial effects.
- To increase eye size in a portrait (i.e. to enlarge a model's pupils for that wide-eyed look; it can also be used for reducing the size of other unsightly body parts like noses, if it's important).
- Straighten facial detail (i.e. a broken nose).
- To entertain your kids.

The **Warp Brush** works just like any other brush in Paint Shop Pro in so far that you can run it over the picture and it applies a direct change. In this situation you have massive influence over how the pixels bend and warp under the brush. Some computing power is needed to make this work swiftly.

There are seven warp modes to choose from. All can be combined – or you can use them individually to create some digital black magic. Brush effects are: 'Push', 'Expand', 'Contract', 'Right Twirl', 'Left Twirl', 'Noise' and 'Iron Out'.

If you don't like what this extremely powerful brush does to the photo, click the 'Cancel' tab. Other options with this tool include 'Brush Size', 'Hardness', 'Strength', 'Step' and 'Noise'. When you have finished the warping process, click the OK tab to render the warping action. The neat thing about this tool is that you can preview everything in four different 'draft' modes depending on how much of a hurry you might be in and then finish the job in two final 'render' quality modes.

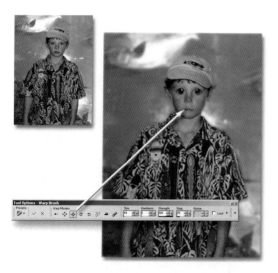

Like many things digital it is quite easy to use the Warp tools but hard to get a result that is useful, flattering, funny (or all three). Care must be taken not to overdo things. On the other hand, let your kids run riot and have fun making weird photo effects like this one!

If you are in a hurry, use the **Coarse** draft mode but render it in the better mode. For best quality results, go for the **Finest** quality settings in both modes.

Scripting

A powerful addition to Paint Shop Pro's expanding rank of extremely capable photo-editing tools is a new feature called **Scripting**.

This is the ability to record a series of actions, and to replay those actions on other pictures for the sake of increasing productivity. These record and replay actions are similar in action to the workings of a video recorder. Click 'record', perform the actions, click 'stop' or 'pause' and save those recorded steps into the scripts menu for replay at a later time.

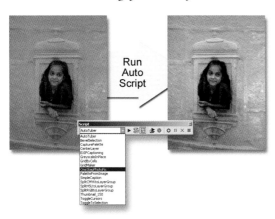

Run
Auto
Script

At a basic level, scripting allows users to run a pre-recorded action over an image (or images) in order to produce a quick – and predictable – result. Or you can record your own script and save them for use another time.

Applications

Scripting has a number of powerful uses, which include significant productivity enhancements, the ability to run complex actions with little or no previous knowledge, batch editing, and to download and use scripts for actions that you have no time or skill to record for yourself.

Scripts are particularly apt for anyone who has to deal with a lot of pictures: web and graphic designers especially. Use the scripts feature for running repeated commands used in the preparation of web pictures, catalogue work, designers and heaps of other applications.

The Script toolbar comes with a drop-down list of pre-recorded actions or scripts that have already been made for you; however, click the diskette symbol on the toolbar and you can save your own actions for application to pictures at any other time. Save the action using the Run and Save buttons and it appears in this drop-down menu. Some of the out-of-the-box scripts include: Art, Bevel/Selection, Black and White, Black and White Sketch/Pencil, Color Sketch, Full Image Drop Shadow, Photo Edges, Pointillist, Sepia Frame, Vignette, Watercolor and many more.

SIMPLE PICTURE MANIPULATION

STEP-BY-STEP PROJECTS

Technique: repairing damaged photos

Global scratch removal techniques

In the analog world, prints often suffer from dust spotting and scratches, a legacy from the darkroom. These blemishes are difficult to avoid and require careful treatment with ink and a fine spotting-out brush to remove. Digital files don't suffer from dust specks – but scanned pictures do because we either forget to clean the film before it's scanned or because the scanner picks up details not normally visible with the human eye on a small strip of film.

Lasso damaged section with the Magic Wand tool and move it back into place with the Move tool. Clean up with the Clone tool and the Automatic Small Scratch Removal filter

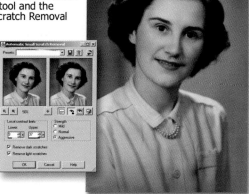

For really large scratches, blemishes and other assorted rips, tears and missing pieces, like the join seen in this illustration, you'll have to use the **Clone tool**. Select the scanned edges, copy and paste the missing bit to a new layer and, using the Move tool, push it back into place. In this example I used the Magic Wand tool to make the initial selection and pushed it into place before fixing up the join line using the Clone tool before flattening the file to its original single layer.

Paint Shop Pro has a range of scratch removal filters and specific retouching tools. Begin by trying the **Automatic Small Scratch Removal** filter, from the Photo toolbar (rather than simply applying the default filter effects, you can get better results by fine-tuning the controls provided in the tool dialog).

All scratch removal filters work quite efficiently but, in order to remove all the blemishes, the picture must be blurred all over. The resultant picture often looks softer than the

original. Too little filter and you may not see any improvement. Sometimes scanned photos look worse than the original because they pick up too much detail from the print surface, resulting in a spotty-looking scan. The **Despeckle** filter ('Adjust>Noise>Despeckle') is suitable for reducing this kind of scan flaw – but be aware that it will also soften the picture, so try not to overdo it.

Local scratch removal techniques

If you don't want to apply a global effect to the image, use Paint Shop Pro's **Scratch Remover tool**. This works a bit like a band-aid, laying a strip of blurred tone over the selected area to conceal damage. The results can be quite subtle or quite marked, depending on how many times it's used over the same spot. (Note: In the Tool Options palette, you can alter the pixel width and shape to better match the scratch size.)

Paint Shop Pro has a range of manual tools designed to significantly refine the retouch/repair process. For greater accuracy, use a graphics tablet. These tools include:

- **Dodge tool.** As in the traditional black and white darkroom, this aptly-named tool reduces the exposure reaching the picture, effectively lightening it.
- **Burn tool.** This tool works exactly like the Dodge tool, only in reverse, by darkening parts of the picture. Use the 'Size' control to change the area affected and the opacity to change the amount of change added with each mouse-click.
- **Smudge tool.** Use this tool to move and soften the pixels under the brush.
- **Push tool.** Use this to physically displace the pixels under the brush (i.e. to push them out of the way).
- **Soften tool.** Use this to make the pixels appear out of focus. Great for emphasizing the optical effects of a long telephoto lens or for diffusing parts of the photo to concentrate the eye on specific sections.
- **Sharpen tool.** This one works in the reverse fashion to the Soften tool, actually sharpening the pixels under the brush. Care must be taken not to overdo this otherwise you end up with harsh, over-pixelated areas. By using the options palette for each of these tools you can add tremendous flexibility to the speed at which each works, as well as to its density and efficacy.

Heavily retouched photos often appear softer. This may be an illusion created by less grain, but, more than likely, it will be softer! Scanning also does this.

To fix this I'd suggest reassessing the contrast in the picture. If the photo appears on the flat side, increasing contrast will improve the **apparent sharpness** significantly. However, if the contrast is already fine, add sharpening using one of the available sharpen filters (like the **Unsharp Mask** filter).

Unsharp Masking gives you incredible control over how the final picture looks. However, don't use this until you have finished cleaning up all blemishes. Too much Unsharp

Masking can also increase the appearance of the film grain. As with most filter effects, the Unsharp Mask filter dialog has a resizeable preview window, enabling you to fiddle about with the settings before making a commitment to the original file.

Begin with a **Radius** of around 5 or 10 pixels, a **Strength** setting of about 100–200% and a **Clipping** level of less than 20. Note that these figures are quite arbitrary for each different picture but, with practice, you'll pick up on which are best for your style of image-making.

Technique: hand-coloring effects

Like many photo-editing programs, Paint Shop Pro has a **Flood Fill** (keyboard shortcut 'F') tool (also sometimes called the Paint Bucket tool). This feature is used to flood an area in a photo with color selected from the program's Materials palette.

Though Paint Shop Pro's Flood Fill feature is quite sophisticated, it can be used to create a range of hand-painting style effects with little or no previous knowledge.

How does this work? Open a picture, choose the Flood Fill tool (the paint can symbol on the Tools toolbar) and click anywhere in the photo.

If the tool's tolerance value is set to 200%, the Flood Fill tool 'floods' the entire canvas with the foreground color. If you are not used to using the Materials palette with its fore- and background colors, don't despair. Select 'Edit>Undo Flood Fill' or keyboard shortcut 'Cntrl Z' and reduce the tolerance value to '20' or less. With the tool still selected, click the photo again. Note that with a drastically reduced tolerance, the paint flood is greatly restricted. Tolerance controls the action of any tool to similar-colored pixels. Reduce this value and you narrow the amount of nearest-neighbor type pixels that can be drawn into the effect – whatever this might be. The Flood Fill effect might still not be apparent.

Choose the Materials palette and select a color that you'd like to flood over parts of the picture (if this is different to the default already used). Double-click the foreground color properties box and choose a new color. Reduce the opacity value in the options palette to 50% or less. Click the picture again. You should be able to see the selected color being 'washed over' the print. If you set the opacity to a low value (say 12%) and the tolerance to a high value (say 150–200%), the Flood Fill tool applies a color wash over the entire picture.

Reduce the tolerance and it begins to drop the color into restricted pixel tones only. So, for example, it there's a white cat sitting on a black mat, you can change it quickly to a yellow or red cat, without affecting the mat color. All that's required to achieve this kind of color swap is the right balance between tolerance and the opacity values.

The real power of this tool can only be realized once you begin to experiment with its **blend modes** in the Options palette. Although blend modes will be dealt with in greater detail in Chapter 5, it's important to note that using the default, 'Normal' blend mode usually produces the most abrupt result. Modes like 'Color', 'Overlay' and 'Soft Light', on the other hand, might produce an effect that's far more attractive and, ultimately, more useful to the image-maker.

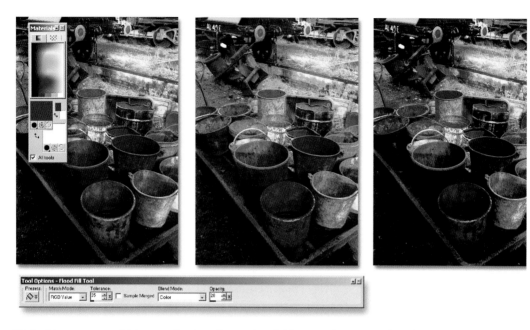

Bit by bit, you can add layers of color, chosen by clicking on the Materials palette, into the monochrome original. If too much color floods into the picture in one hit, Undo that action and reduce the Tolerance value in the Tool Options palette. Then try again.

In this example I toned the final image further by reducing the color saturation. If a darker than normal color is chosen for the Flood Fill tool, you can also lower the contrast and brightness of the image – adding mood and atmosphere. Don't overdo it though!

> ## Tip
>
> Use the Flood Fill tool to add contrast by selecting dark colors from the Materials palette and adding those to the shadow areas. Setting the opacity to a low value makes the color addition seamless, although it also requires more mousing to bring the effect up to strength.

Technique: surreal color techniques

Traditionally, photographers have sometimes processed their film in the 'wrong' chemicals in order to create distinctly offbeat color effects.

For example, if you shoot slide (reversal) film, but process as if it were color negative film, the colors produced are 'crossed over' and appear distinctly odd. The same applies for color negative film processed in color slide chemicals. This is a bit of a hit-and-miss process, requiring a lot of expensive testing to perfect. Once reasonably sure that it's going to work, you were also restricted to using up the entire roll of film.

With digital, dabbling in health-damaging chemistry like this is no longer required. Nor is it necessary to spend heaps of time experimenting, in the dark, before you get a result. All that's required is Paint Shop Pro and these simple instructions.

The trick is to slightly change the contrast in each color channel so that they 'cross over'. That is, the colors do not represent properly. Do this using the Curves dialog in the following way.

Step 1. Open the photo and choose the **Curves** tool from the 'Adjust' menu ('Adjust>Brightness and Contrast>Curves').

Step 2. This tool gives you the option to add a contrast change to the entire RGB file or to the individual color channels only. Start by choosing the Red channel from the drop-down menu. With the cursor, click on the diagonal line across the center of the Curves graph. Clicking on the line adds an anchor point which can be dragged up or down to change the contrast for that color. You can add more anchor points by clicking again and you can take them away by click-dragging them to the apex of the Curve. Add a total of two anchor points as per the inset box (right) to create a very shallow

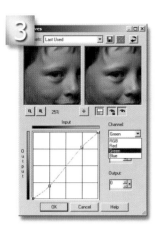

S-curve. Once an anchor point has been added the cursor changes to the standard four-pointed arrow symbol for the move tool. Use this to reposition the S-curve anchor points.

Step 3. Repeat this process for the Green channel but create a slightly flatter S-curve.

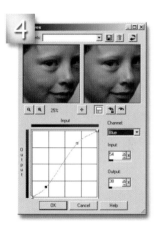

Step 4. Repeat the process for the Blue channel but create a slightly flatter, inverted S-curve. You should begin to see a significant color change in the picture with a lot of blue and yellow replacing the natural skin tones in the image.

Step 5. The final step in this process is to add an adjustment S-curve to the entire RGB file to boost the contrast. Don't make the S-curve too steep because you might lose all the highlight detail (although this is a common result in cross-processing). Balance brightness with loss of details where you can.

(Note that this is not the definitive recipe for the perfect cross-processed look. All pictures will need a different S-curve application.)

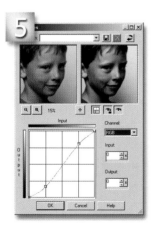

Creating a cross-processed look is just the start. If you treat the diagonal tone line in the Curves dialog as if it were just an elastic band and bend it every which way, you'll embark on a magical carpet ride of visual color effects you'd never thought possible.

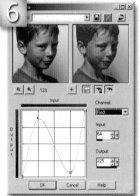

Step 6. To make the color go completely over-the-top do this: with the Curves dialog open, click the tone line and drag the curve down to the base. Click again and drag another part of the line up. Click on another part again and drag the line down. Create a zig-zag line and see what happens to the color! Once done save the file or, better still, save the multiple S-curve pattern as a 'preset' for use on other pictures. (As an alternative, try applying the zig-zag effect to a single channel and then to two channels. Alternate the zig-zag line between channels. In this way you can easily create startling color effects with little effort.)

The final result.

Using Curves to create wacky color effects is similar to a behind-the-scenes technique called Posterization (Effects>Artistic Effects>Posterize). This is an effect where smooth tones in a regular picture are replaced by colored banding. In this case, the fewer tones remaining in the picture, the more startling the Posterized effect.

Like Posterization, Solarization effects are created by radically 'crossing over' the Curves tone line so that some colors reverse out, much in the same way that color photo paper does if exposed to white light part-way through its chemical development. Using PSP's Solarization feature (Effects>Artistic Effects>Solarize) is both less messy and considerably more reliable!

14

Controlling Change:
Using Selections

This chapter will help you to learn how to control change in a picture using the power of selections.

TECHNIQUES COVERED

Desaturating the color in selected sections of a digital picture

Freehand selections

Making a basic selection

Fixing overexposed sky

Selection feathering

Using the geometric selection tools

Using the Materials palette

TOOLS USED IN THIS CHAPTER

Alpha Channels

Background Eraser brush

Create New Layer (command)

Cutout filter

Feather

Hue/Saturation/Lightness

Lasso tool

Levels (tool)

Magic Wand tool

Materials palette

Match modes

Selection Modifiers

Selection Edit mode

Understanding selections: adding creative power

TOOLS USED

Lasso

Geometric

Magic Wand

Selection Modifiers

Selection Edit mode

There comes a point in the digital learning curve where it's vital to embrace the concept of the **selection**. We have seen that Paint Shop Pro's filter effects, tonal adjustments and various color controls work on the entire image. Each is said to function 'globally'. For a lot of pictures you'll find this works well enough, but there'll come a time when it's necessary to limit this global effect to a smaller, more controlled section in the picture. The easiest and most accurate way to make this

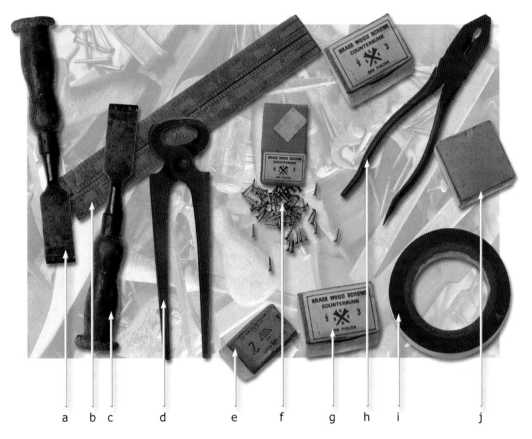

a b c d e f g h i j

Paint Shop Pro has a wide range of special selection tools for different objects. For example, irregular shapes (a, c, d, f and h) can be quickly grabbed using the Magic Wand tool, while more regular-shaped objects can be selected using either a rectangular marquee tool (for objects like b, e, g and j) or the Freehand Selection tool set to a special Match mode like Edge Seeker, that assists in lining up object edges to be selected. Round objects (i) can all be selected using a circular geometric selection marquee.

happen is to generate a specific selection that inhibits the action of a tool to a certain physical area.

Paint Shop Pro has several tools that allow the isolation of specific areas within the picture based on certain selection criteria such as color, tonality, contrast or simply by drawing round it. Because of the irregular nature of digital pictures, you have to distinguish the best selection tool, or tools, to use for the picture in question. For example, sometimes it's possible with one mouse-click to get a good, clean selection round an object. Sometimes this is not so easy because the photo might be multi-colored or irregular in tone. In this case you'd use a combination of selection tools to successfully 'grab' the object cleanly. Paint Shop Pro also has a number of tools that you can use to clean up these selections once started. These are called **Selection Modification** tools.

By setting the right Match mode, you can add tremendous grabbing power to the tool. Some experimentation is necessary plus suitable adjustment in the Options palette.

Selection tools are divided into three types:

- **Lasso** tools that have edge-seeking ('magnetic'), point-to-point (polygonal line), smart edge (linear 'magnetic') or just freehand characteristics.
- **Geometric Marquee** selection tools that come in rectangular, square, circular, star, triangular and ten other preset shapes.
- The **Magic Wand** tool. This finds pixels either of a similar contrast, color, hue, brightness or opacity within the picture. That's a combination of 20 selection tools to choose from.

Bear in mind that the Options palette has more refining controls for most of the tools mentioned (some already mentioned are accessible through this palette only). Controls include a **Tolerance** level, **Blend mode**, **Anti-aliasing**, **Smoothing**, **Feathering** and **Match mode**.

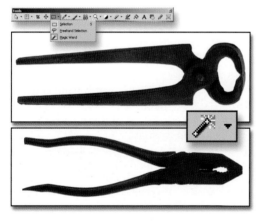

As with anything photographic, shooting the products or objects on a clean, colorless background will make your selection technique much easier – although nature is never quite that generous!

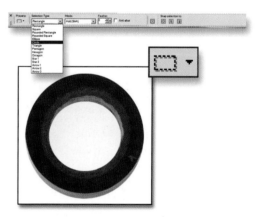

The geometric selection tool has a number of preset shapes that make the job of grabbing regular-shaped objects far easier.

What else can you do with selections?

- All selections can be saved and stored for later use in an Alpha Channel.
- Selections can be used like a painter's drop sheet – to inhibit brush actions along straight edges, and from getting paint into areas that you don't want to get paint into.

- All selection tools have an 'Add To' and a 'Subtract From' function. Hold the Shift key when making a second selection and it's added to the first. Keep holding the Shift key to add further selections. In this way you can build, or reduce, extremely accurate selections.

- To further refine the process, selection tools are interchangeable. Make an initial selection using the Magic Wand tool, for example, and add to that using a marquee tool. Finish off using the freehand selection tool. Use the Shift and Control keys to apply additions and subtractions, or set the same parameters in the tool Options palette.

- Use the **Options palette** to make custom selections using numerical values entered into the fields provided ('Customize Selection' in the Options palette).

- Paint Shop Pro also has a **Selection Edit mode** ('Selections>Edit Selection'). In this mode, all the raster painting/drawing tools and many filter effects can be used to modify the selection marquee. In this mode it's rendered in a red opaque color so it's easy to see. This is a powerful and a fast way to make an average-looking selection into something that has professional accuracy.

- Use the program's **Selection Modify** tools to perfect the selection edges. This function provides enough sophistication for you to produce surprising accuracy from even the roughest of initial selections.

If the background is 'clean', selection using any tool is far more efficient. You might even like to make the background lighter (using the brightness and contrast tools) so that it is easier to grab objects cleanly.

Remember, even if the regular-shaped object is not in a linear alignment, it can be rotated on a layer, selected with a regular selection marquee and then rotated back into place. In this example, rotate the ruler to lie horizontally and 'Add' a small circular selection to the first to complete the object grab.

Using the geometric selection tools

TOOLS USED

Rectangular Marquee	Levels
Feather	Match mode
Alpha Channel	Cutout filter

Paint Shop Pro's geometric selection tools are the easiest to use because they are 'preset'. They don't rely entirely on the accuracy of the mouse action.

Open a picture and duplicate the layer ('Layers>Duplicate') so that you can practice on a copy of the original rather than the original itself. Make sure that the top layer is active (click once on its title bar on the Layers palette to do this).

Choose the **Rectangular Marquee** selection tool from the **Tools** toolbar, left-click and drag the cursor across the picture about 20% from the edge of the image. The moving line that appears where the selection was drawn is called the selection **marquee**. Any further editing on the picture applies to the area inside this selection only. Because we want to add an effect to the area outside this selection it must be reversed or 'inverted'.

Choose 'Selections>Invert' from the Selections drop-down menu and note how it flips to the opposite part of the frame. Use the keyboard shortcut 'Ctrl+Shift+M' to hide the marquee to make it easier to see any tone changes you make. Note that though it is hidden, the selection is still active.

Open the **Levels** dialog window ('Adjust>Brightness and Contrast>Levels') and slide the right-hand slider (in the Output scale) to the left. This darkens the selected area. Push the slider far enough to make the edges significantly darker, but still keep them semi-transparent.

You can refine all selections using the **Feather** adjustment. This spreads the selection line across an adjustable pixel width so that you can soften those typical scalpel-sharp selection cut-lines.

Tip

To feather the selection enter the amount from the Options palette before you start.

Tip

All angular selections 'round-out' if a feather is applied so that, if the feather value is high enough, a rectangular marquee can appear almost spherical.

> ## Tip
>
> You can also save selections to either the hard disk or to an Alpha Channel ('Selections>Save Selection>To Disk/To Alpha Channel'). This is recommended because you never know when you might want to use that selection again.

Adding to the selection

To add to a selection, hold the Shift key down and make several more geometric selections, adding one on top of the other to build up a complex irregular but still geometric selection with each new mouse drag. Change the shape of the selection (circular, square, octagonal, etc.) using the Options palette. Remember at all times to update the save to preserve the selection information in an Alpha Channel ('Selections>Save to Alpha Channel').

Introducing another selection tool

You may find that the geometric selection tools are not accurate enough or simply not the right shape to capture the subject in the picture.

If this is the case, choose the **Magic Wand** tool to fine-tune the selection process. While holding the Shift key, click in the area that you need to add into the existing selection. How much that's grabbed in one click is principally influenced by its **tolerance settings**. High values will select a wide range of pixels, a low value significantly less. To help this fine-tuning process, choose whether you can elect a **Match mode** color to grab or if it can be described through its Hue, Brightness or Opacity values. Experience will help, but experimentation is quick enough in this program. Try one match mode and if it doesn't work too well, adjust the tolerance or change the mode. Paint Shop Pro gives you an unprecedented 1000 levels of Undo if your computer has the RAM and disk resources to handle that demand. Even if you set this to 100 in the General Preferences ('>Undo'), it still offers considerable 'go back, erase and try again' potential!

The reason for making a selection is to isolate a part of the picture for the purpose of adding some sort of change to the selected area only. Having saved the latest version of your selection, apply a tonal change to it using the **Color Balance** dialog. To start with, add a suitable feather value to soften the change edge, otherwise the selection line will be very obvious. The amount of feathering is principally reliant on the resolution of the picture in question. The higher the resolution, the greater the feathering amount required. As often as not, the subtler your use of feathering, the more convincing the resulting effect becomes.

Because the Color Balance dialog has separate radio button selectors for the picture **shadows**, **midtones** and **highlights**, you can refine your color or tonal changes even further.

Save the Color Balance changes and load the previous edge selection from the stored Alpha Channel ('Selections>Load Selection>From Alpha Channel'). Invert it again so that it forms around

the outside of the picture. From the drop-down 'Effects>3D Effects' menu choose the **Cutout** filter and set its parameters to about 20/20 offset with a 50% opacity and a 20% blur. Click 'OK' and assess the result. Because all Paint Shop Pro dialogs have wide Undo latitudes, you can carry on experimenting with these filters till you decide on the 'right' one before clicking the 'OK' tab. If you are not sure what the 'right' one might be, use the Randomize tab and let the program make that decision for you!

With the Layers palette open, click the eye icon 'on' and 'off' so that you can see the before and after versions.

Freehand selections: creating an artificial point of focus

TOOL USED

Freehand Selection

Because life is never straight, Paint Shop Pro has a **Freehand Selection** tool. This is used to manually draw around an object for the purpose of isolating it from the rest of the picture. While this can be the most accurate of all the selection tools, it can also be the most tricky because you have to rely on the accuracy of the mouse, which is a bit like drawing with a bar of soap at the best of times.

I'd recommend buying a graphics tablet so that you can get the most from this tool. Jasc has spent a great deal of design time incorporating pressure-sensitive tool features into this version so that it's optimized for use with a tablet. Once you've had a go with one of these remarkable (and inexpensive) drawing tools, you'll wonder how you ever managed with a mouse!

As with all tools, the Freehand Selection tool comes with a wide range of control options available through its multi-functional Options palette.

Step 1. Open the photo and copy (duplicate) the layer. This gives a reference 'before' and 'after' picture (by clicking the eye icon in the Layers palette 'on' and 'off').

Step 2. Choose the Freehand Selection tool and decide its selection parameters: 'Freehand' works simply by dragging the mouse over the canvas. Its 'Edge Seeker' option works as if it has slightly magnetic properties. Use the Smoothing option to make the selection line, well, smoother. 'Point to point' draws a straight line from point to point and is ideal for selecting regular objects such as products. The 'Smart Edge' mode drops a wide line over the desired edges and locates the contrast or color differences underneath that line.

Step 3. Save the selection to an **Alpha Channel** ('Selection>Save to Alpha Channel').

Step 4. Choose a blur filter from the 'Effects' drop-down menu and add diffusion to the picture to simulate an out-of-focus effect.

Photographers have perfected this software technique to simulate the effect you might get if the picture was shot using a specialist wide aperture lens, like the **Canon EF85mm f1.2L USM**. Develop this software technique to avoid spending US $1000 plus on the hardware.

One selection is never enough

Using the Freehand Selection tool, make a series of three complete selections, moving further away from the subject with each one. The closest selection should be blurred relatively lightly while the outer, the final blur, can be applied heavily.

The idea is that, with a good quality lens, the 'out of focusness' increases the further back the eye travels from the subject (see the figure below). Objects in the far distance no longer become visual annoyances (nor do objects in the immediate foreground areas of the picture).

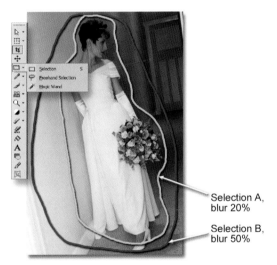

Selection A, blur 20%

Selection B, blur 50%

The more outline selections you can make around the object (as shown by the colored outlines), the better the resulting defocus technique appears. If this is just done as a one-off blur, the result will look exactly like it was fixed using software and it will not look like a genuine photographic visual.

STEP-BY-STEP PROJECTS

Technique: fixing an overexposed sky

TOOLS USED

Histogram Adjustment Background Eraser
Levels Selection Modifiers
Curves

All cameras have a habit of making exposure 'mistakes'. Very often this produces a picture with a correctly exposed land section and a poorly exposed sky section. This is usually because the CCD in the digital camera (the light recording bit) cannot cope with the contrast differences between the land and the sky – so it opts for the land! Even with many film types, a wide contrast range is hard to record accurately. If you shoot color slides (which have the narrowest scene contrast ranges), the answer is often to return to the scene when there's less contrast (earlier or later in the day) or to use a graduated filter over the lens to balance out the brightness in the sky.

For the digital photographer there are other solutions:

■ Return to the location at a time of day when the sun is not so high in the sky (and the contrast is lower).
■ For static subjects, secure the camera on a tripod and take two snaps – one exposed correctly for the sky and one exposed for the dark(er) landmass. Combine the two exposures in the same document on two layers using Paint Shop Pro and erase the under- and overexposed pixels.
■ Make an 'average' exposure of the scene and use selections to grab the sky and apply local contrast, color and tonal changes to that.

Replacing an overexposed sky

Step 1. (See top figure opposite.) Open the picture in Paint Shop Pro. Use the **Histogram Adjustment** dialog to make the landmass appear tonally satisfactory and leave the overexposed, wishy-washy sky alone. That will be fixed later (other tools to use to do this include **Levels** and **Curves**).

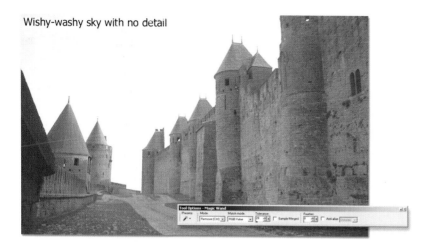

Wishy-washy sky with no detail

The sky holds no real detail while the foreground is too dark. Making the latter lighter produces less detail in the sky...

Step 2. With the landmass tones set to the correct density, use the **Magic Wand** to select the sky. You might need to shift-click the sky several times to grab all the tones. Use the tool options to vary the Tolerance value to make this easier/more accurate. Consider using the range of Selection Modifiers ('Selections>Modify') to make the sky 'grab' more accurate. Here I have chosen the 'Edit Selection' mode (the visible red opaque layer) so that a brush and or eraser tool can be used to paint/add to the Magic Wand selection. You can also apply a small feather value to this selection to soften the line where the sky and the land join (i.e. set the selection feather to a value of two or three pixels only). Alternatively, try using PSP's new **Background Eraser** brush to cut out the sky (i.e. to make a matte).

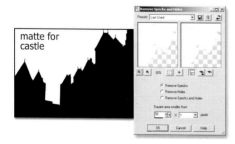

matte for castle

Step 3. Check the accuracy of the selection up close and, if there are any missing bits, I'd suggest using the **Remove Specks and Holes** Selection Modifier to clean it up.

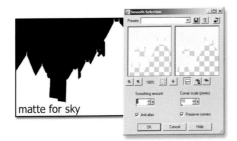

matte for sky

Step 4. Another effective modifier is the **Smooth Selection** dialog. Again, this is chosen from the 'Selections>Modify' drop-down menu. Use it to straighten out all ugly jagged edges.

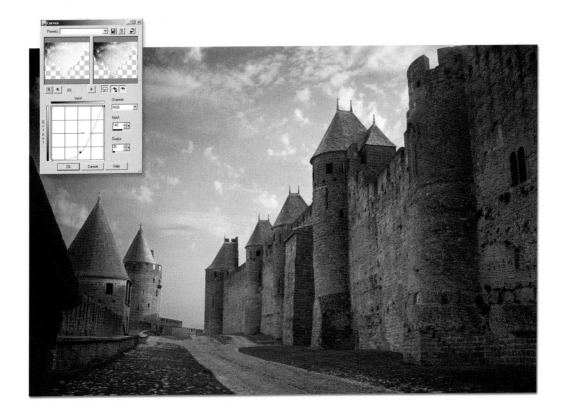

Step 5. The trick is to use the **Histogram Adjustment** tool to make the sky section darker via the selection. Use one or both tone sliders to increase the contrast and density by squeezing them into the center of the histogram. If there's no tone in the original (unlikely, unless the sky is drastically overexposed), you'll have to copy another sky from a different picture.

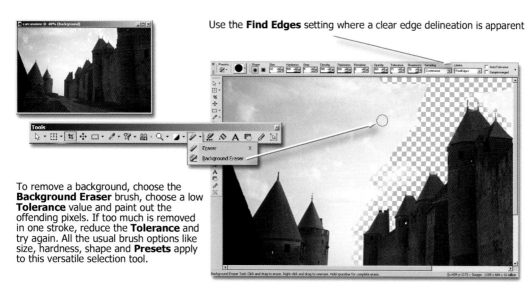

Use the **Find Edges** setting where a clear edge delineation is apparent

To remove a background, choose the **Background Eraser** brush, choose a low **Tolerance** value and paint out the offending pixels. If too much is removed in one stroke, reduce the **Tolerance** and try again. All the usual brush options like size, hardness, shape and **Presets** apply to this versatile selection tool.

Paint Shop Pro's Background Eraser tool is fantastic for jobs like this. Once the Opacity and Tolerance levels have been set to the right level it's a simple matter of painting out the sky and either pasting in a new one or using a selection tool to make a very accurate grab of the landscape or sky areas so that they can be modified using a tone command such as Levels.

Technique: desaturating pictures

TOOLS USED

Hue/Saturation/Lightness	Alpha Channel
Selection Modify	Feather

While adding basic tonal changes and filter special effects might work for some pictures, selections give you the power to control precisely what happens (and where) in the digital image-making processes.

One of the best examples is to use Paint Shop Pro's **Hue/Saturation/Lightness** feature to desaturate or reduce the color intensity in parts of the photo in order to add visual impact.

Tip

An easy, more localized way to do this is to desaturate parts of the photo using the Hue/Saturation brush (see accompanying wedding snap). This technique works just like any paintbrush – but it removes color. Choose this option from the menu. If you make a mistake, swap again in the options to increase saturation and make good the mistake.

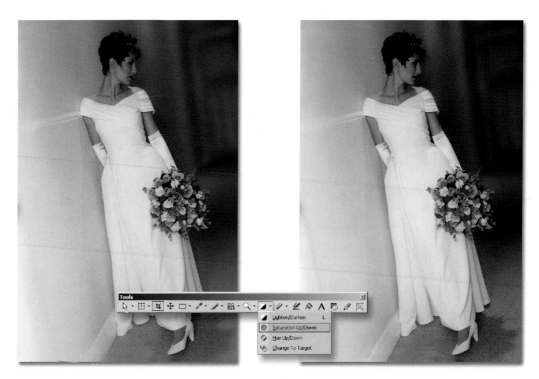

An easy, more localized way to desaturate a photo is to use the Hue/Saturation brush. This is akin to adding water to a watercolor paint mix. If it's over-desaturated by mistake, swap to 'saturate' in the Options dialog to replace the lost saturation and make good the mistake. This is a technique that photographers used to try a lot – slaving away in the darkroom making masks and opaque mattes before soaking prints in bleaches and other assorted chemical dye baths. Now you can preview the exact effect before it happens and change it quickly if it's not the effect you're after. That's the power of digital imaging. Its test-and-repeat nature permits you to try techniques again and again, techniques that you might never have the time, patience or skills to execute using traditional film-based technology.

Step 1. Open a picture and, using the **Freehand Selection** tool, draw round the object that you want to highlight. You'll find that drawing accurately with this tool is nearly impossible. A graphics tablet will make the process much easier and, more importantly, neater. However, to get the selection looking perfect use the many **Selection Modify** tools to perfect the accuracy of that selection (i.e. 'Smooth', 'Feather').

Step 2. Save the selection to an **Alpha Channel** ('Selection>Save to Alpha Channel').

Step 3. Once happy with the selection improvements, make sure that you save the selection ('Selections>Load/Save Selection') and then invert the selection ('Selection>Invert' or 'Ctrl+Shift+I'). Do this because you need to apply an effects change to the rest of the picture, not to

the subject that has been selected! Once inverted, save the selection again (you should now have two selections – one inside and one outside the subject).

Use this powerful tool to reduce the saturation in the rest of the picture. Reducing the saturation totally leaves you with a black and white image, also a nice touch if that's the effect you are after. If the selection line appears too sharp between saturated and desaturated areas go back to the Selection Modify tools and choose **Feather**. Use this to soften or spread the selection line across a number of pixels. Try a setting of five to ten to begin with.

5

Combining Images: Working with Layers and Layer Masks

This chapter shows how to combine and create multi-picture documents using the power of layers.

TECHNIQUES COVERED

Advanced layout tools	Layer masks
Combining pictures into one document	Modifying and combining layer masks
Deformation tools	Understanding layers
Layer blend mode effects	Using adjustment layers
Layer transformations	

TOOLS USED IN THIS CHAPTER

Adjustment Layers	Move tool
Background Eraser (tool)	Paste as New Image
Blend modes	Paste as New Layer
Deformation tool	Paste as New Selection
Floating selections	Perspective tool
Grid, Guide & Snap Properties	Paste as a Transparent Selection
Layers	Rulers
Layer opacity	Snap to Guides
Layer transparency	Selection Modifiers
Layer masks	View (command)
Lens correction filters	View Grid
Merge (command)	View Guides
Mesh Warp	

Understanding layers

TOOLS USED

Layers	Merge

After learning about selections, the next real hurdle for the digital image-maker is probably to learn all about **layers**.

What is a layer? A layer is simply one picture sitting directly on top of another. Layers can be whole photos, text, vector drawings, scanned art or anything else that can be digitised. You can add as many layers as you want in one document, depending on your requirements. The reason for building up these layers is to maintain the pictures' editability. While a picture retains its layers, it can always be edited. Flatten (or squash) those layers, so that it can be emailed, for example, and you lose the power to edit it.

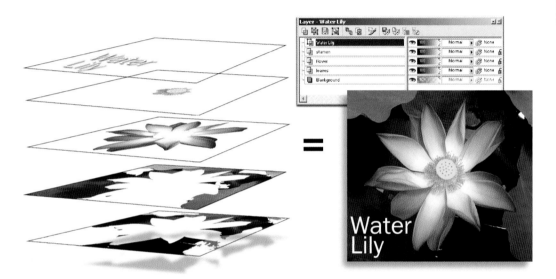

The illustration here shows how a layered image works. Viewed from above (i.e. on the desktop) the picture looks perfectly normal, but exploding the layer palette shows that it is in fact composed of five separate layers – all of which can be moved or can have their color/tones changed independently. Layers files must be saved as either '.pspimage' files or, for more cross-computer compatibility, in the '.psd' (Adobe Photoshop) file format. Using either of these file formats preserves the layer integrity.

Paint Shop Pro has quite sophisticated layering capabilities. What I mean by that is you cannot only create montages from multi-layered documents, but it also has a range of features like adjustment layers that open up even more editing possibilities. So much so that every stage in the image-building process can be deconstructed, changed, altered, improved and returned to its place, over and over again with incredible accuracy and remarkable ease.

Who uses layers?

Layers are used by anyone who adds text to a document, whether this is one number or a page of copy for a brochure. Layers are used to make multi-image **montages** where several pictures

blend seamlessly into one picture. Layers are also used extensively by designers, publishing and even web designers. Anyone, in fact, that uses images that have more than one picture element in them.

What can you do with layers?

A layer is like a clear sheet of acetate that sits above the original (background) layer. Layers can be opaque or transparent, floating (temporary), full-sized or cover only a tiny part of the background layer. Layers can contain pixels (bitmap) or vector data (text).

You can cut, copy and paste layers from one document to another. Layers can be flipped, rotated, resized, distorted, rearranged or grouped in any number of combinations. You can apply color and tonal adjustments to single layers – and you can add a full range of filter effects, as if one layer were a single picture. Only while the layered document retains its original layers does it remain editable. For seasoned image-makers, this layer editability remains a powerful attraction. How many times have you finished creating a particular work of art only to spot something that you missed but that you now can't change? If you use layers, you can!

Before you get too excited, layers have disadvantages:

■ Multiple layers create a spaghetti-like complexity that can be hard to keep track of.
■ The more layers you add to a document, the harder it becomes for the computer to process changes. Each additional layer adds to the document file size.
■ Layers offer a tremendous potential for the creative image-maker. Simply adjusting the **opacity** of an individual layer allows you to see everything on the layer beneath. Each layer also has a range of **blend modes**. These can be adjusted in order to radically change the way it reacts with the pixels in the layer directly underneath it.

Once you understand that layers are similar in appearance to Disney-style punched **animation cells** or kids cartoon flip-books, you can begin to appreciate the idea behind its function.

We already know that Paint Shop Pro has a multiple undo feature ('Cntrl Z'). This means that you can reverse the picture building process by up to 1000 steps; however, in accepting an undo command and then saving, those steps are lost for ever. If you are working with layers, you can apply major editing stages to different layers and retain everything in the one document, regardless of whether you are using it or not. Each layer has a small eye icon that signifies whether it is switched 'on' or not. Click the eye to switch it off, click again to switch it back on.

Like the Disney animation process, layers sit perfectly aligned ('registered') over the layer beneath. If the top layer has an opacity of 100%, you won't be able to see through it to the layer underneath. Reduce its opacity (or change the blend mode) and you'll see the layer, or layers, beneath it. Reduce the size of the picture sitting on the top layer and you'll be able to view at least some of the layers below.

If you build up the number of layers in a document, the total file size increases. Image-makers need to be aware of this because if the computer has limited amounts of RAM or

processing power (megahertz or MHz), it might affect performance. To make this less of a hassle, Paint Shop Pro allows you to **merge** selected layers into each other. You'd do this to layers, or groups of layers, that are similar or are finished with (i.e. you are sure that they'll never need changing).

You might also do this to layers that, once merged, can be separated again if necessary using a selection. Though merging or flattening layers frees valuable computer resources, RAM is cheap enough to buy, so I'd suggest buying more and keep the layers for editing because you never know.

What features can be found in layers?

- Layers in the master file are called the **Stack**.
- Move the picture elements on layers in any direction.
- Change the tone, color, contrast and alignment of any layer.
- Mix vector and bitmap layers in one document.
- Create new, blank vector and bitmap layers at the press of a button.
- Collect selected layers into **Layer Groups**.
- Copy single layers, or groups of layers, into the same or a new document.
- Convert selections into layers.
- Paste layers and selections from other documents into a new document.
- Layers can be reordered by dragging up or down with the cursor.
- Layers can be switched 'on' and 'off' (by clicking the palette eye icon).
- A new layer is created every time you paste the contents of the clipboard into a master file.
- Create a new layer using the **Duplicate** command (Layers>Duplicate) or by pressing the duplicate tab in the palette.
- Use the 'Edit>Layer' tab in the Layers palette to edit a selection (Selection Edit mode).

Combining pictures

TOOLS USED

Move
Deformation tool
Paste as New Image
Paste as New Layer
Paste as New Selection
Floating selection
Paste as Transparent Selection

Paint Shop Pro permits the user to save every stage of the image-building process as a separate **state** or **layer**. These layers can be switched on or off according to their application. You can also store masks and selections as separate channels in layered documents. These too can be switched on and off. In Paint Shop Pro, any document that has layers, masks or selections has to be saved in a special native Paint Shop Pro file format with a unique '.psp' (< version 8) or '.pspimage' (> version 8) file ending.

As layers exist in this native file format, you cannot use '.pspimage' files for email and (some) other jobs. The file has to be converted first or copied to a more suitable file type, such as JPEG or Tiff. First you must flatten the file ('Layers>Merge>Merge All (Flatten)'). Doing this turns it into a single-layered document. This loses all of its editability, which is why you should only do this to a copy of the original .pspimage file. Save your layered documents as **Master** files and then, when required, make copies from that master for use in other, non-layered file applications.

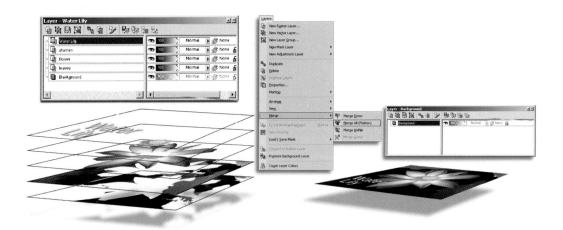

A layered (.pspimage) document is more editable than any other format. Because of this it's also too large for many applications, such as emailing or storage on a limited size disk. For this reason it is important to make a copy and to Flatten or Merge those layers so that the resulting single-layered document can be resaved in another, more versatile file format, like JPEG or Tiff.

There are two quick ways to combine two pictures into one document:

■ Copy one picture and paste it into another document.
■ Use the mouse to click-select and drag a thumbnail from the browser or layers palette to the picture.

While these multiple layers are totally separate to each other, it's important to note that they can be edited at any time as if they were two totally different picture elements. However, because they are

in the same document, you also have to contend with their relationship. While copying and pasting one picture into another is by far the easiest way to add another picture to a document, there are a few points to consider first.

The resolution of the pasted image, measured in pixel dimensions or dots per inch, is relevant. For example, if this is larger than the receiving image it will overspill (bleed off the edges) once pasted. However, even though it looks as if the edges of the pasted image have disappeared, the program does not discard them; they are still there but only become visible if dragged into view using the **Move** tool ('M').

Tip

The base layer is called the 'background' and is, in fact, not a layer at all. However, it can be 'promoted' (converted) into a layer, if needed (right-click on the layer palette and choose 'Promote to Layer' from the contextual menu). If you don't want to promote the background, you can simply duplicate it.

Tip

If the image pasted into the new document turns out to be the wrong size, choose the Deform tool and resize the layer by dragging one of the edges or corner handles.

Tip

If you need to lock the perspective off, drag a corner handle using the right mouse button.

Another factor to watch out for when combining pictures is their respective **color spaces**. Providing that the color space of the master document is either 24-bit or Grayscale, it will prevail over what is being pasted into it. So, if you copy an 8-bit picture into a 24-bit color picture, the color space of the pasted picture will be increased to match that of the host document. On the other scale, if you try to paste a color picture into a black and white image, it will be converted into the mono layer.

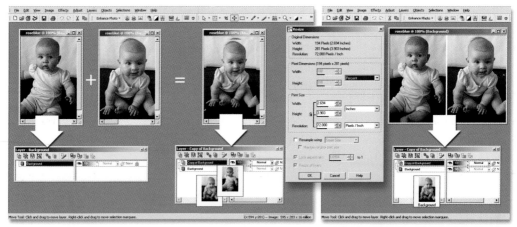

Copy the first open photo (Edit>Copy), select the second (click on the title bar once to bring it to the front) and paste the contents of the clipboard into it (Edit>Paste As A New Layer) to produce a two-layered document. Use the Image>Canvas Size feature to increase the physical size of the canvas (the white background) so that the photos can be positioned side-by-side, rather than on top of each other (as seen here, center, left desktop view). You can resize the canvas at any time to accommodate one, or more extra photo or vector (text) layers. In contrast, changing the Image Size actually increases the picure size (or pictures) on all layers, as well as the canvas background.

Layered documents are, therefore, ideal for composing multi-image files, as shown here. Each copied and pasted image appears in the document on its own layer, which can be preserved or merged into the background layer should that be necessary.

How to create a multi-picture document

Step 1. Open two photos on the desktop. Select the first by clicking once on its title bar (the bar at the top of the window; gray is unselected, blue means it's selected) and copy the picture into the program's clipboard ('Edit>Copy').

Step 2. The picture is now in the computer's memory (called the **clipboard**). Select the second picture by clicking on the title bar, and paste it ('Edit>Paste') from the clipboard into the target picture window. If the pasted image has the same physical dimensions as the master document it will cover it exactly.

Step 3. Once the picture has been pasted and positioned over the second image (now called the 'background' image), you might need to resize the new layer to fit the overall design or to simply reveal some of the background layer. Do this using the **Deformation tool** in one of two ways.

■ Ensure that the layer to be resized is selected (click once on the title bar in the Layers palette), select the Deformation tool from the Tools toolbar and note the handles that appear in the corners of the layer (you can only resize a layer). Handles are used to change the proportions and geometry of a layer. Move the cursor over the corner and note that it changes into a rectangle. Click-hold the corner handle and drag out to increase the layer size and inwards to decrease the size. This is a freehand operation so you will probably change the proportions of

the layer and the picture sitting on it. To lock the proportions, drag the layer using a right-click.

■ Alternatively, use the deformation settings in the Options palette. There are numerical fields for changing all possible axes in the picture including rotation. Click 'OK' and the layer is resized to that proportion. This will not work on the background unless it is first promoted to a layer.

Step 4. Use the **Move** tool to position the newly-resized layer. Save the layered document in the Paint Shop Pro ('.pspimage') format so that you retain all the layers for editing later. To add more pictures to the same document, repeat steps 1–3.

Paint Shop Pro offers a number of ways to paste copied images into another document via the Edit menu or by right-clicking in the new document. These are:

■ **Paste as a New Image.** This creates a new picture on its own background.
■ **Paste as New Layer.** This adds the contents of the clipboard to the selected document background. Paint Shop Pro automatically creates a new layer for the pasted image. If the pasted image matches the physical dimensions of the target image, it will obscure the lower layer or background picture.
■ **Paste as New Selection.** This pastes the newly-selected picture into the target document, but it remains attached to the cursor so that it can be positioned other than directly on top of the background. Left-click to offload the layer and view the selection marquee. The pasted layer then becomes a **floating selection** until it is deselected. You can save this selection in the document's Alpha Channels (in case it is needed again: 'Selections>Save To Alpha Channel'). If you already have a floating selection, it will be defloated and deselected before another picture can be pasted into the document (i.e. you can't have two floating selections in one document).

Tip

Deleting the floating selection at this stage removes the picture contents but leaves the selection marquee. Deselecting the image ('Selections>Select None') affixes the floating selection to the layer below. If you decide that you want to save that floating selection as a separate layer, either delete it and repaste the contents of the clipboard as a New Layer or select 'Selections>Promote to Layer' from the menu bar. Paint Shop Pro creates a new layer for it to sit on.

■ **Paste as Transparent Selection.** This command does the same as the Paste as New Selection command, but enables you to import transparency from another image. Because of this transparency, the pasted layer is attached to the Move tool for easy repositioning. Click in the image to free it once it is in the right position.

What can you do with layers?

- Change the individual tonal appearance of each layer.
- Make and edit selections on individual layers.
- Add blend modes to individual layers for special effects.
- Save layer selection and mask information to an Alpha Channel.
- Add adjustment layers.
- Apply any of Paint Shop Pro's filter effects to a layer.
- Bend and transform the shape of any object on a layer.
- Convert vector layers to bitmap layers.

Advanced layout tools

TOOLS USED

Rulers	Arrange
View	Layer Opacity
View Grid	View Guides
Grid, Guide & Snap Properties	Snap to Guides
Merge	

As we have seen, there are many ways to use Paint Shop Pro for combining multiple layers into a single document. In this exercise we'll use several advanced features designed to make laying out and arranging multiple picture documents less confusing, and faster.

Under Paint Shop Pro's **View** menu there are a number of highly useful productivity-enhancing features designed to make aligning and arranging multi-layer images faster and easier. These are:

- **Rulers.** Keyboard shortcut ('Cntrl+Alt+R') adds rulers along the X- and Y-axes of the picture window. You can change the units of measurement (pixels/inches/centimeters) through the program's General Preferences ('File>General Program Preferences>Units'). Place the cursor anywhere in the image and you can read out the exact location in the corresponding margin. It's a handy tool, especially if you are working with extremely small picture elements on multiple layers.

Tip

Set the rulers to the same measurement that you use for your print output.

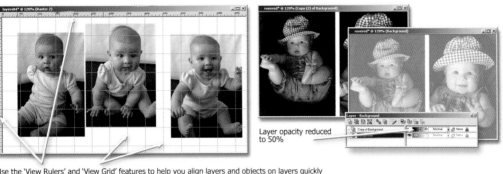

Layer opacity reduced to 50%

Use the 'View Rulers' and 'View Grid' features to help you align layers and objects on layers quickly

Layer **Blend Modes** affect the appearence of the picture directly below in the layers stack

Customise layout options using the 'View Guides' option. Change the settings by opening the Grid, Guide and Snap Properties dialog box (above)

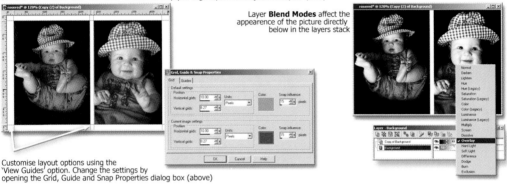

Paint Shop Pro has a range of sophisticated edit and design tools that make it a thoroughly professional designer's and photographer's software program. Its guides and grid are there to help you lay designs out quickly and with great accuracy. The real beauty is that, although they appear on the desktop, none of these visual aids are printable!

- **View Grid.** If you find the grid too heavy, double-click on the rulers in the margin and you'll see the Grid, Guide & Snap Properties dialog. Change the units used and the color to make it appear friendlier. You'll need to make adjustments every now and then for different-sized pictures. This is a useful feature for precise layer or picture element alignment.
- **View Guides.** This is one of the neatest design assistants in Paint Shop Pro. They work only if 'Rulers' are switched 'on'. Guides are colored lines that can be pulled out of the margins (using the cursor regardless of the tool currently selected) and dragged over the picture to form, well, design or layout guides. There are no limits to the number of guides that can be used in one document. Guides can be repositioned by grabbing the guide handle (that's the thicker bit of guideline that appears inside the ruler margin as you move the cursor over it). If you want to change the guide properties, double-click the ruler to open its window or just click the guide handle in the margin to open the **Grid, Guide & Snap Properties** dialog. This allows you to change its color, position or existence!
- **Snap to Guides.** This function adds tremendous power to the task of aligning multiple layers along a common axis – by selecting this option and making sure that, in the **Grid, Guide & Snap**

Properties dialog, the Snap Influence setting is set to more than one. What this does is that if you grab an image layer using the Move tool and drag it towards the guide it appears to be magnetically attracted to the line. In fact, it 'snaps' to the line. Increase this value to increase the magnetic power.

You can change any of these settings for the opened document only, or for the default settings. This feature is a real production enhancer.

Under the **Layers palette**:

■ **Layer Opacity.** All layers have an opacity scale controlled from the Layers palette. Default setting is 100%. Reducing this allows you to see through the layer to whatever lies beneath. Do this to help align specific pictures or graphic elements with stuff that lies beneath.

Under the **Layer menu**:

■ **Arrange.** This feature allows you to swap the layer order, although you can also do this by using the cursor to grab a layer in the palette and dragging it to another position in the layer stack.
■ **View.** Controls which layers are visible and which are not. You may also switch a layer on and off by clicking on the eye icon in the palette itself.
■ **Merge.** Merge allows you to do just that: merge or blend selected layers. **Merge Visible** flattens only the layers with the eye icon switched 'on' (i.e. those that are visible on the desktop).

About deformation tools

TOOLS USED

Deformation tool
Straighten
Perspective Transform
Mesh Warp
Lens correction filters

Altering the shape or alignment of a layer is easy using Paint Shop Pro's **deformation** tools.
Why use the deformation tools?

■ To change the alignment of a layer.
■ To modify the size of the layer.
■ To modify the perspective and skew of a layer.
■ To significantly change the appearance of a picture.

There are four to choose from:

- **Deformation** tool – used for relatively simple layer changes.
- **Straighten** tool – especially handy for straightening horizons in scans.
- **Perspective Transform** – used for adding exaggerated (or corrective) perspective to objects.
- **Mesh Warp** – the 'big daddy' of the subset, Mesh Warp gives you the freedom to bend, distort, warp and buckle 25 sections within a layer.

The most obvious or immediate use for the Mesh Warp tool is fun. Choose the tool, stretch the wire frame that appears over the picture and watch Paint Shop Pro treat those pixels like so many rubberized elements! It's quick, it's fun and can keep your kids out of trouble for minutes, if not hours.

The procedure is simple enough: open the document and select the layer that needs deforming. Choose the **Deformation** tool from the **Tools** toolbar. Note the marquee and 'handles' that appear at the corners of the layer. If you hold the cursor over any of these handles, the normal four-pointed arrow Move symbol changes to a rectangle, indicating that this has changed from the **Freehand Deformation** mode to **Scale** mode. You can further change the type of the deforming action by holding down the Shift key (for a **Skew** action) or by holding the Control key to change it to **Perspective Deform**. The handle at the center of the marquee is used to rotate the entire layer. While holding the Shift or Control keys, drag the handle for the desired change and then release it.

Tip

You can mix-and-match deformation types as many times as it takes to gain the correct effect. Use the **Undo** command to take a step back if you want to reverse any of the actions.

Use similar mouse actions to directly change the perspective (**Perspective Correction tool**) and to align the horizon (**Straighten tool**).

Advanced users can use the deformation tools to manipulate selected layers to create super-real perspective effects or to add extra realism such as shadows to product photos.

Lens correction filters

Paint Shop Pro also has a range of filter effects specifically designed for correcting the detrimental effects caused by poor quality lenses. These are: **Barrel**, **Pincushion** and **Fisheye Distortion Correction** filters.

Not many lenses suffer unduly from this type of optical aberration any more, but note that these filters are fantastic for **adding** distortion to make, in some examples, quite surreal-looking results.

Fisheye lenses are a bit of a thing of the past these days – especially when you consider the limitations imposed on digital photography by the linear nature of the CCD. So it is a bit odd to find such a correction tool in PSP 8, unless of course you use it in the opposite fashion – to apply wacky distortions to a photo or layer.

The Pincushion Lens Correction filter produces the least amount of distortion effect and it was the one that I liked the most (although I don't think my nephew necessarily agrees with me – Sorry Danny!).

Using adjustment layers

TOOLS USED

Layer transparency Adjustment Layers

Sometimes it's not a good idea to apply too many tonal changes directly to the layer or photo that you are working on because it will eventually begin to fall apart at the seams. This is of particular concern to professionals working for the print or web environment, where it is vital to keep the integrity of the file intact. If, on the other hand, you are a relative newcomer and only use photo-editing software to display and fix up family snaps, then the often obsessive behavior of some image-making techniques might not be of such interest.

The best way to avoid damaging the original pixel data in a digital photo or scan is to work with adjustment layers.

This sounds complex, but in fact adjustment layers are not only easy to use but can produce quite powerful results. Open the file and choose an adjustment layer from the layers drop-down menu. Note that there are a range of options: Brightness/Contrast, Channel Mixer, Color Balance, Curves, Hue/Saturation/Lightness, Invert, Levels, Posterize, and Threshold. Apply an adjustment layer and it affects everything under it in the layers stack. Like real layers, the order of adjustment layers can be freely changed when necessary.

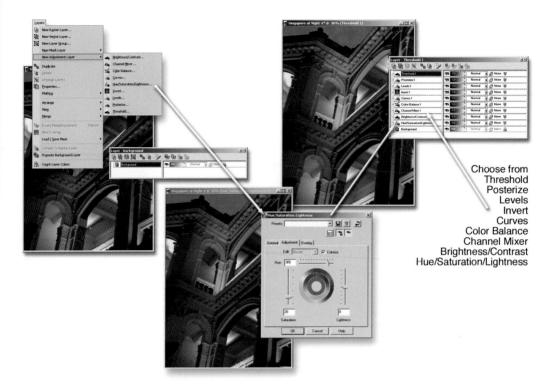

Choose from
Threshold
Posterize
Levels
Invert
Curves
Color Balance
Channel Mixer
Brightness/Contrast
Hue/Saturation/Lightness

For the casual imager, I suspect adjustment layers are somewhat unnecessary – for the simple fact that digital photos are stable enough to take a lot of tonal tweakings before they appear a bit strained. For the purist, however, they offer a simple, non-lossy method of trying a number of effects without touching the integrity of the original picture data. Choose between Threshold, Posterize, Levels, Invert, Curves, Color Balance, Channel Mixer, Brightness/Contrast and the Hue/Saturation/Lightness tools. Have a go and decide on their merit for yourselves.

Adjustment layers produce exactly the same result as if you'd applied any of the above tonal changes to the layer – but with one fine difference: adjustment layers do not touch the original. There's no limit to the number of adjustment layers present in a file, although the fewer there are, the less complex the process.

Layer transparency

Not all layers are opaque or not all objects on the layer need to be opaque. Paint Shop Pro gives us a simple solution to this: layer transparency. By using the slider in the Layers palette, you can alter the transparency of each layer from its native 100% opaque state to a zero value – the layer disappears entirely. Layer transparency is ideal for when you need to blend layers into each other to create a new look to the image as well as to reduce the impact of a particular blend mode.

In connection with adjustment layers and their respective blend modes, this gives the creative an immense set of choices as to how the master picture appears.

Advantages of adjustment layers

- Add a range of tone and effects changes to a layer or layers without actually changing the original layer.
- Useful for applying overall color or tone changes to multiple layers at a time.
- Ideal for anyone working with panoramas.

Creating layer blend mode effects

Blend modes are settings that alter the way one layer of pixels reacts or appears with another when mixed or superimposed with each other. You can paint in a specific blend mode or you can apply one to a selected layer to affect the pixels in the layer below.

Why would you use blend modes? The simple answer is so that you can create stunning special effects just by selecting a blend mode from the Layer menu. Blend modes are available through the Layers palette as well as through some of its tools. You can take a regular picture, copy it to make a second, identical layer, change the blend mode in the top layer (its default is 'Normal') and create an instant special effect that might just blow your mind.

Choose a photo and open the Layers palette. Note that the blend modes drop-down tab is grayed out. It's unavailable. Copy the layer and note that now the blend mode on the top layer is no longer grayed out. It's available for action.

If you have never used blend modes before you'll not appreciate what they can do to the image. Refer to the illustrations for a better idea. Note that some have little or no effect on the image. Others have a dramatic influence. The beauty of this technique is that you can add as much, or as little, of the blend mode as needed.

Use the Layers palette **opacity settings** to dim the effect or copy the layer to increase the potency of the effect. Note also that most of Paint Shop Pro's brush tools also have blend modes in their respective options palettes. These give you an additional string to your creative bow, enabling you to invent a wider range of color effects using a relatively basic, 'click and choose' type tool.

Using layer masks

A **layer mask** is used for blocking the visibility to any layer, or layers, that are beneath it. You'd use a layer mask when combining multiple photos into one 'Master' document.

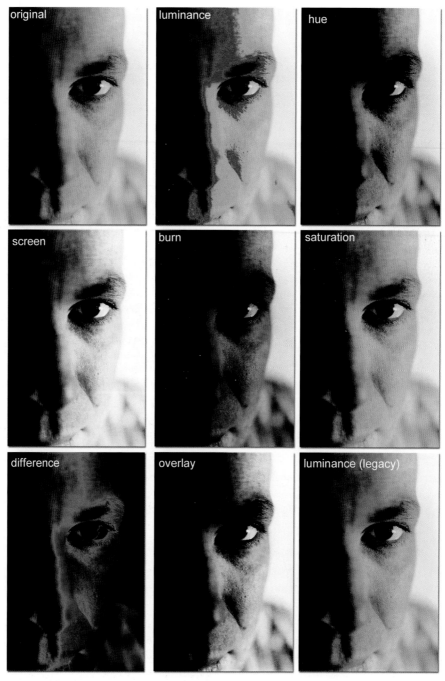

Not all blend modes have an effect that is either useful or noticeable. Many often have little effect on the lower layers at all while some, like those in the illustration, offer dramatic changes in the appearance of the photo. There are no hard and fast 'rules' for using blend modes correctly other than extensive experimentation. Try them on a different picture from the one seen here and you'll get totally different results. That's half the fun!

Layer masks can be edited, stretched, rotated and softened at any time so that you can superimpose one image over another, allowing that lower image to show through, in part.

To make a layer mask, select the layer first (by clicking in the palette once) and then choose 'Layers>New Mask Layer>From Image' from the Layers drop-down menu.

Once a mask has been made (using either the **Luminance**, a **Non-zero** value or the **Source Opacity** choices in the dialog) it appears in the layer stack. Masks can be dragged to any position in

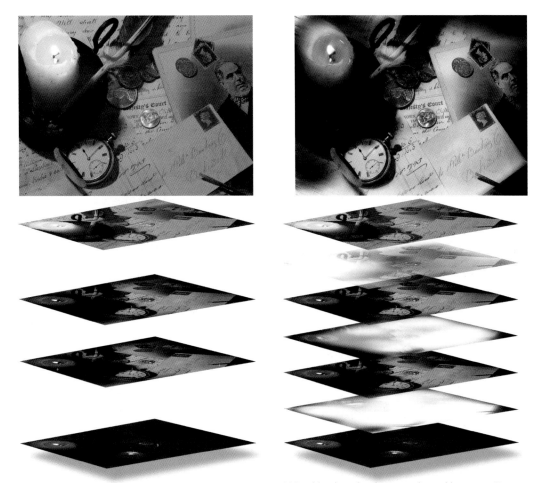

Using layer opacity and blend modes Using blend modes, layer masks and layer opacity

Layer masks can be quite confusing to understand let alone to use effectively. Have a look at the two illustrations here. The one on the left relies on blend modes and separate layers to change the nature of the final picture, while the one on the right relies more on masks – layers with varying degrees of opacity and density to create specific effects. You can make simple layer masks using the Eraser tool (rubbing out pixels means that you can see through to the layer beneath) and any of Paint Shop Pro's brightness and contrast tools to make the layer fully opaque to restrict opacity to the layer beneath. Reducing the layer opacity also significantly increases the action a mask has on the layers beneath it.

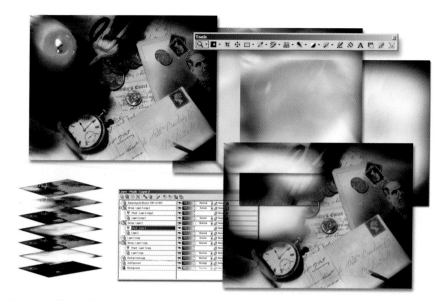

Like the lighting filters, layer masks can be used to highlight and disguise sections of the image – it's a simple but highly effective method of steering the eyes to relevant sections of the picture and for obscuring those that are less important. Simple masks can even be hand drawn on a blank layer using any of the paint tools. Most sophisticated layer masks can be created from selections or simply from the existing layer data.

Though the resulting picture might take up to an hour or so to make on the desktop, it would take hours more to create using a camera and lights in the studio (and even then, you'd never quite be sure if it was going to turn out OK till the film had been processed).

the stack in order to change the way they alter the appearance of the image or the layers beneath them.

You can also apply a range of brush and special effects filters to the mask so that it can be further refined to fit the image it's masking. Masks can also be merged or grouped with other layers.

Modifying layer masks

Layer masks can be modified just as if they were regular raster or vector layers. You can use any of Paint Shop Pro's brush tools to add or remove bits of the mask and then alter orientation using the

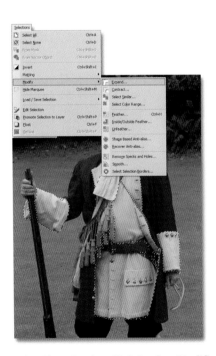
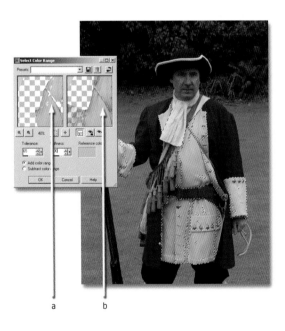

Paint Shop Pro has 12 Selection Modifiers, tools designed to help you get the perfect selection. Here's how they work. Make an initial selection and then choose the modifier that you think works best for the type of image open on the desktop. This might be simply to fill specks and holes in the mask or, as in this case, to choose a wider selection parameter using 'Color' as the base index. Check the before (a) and after (b) previews to see how effective each specific modifier tool appears.

deformation tool (rotate, change perspective). The advantage of using masks is that you can apply a range of filter effects to the mask layer only, reducing its opacity or saving it for use in another file.

To edit a mask, click the mask layer once to make it active and then either run a filter action over that (mask) layer or add/subtract from the layer using any of Paint Shop Pro's brush tools. Click the mask icon to the right of the layer in the palette to view the red ruby lith mask overlay. Use this mode to make and view changes made to the mask. For a quick view of the mask thumbnail, hold the cursor over the layer icon for a few seconds.

Tip

When preparing a layer for masking using any of the selection tools (i.e. Magic Wand, Marquee or Freehand Selection tool) make sure that you use the Selection Modifier tools (under the Selection menu) to fine-tune the selection.

The 'cleaner' the selection, the better the mask quality and the more agreeable the end-product. The exhaustive range of Paint Shop Pro's Selection Modifiers make this one of the most sophisticated of all selection tools on the market.

Combining layer masks

TOOLS USED

Merge Group	Merge Down
Merge Visible	

Some digital image-makers work with multiple images and image masks. In this situation it is vital to remember exactly what you are doing and what the final planned result should look like.

To this end, use sketches to keep your mind clear where each image is to be placed in the frame and try to label all the layers, layer groups and masks. Doing this (by double-clicking each layer and entering the details in the dialog) will make the masking and blending process somewhat clearer, especially when there are 20 or more layers to contend with. You can also combine groups of layers (Merge Group) using the combine instruction in the Layers menu. Alternatively, you can merge layers that are not associated with each other through a group simply by choosing the Merge Visible or the Merge Down command.

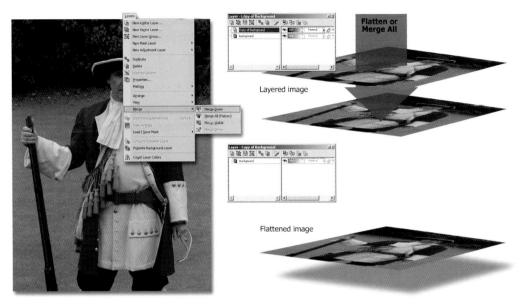

Layered image

Flatten or Merge All

Flattened image

Merge All or Flatten squashes all the layers into a single-layered document. Only then can you resave the file in another file format such as JPEG (i.e. 'pspimage' files support layers, JPEGs do not).

STEP-BY-STEP PROJECTS

Technique: correcting faulty perspective (optical distortion)

TOOL USED

Deformation tool

Paint Shop Pro can be used to change the size, shape and orientation of any picture or layer in a picture.

Besides simple orientation changes, you can use the **Deformation** tool to alter, even create, new perspectives in a picture. Architects, real estate agents and PR companies might be painfully aware of how much it costs to hire professionals to get it right first time. Cost is why so many non-photographic professionals opt to do it themselves. While this might be a cheaper option, be aware that you might also create your own set of unique optical problems.

Here's a technique to control perspective in an architectural photo.

Step 1. Open the picture in Paint Shop Pro ('File>Open').

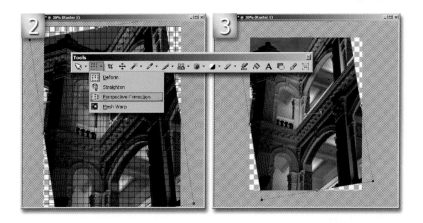

Step 2. Open the Layers palette and duplicate the layer. This copies the selected (active) layer. If there's only a single layer in the picture, that's the one that gets copied. There should be two, identical, layers in the same document. Click the title bar at the top of the layer stack to make that one active. Now choose the Deformation tool from the Tools toolbar and note the bounding box that appears on the image. Use the Straighten command to straighten out the vertical lines in the image.

Step 3. Then choose the Perspective mode and stretch the perspective back into shape.

Tip

You might have to maximize the window to see the bounding box sitting at the edge of the frame. Move the cursor over a corner of the marquee and note the change in the cursor shape from a four-point arrow to a rectangular block shape. Move the cursor over one of the corner handles and hold down the Control key. The cursor shape changes to an irregular block rectangle. This is the Deformation tool's **Perspective mode** (alternatively, choose 'perspective' from the tool options palette). Selecting this locks the two top 'handles' so that when one is moved horizontally left or right, the opposing handle moves in sympathy, mirroring the action, but in reverse.

If you take a snap of a building with a camera fitted with a wide-angle lens, chances are that you'll suffer from optical distortion; the building will appear narrower at the top of the frame than at the base. Grab one of the two edge handles and pull it away from the frame (i.e. off the canvas to the left or to the right). Its corresponding handle moves in the opposite direction and the top of the layer is stretched as if it were made from a rubberized sheet, not from pixels!

Step 4. Care must be taken not to overdo this perspective-stretching action, especially if the original picture is low resolution. By making any deformation, Paint Shop Pro radically stretches and distorts the pixels in the layer.

Tip

Pushing the top or bottom perspective handles 'in' is easy enough in 'normal view'; however, if you need to expand the perspective, you'll have to maximize the image view. Click the middle tab on the Windows title bar (middle of three).

Step 5. Double-clicking inside the bounding box completes the deformation action. Though this distortion seems pretty responsive, there are limits to the amount of distortion possible (i.e. how far the handles can be pulled out). This is especially so if it's a low-resolution picture. If this is the case, the photo will lose definition and sharpness. Because of the perspective and rotational distortion you'll have to paint some of the edges back in using the Clone Brush.

Before and after. A building that, at first, appears to be falling over backwards, now appears to be more architecturally stable.

Tip

If you want to change the deformation again, reselect the Deformation tool and repeat the action. If you try to change the perspective too much, a dialog box appears: 'Size of deformed image exceeds maximum size allowed'. You have been warned! Save the picture and try the Deformation tool again. It might then perform that extra bit of deformation; if not, I'd suggest go back and reshoot!

> **Tip**
>
> Single-layered pictures have to be 'promoted' to a full layer before they can be deformed. To be saved they must then be flattened. All multi-layered images have to be flattened after deforming if you want to save them in a format other than the '.pspimage' file format – because they contain more than one layer. Flattening loses editability.

> **Tip**
>
> Even though, in maximized view, the layer is only visible over the canvas, Paint Shop Pro does not crop the excess running off the sides of the frame so that, should you go back and move the layer that has been deformed, the pixels previously outside the frame can be dragged into view.

> **Tip**
>
> Care must be taken with the amount of distortion used. The more distortion added, the more it affects other parts of the image. You might have to crop the picture after radical perspective deformations.

Technique: layer deformations – creating the perfect shadow

TOOL USED

Background Eraser

In this section we'll have a look at how to use the deformation tools to create special effects in a layered document.

Advanced users can use the deformation tools to manipulate selected layers and thus create super-real perspective effects or to add extra realism such as shadow effects for different lighting in product photography. For example, if a product has been shot, cut out, then placed in a new document, it's easy enough to duplicate that product layer and create a new, perfectly distorted shadow, using the deformation tool and the opacity sliders. This is done as follows:

Step 1. Create a new document with a white background ('File>New').

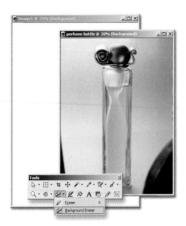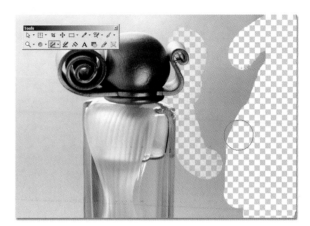

The Background eraser makes quick work of removing unwanted pixels.

Step 2. If the product is on a background it needs to be removed using the new **Background Eraser** tool. Note that there are the usual brush type adjustments (size, hardness, etc.) plus settings for the type of sampling done (Once, Continuous, Back- and ForeSwatch), as well as the types of limit you can add the tool's search for an edge (Find Edges, Contiguous, Discontiguous). Click on the background and watch as the brush removes the tone. Use the Auto tolerance first, as this seems to do the trick. Set your own tolerance level if the brush is not working so well. Use the Opacity level to soften the eraser action. Choose Find Edges for a quicker result on subjects that are quite well delineated. It's a great tool. Simple to use, yet highly effective.

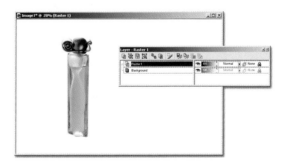

Step 3. Copy and paste the newly erased background image into the new, blank document.

Step 4. Using the Move tool, position the new layer and resize it using the Deformation tool so that there's plenty of room in the lower portion and to one side of the frame (this is where the false shadow effect will be placed). Duplicate this layer ('Layers>Duplicate'). You should now have three layers in the document: a background layer (blank white canvas) and two layers containing identical product photos each with their backgrounds removed. In the Layers palette, double-click the middle layer and, in the dialog that opens, rename it 'shadow'. Name the top layer 'product' (or something similar). While naming layers in this fashion is not vital, it makes working on the document later less confusing. To make working more straightforward, click the eye icon on the top layer to switch it 'off' (make temporarily invisible). Make the middle layer active (click it once).

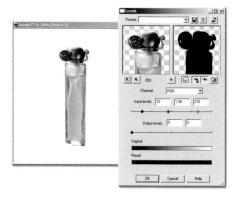

Step 5. Open the Levels dialog window ('Adjust>Brightness and Contrast>Levels') and push the right-hand Output slider to the left. The image on that layer should turn black.

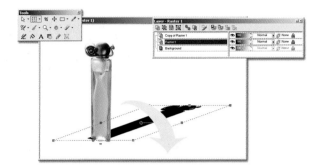

Step 6. Select the Deformation tool from the Tools toolbar, hold the Shift key down and drag the top center handle to the right. This should distort the black outline to make it appear leaning over backwards. Double-click inside the bounding box to confirm the deformation. Release the Shift key and, grabbing the center, top handle again, shrink the bounding box some more. This should further emphasize the proportions of the shadow.

Step 7. Don't worry if, while making these layer deformations, you move the entire layer, putting it out of register with the undistorted layer above (which you won't be able to see till the eye icon is pressed to 'on'). This can be repositioned with the Move tool later. As shadows are rarely pin-sharp, it must be blurred to add authenticity. Select the Gaussian Blur filter from the drop-down Effects menu ('Adjust>Blur>Gaussian Blur'). In the dialog that appears, enter a Radius value of '8' or maybe '10'. Press the Proof icon to apply that change to the layer. If it looks convincingly soft enough, click 'OK'. If not, apply more (or less) blur effect. Click the eye icon of the product layer above to ensure that the shadow is aligned with the product it's supposed to be created from! To add the final touches to the fake shadow, reduce its density to about 30%. Do this by sliding the layer opacity slider (next to the eye icon in the Layers palette) to the left. You might want to reduce this opacity even more, or not so much, depending on the context of the shadow effect desired. As a final touch, select the Move tool and ensure that the shadow at the base of the object doesn't spill over the front of the top layer. Shadows must fall behind an object and not in front! You might want to use the erase tool to remove spillage from the shadow layer around the front of the product.

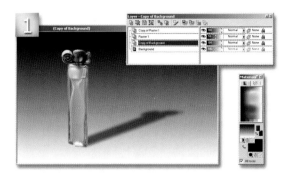
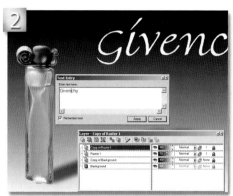
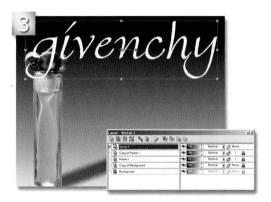
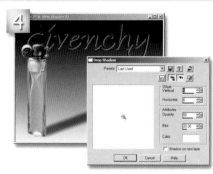

(1) Make a copy of the background layer adding a gradient to it from the Materials palette.
(2) Choose the Text tool and enter the type, as shown here. Note that PSP automatically puts the vector text onto its own layer. (3) Use the bounding box handles to resize the text to the desired shape and proportions. (4) As a final touch, add an effect to the text to give it depth and character.

Copy the text layer and reduce the opacity of each to produce a graded or fading effect. With skill this can be made to blend almost exactly into the graduated background, should you wish.

6

Using Text:
Understanding
Vector Graphics

USING TEXT

 n this chapter, learn how to create vector graphics for illustration and apply text to your pictures.

TECHNIQUES COVERED

Adding basic text elements	Putting together a greetings card
Combining photos to make a calendar	Special text effects
	Working with the Pen tool
Creating basic vector shapes	Working with brushes

TOOLS USED IN THIS CHAPTER

Airbrush (tool)	(Text) leading
Chisel/Cutout filters	Pen tool
Grid	Paint Brush (tool)
Guides	Pencil (tool)
Inner Bevel filter	Preset Vector Shape (tool)
Kerning (text)	Text tool
Layers	Text layer effects

Vectors: learning the basics

TOOL USED

Preset Vector Shape tool

Vector images are different to bitmap (raster) images. Whereas a bitmap image is made entirely of pixels, a vector image is made from a set of mathematical instructions or coordinates.

Advantages of vectors are:

■ Vectors are quick to work with.
■ Vector file sizes can be small and still display a large dimension.
■ Because of their size, vector graphics are fast to load/download and are ideal for Web use.

■ Vector graphics are fully editable with absolutely no loss of quality.

■ They create perfectly clean, alias-free lines and curves.

Disadvantages of vectors include the fact that they lack good tonal gradation and depth. Bitmaps have the disadvantage that they are:

■ not scalable;

■ physically large and bulky to store;

■ slow to open;

■ slow to save.

Vectors, therefore, are ideal for illustrations where scalable drawing, text and shapes are required. Paint Shop Pro's preset vector shape tool has a myriad range of fully editable subjects in its library.

Choose a suitable line style

Choose a suitable line style from the Preset Shapes toolbar.

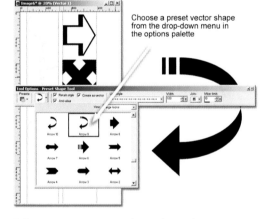

Choose a preset vector shape from the drop-down menu in the options palette

Select a preset vector shape from the drop-down menu on the Preset Shape Tool Options palette, click and drag the cursor over the canvas to create the variable-sized vector shape.

Use the Magic Wand tool to instantly select the vector shape and the Flood Fill tool to add color, pattern, textures (chosen from the Materials palette) or even a gradient.

Have fun creating your own vector speech bubbles!

Fill speech bubbles to give a real message to any regular photo.

The Preset Shape tool is a powerful and quick way to make almost any size or shape of object for illustration.

Take this one step further, adding drop shadows, bevels and a range of other specialist (filter) effects to make those flat, unexciting shapes something special.

If, for example, you like the shape in one of the presets, but not the color or edge detail, you can edit it using its edit palette. In this respect, vectors are powerful and, with the current fascination focused on the Internet, can prove incredibly useful. One of the few areas of web design growth remains the vector animation area, a topic we'll look at more closely in Chapter 9.

If you need to create your own vector illustrations from the ground up, use the **Pen tool**.

Working with the Pen tool

Pen tool

The **Pen tool** is the ultimate vector shape creation tool. With it, illustrators and graphic designers can create any type of shape, line or layer object they'd care to image. The Pen tool gives you scope to design entire websites; however, because the shapes it creates are formed using vectors, whatever is created remains infinitely editable at all times.

Drawing tools rely on manual brush actions for their accuracy and we all know how silly it is to try and draw with a mouse! It's like sketching with a house brick, only less accurate. The Pen tool allows you to ignore many of the physical limitations of the mouse and to apply extreme linear accuracy to the most delicate of shapes.

The principal driving force behind this is the ability to draw using **Bezier** curves. These are infinitely editable lines that can be used to describe mathematically perfect shapes such as curves and circles. The curves were 'invented' by Frenchman Monsieur Bezier, no less. If you are not into vector illustration then this might not be a tool that you are likely to need but, for the designers among us, it's essential.

Check out the stack of controls provided in the options palette and you'll get an idea of how powerful this tool is. Here are some of its most important features:

■ Draw lines and shapes of any size freehand.
■ Draw a myriad range of shapes using point-to-point techniques.
■ Fill objects with color, texture and transparency using the Materials palette.

On a superficial level the Pen tool works by dropping editable nodes into the picture, whether blank canvas or existing picture. Each mouse-click adds another node that's automatically joined to the previous one with a straight or curved line, depending on the type of drawing implement chosen. Clicking a node back onto the original start point completes the shape. You can add as many, or as few, nodes as needed.

The Pen tool can be used to create new vector shapes and edit existing pictures in a wide range of styles. You can change any aspect of the Pen tool, at any time and in any aspect: thickness of line, color fill, texture, linear aspect, curve aspect and more. Right-clicking displays its principal attributes, which include: **Edit**, **Node Type** and **Transform Selected Nodes**. Using these allow you to perform more than 30 different edit functions.

Uses for the Pen tool

- Creating accurate masks.
- Creating complex vector shapes and illustrative elements using rectilinear or Bezier-controlled lines.
- For creating perfectly curved lines around irregular objects.

Here's how to make a vector illustration:

Step 1. Create a new document with a white background and a resolution of your choice ('File>New').

Step 2. Click the Pen tool icon on the Tools toolbar and open the options palette.

Step 3. From the palette select the Line Style required.

Step 4. Select the line width.

Step 5. Select a line application (Line, Point to point, Freehand).

Step 6. Check 'Anti-alias' and 'Create as vector' boxes before drawing in the document. As you make the first line on the canvas, notice the bounding box – this is there specifically for editing purposes. The handles on the box allow you to rotate, stretch and deform the vector shape without fear of losing detail. If at any time you decide to change the appearance of the line, open the Layers palette, select the vector layer and click the '+' tab. This opens the vector layer to display the individual elements. Double-click the element concerned to open the Vector properties box.

Step 7. Save the vector document as you would a bitmap file.

(1) Creating geometric shapes with the Pen tool is simple. (2) However, the real power of this tool only becomes apparent once you begin to experiment with the Bezier curves. (3) Bending and curving straight lines till they form. (4) Perfect curves.

Note the following:

- Single Line draws just that, a single line.
- Bezier Curve is an infinitely editable freeform line controlled by Bezier technology: grab a controlling handle to bend the line any which way. Bezier curves are ideal for creating seamless freehand shapes.
- Freehand line is the same as drawing on a piece of paper.
- Point to point indicates that the line is applied across two user-defined points.

Working with brush tools

Paint Brush Airbrush
Pencil

Paint Shop Pro comes with a staggering array of brushes, enabling the user to create a range of simple, or incredibly sophisticated, painting tasks. Brush tools introduce the photographer to the concept of original creativity – you can literally make something from nothing using one of PSP's brushes (in the same way that you might with a crayon and a blank sheet of paper).

This is a very ordinary snap of a very pretty rose. There are a number of preset filter effects that I could apply to the entire photo or even to a selection. However, it is also possible to make quite radical changes merely by using a brush on the canvas. (1) Open the photo and enlarge the canvas to add a white border all round the edges. (2) Duplicate the layer. (3) Desaturate the color. Reduce it almost to black and white.

Use the Brush Options palette to change the physical nature of all brushes. Use the Materials palette to choose different brush colors as well as textures and gradients in the brush action. Simply paint over the image to add texture and additional color. Right-click to reselect color whenever needed from the Materials palette.

An advantage of this process is that brushes can be used to add a non-photographic influence to a picture in order to create the illusion that it's something other than a plain old photo.

Brush tools are infinitely variable in terms of size, density, opacity and hardness. Naturally the best results will only be attainable using a graphics tablet rather than with the usual blotches a standard mouse might produce. A graphics tablet allows you to draw, select, erase and paint with the accuracy and delicacy of a real paintbrush, pencil or crayon. OK, it's not exactly the same but it is 100% better than a mouse.

The Paint Brush can be used to add solid or transparent colors, gradients and textures all selected directly off the Materials palette.

Use the brush tools for retouching photos or for combining freehand artwork with a photo. Besides the Paint Brush and Airbrush tools, Paint Shop Pro has a number of other brush-based tools designed specifically for working on a photographic image for the purposes of adding impact. These are:

- **Dodge tool.** Lightens pixels under the brush – good for extracting detail in dark areas of the photo.
- **Burn tool.** Darkens the pixels under the brush. Ideal for increasing density in overexposed pictures.
- **Smudge brush.** Blurs and smudges the pixels under the brush action.
- **Push.** Makes all the pixels behave just like wet oil paint so that they can literally be pushed about the frame
- **Soften.** Applies a localized soft focus effect.
- **Sharpen.** Increases the contrast, and therefore the apparent sharpness in the pixels.

The textured effect can also be applied to the edges to give the viewer the impression that this is a painting and not a digital photo! Work at a lowered opacity to produce a seamless effect. Too fast and the brush marks become heavy and tell-tale, which is not always desirable.

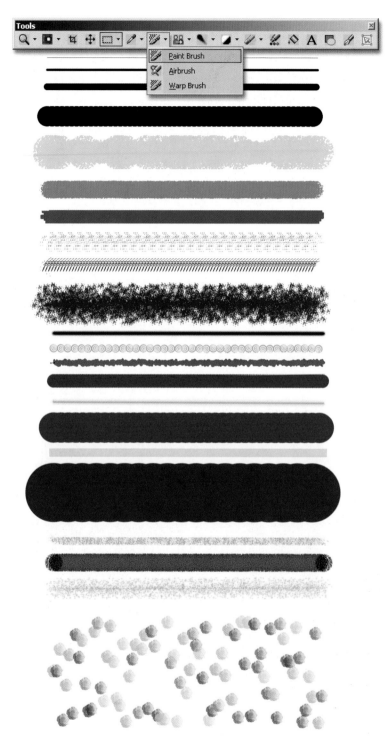

Paint Shop Pro's Paint Brush can produce a staggering array of effects, textures and 'looks' simply by changing its tool set in the Options and Materials palettes.

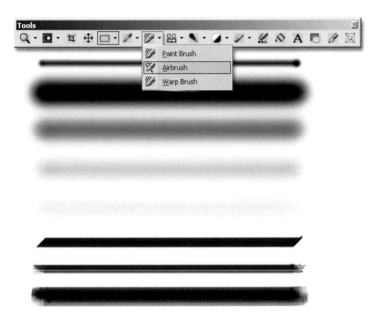

Like the Paint Brush, PSP's Airbrush also has potential for terrific creativity. Once you hit on one combination, record it as a preset for use on other images.

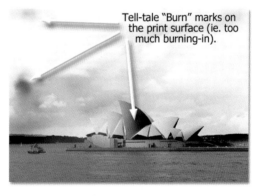

Tell-tale "Burn" marks on the print surface (ie. too much burning-in).

Two of the most important brushes are the **Dodge** and **Burn** tools because, in the form of a brush, you have the power to add (or subtract) exposure to a photo, something that costs a small fortune to have done at a professional photo lab on a film-based print. As you can see, this is a fairly ordinary snap taken in supposedly ordinary weather. I first converted the color picture to black and white by desaturating it. Then I chose the Burn tool and, making sure that I had a low value set in the opacity field (in the tool options palette), I added exposure to selected parts of the sky.

Too much burning produces these tell-tale dark smudges. Back off, reduce the opacity of the brush and try again.

This is what the Burn tool can do for a photo – completely transform an image that would have otherwise perhaps found its way to the trash bin but is now something worth showing to others.

- ■ **Emboss.** Produces a monochrome 3D effect based on edges and contrast in the original image.
- ■ **Lighten/Darken.** Left/right-click acts in a similar fashion to the Burn/Dodge tool.
- ■ **Saturation.** Increases (and decreases) the intensity of the color in the image.
- ■ **Hue.** Changes the color values under the brush.
- ■ **Change to Target.** This brush removes color back to monochrome based on color, hue, saturation and lightness values. A good tool for creating localized special effects and for making quick masks.

Adding basic text

Paint Shop Pro's **Text** tool is used to add text to any type of document, whether photo, vector illustration or scan.

Choose the Text tool from the Tools toolbar and double-click anywhere in the document. This opens the text dialog box. Type what you want in this box, click OK and watch as the text appears somewhere in the document canvas. The program automatically places the text data onto a vector layer in the Layers palette. It remains in a vector format until you need to apply special effects to it. If this is the case, Paint Shop Pro asks you to convert the layer from vector to raster (more on this in the next section).

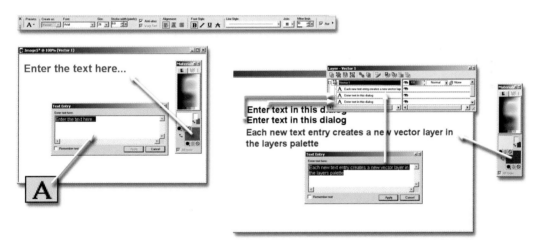

Select the Text tool; click the picture once and type into the text box that appears. Each time this is done PSP makes a new vector layer to hold it. Double-click that layer in the Layers palette to open and re-edit that particular layer. Use the object tool to move or change the orientation of the text in the frame.

Either click the Apply tab in the text box and edit it later or make your changes live in the text box and then click the Apply tab. You can refine this basic text addition process in several ways:

- As new text is being typed it's automatically placed on a new (vector) layer.
- Add as many separate text layers as needed.

■ Use the Move tool to shift the text to get a more accurate positioning (this appears once you move the cursor over the text's bounding box).

■ Use any of the bounding boxes' four corner 'handles' to resize the text in the document. Use the left mouse button to freely resize the text. Use the right mouse button to lock the vertical and horizontal proportions.

Typical text alignment looks like this. Typical text alignment looks like this. Typical text alignment looks like this. Typical text alignment looks like this. Typical text alignment looks like this. Typical text alignment looks like this. Typical text alignment looks like this. Typical text alignment looks like this. Typical text alignment looks like this. Typical text alignment looks like this. Typical text alignment looks like this. Typical text alignment looks like this. Typical text alignment looks like this. Typical text alignment looks like this. Typical text alignment looks like this. Typical text alignment looks like this. Typical text alignment looks like this. Typical text alignment looks like this. Typical text

Alignment:

Left Text Alignment

Typical text alignment looks like this. Typical text alignment looks like this. Typical text alignment looks like this. Typical text alignment looks like this. Typical text alignment looks like this. Typical text alignment looks like this. Typical text alignment looks like this. Typical text alignment looks like this. Typical text alignment looks like this. Typical text alignment looks like this. Typical text alignment looks like this. Typical text alignment looks like this. Typical text alignment looks like this. Typical text alignment looks like this. Typical text alignment looks like this. Typical text alignment looks like this. Typical text alignment looks like this. Typical text alignment looks like this. Typical text

Alignment:

Center Alignment

Typical text alignment looks like this. Typical text alignment looks like this. Typical text alignment looks like this. Typical text alignment looks like this. Typical text alignment looks like this. Typical text alignment looks like this. Typical text alignment looks like this. Typical text alignment looks like this. Typical text alignment looks like this. Typical text alignment looks like this. Typical text alignment looks like this. Typical text alignment looks like this. Typical text alignment looks like this. Typical text alignment looks like this. Typical text alignment looks like this. Typical text alignment looks like this. Typical text alignment looks like this. Typical text alignment looks like

Alignment:

Right Text Alignment

Use the text alignment checkboxes to arrange text left, center or to the right of the box, as illustrated.

■ Use the bounding box's central handle to rotate the text as a block (a spherical arrow indicates the cursor is in the right place for a rotation).

Arial Text 12pt
Chicago Text 12pt
Geneva Text 12pt
Hoefler Text 12pt
Monaco Text 12pt

Times New Roman Text 6pt
Times New Roman Text 8pt
Times New Roman Text 10pt
Times New Roman Text 12pt
Times New Roman Text 14pt
Times New Roman Text 16pt

Naturally Paint Shop Pro comes with a wide range of text types, or fonts. These can be preset to appear in a variety of heights, or point sizes.

■ Use the tool options palette to add a staggering range of sophisticated changes to the text.

■ You can also change the type face, point sizes, add Bold, Italic commands and all the usual formatting instructions to the body text.

■ To change spelling or content to a specific text layer, simply click the appropriate vector text layer in the Layers palette or double-click on the text in the document. Bear in mind that if you need to add effects to the text, the layer needs to be converted from vector to bitmap (raster).

The beauty of working with vector text layers is that they are infinitely adjustable. You can increase or decrease text size at any time with no loss of quality.

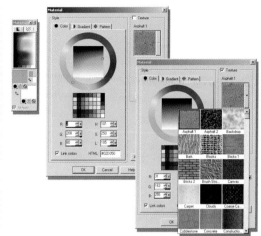

You add extra s p a c i n g to the text. You can even add extra height to vector text layers. If that's not enough, you can also add extra width to the text... Some prefer to include colour, while others prefer gradients or textures. I prefer a drop shadow effects on headings... Embossing is fun, or maybe you'd prefer to add a pattern to create a range of cool text effects?

Text is 100% editable at all times as long as it remains on its unique vector layer. Special effects can be added at any time using the Materials palette and a range of filter-type effects. Some effects might involve you having to render the vector layer to a bitmap state in order to execute the action – this is perfectly OK but is irreversible, so if the text needs to be grossly enlarged after this has been done some quality will be lost.

Alliased type Ugly text 'jaggies' **Anti-aliased type**

Regular text is aliased – something that can, on extreme enlargement, display ugly 'jaggies'. Setting 'anti-aliased' in the text options palette removes this.

Special text effects

TOOLS USED	
Text tool	Cutout
Chisel	Inner Bevel

Now that you have had practice adding text to a picture, you'll want to try adding special effects to jazz up the results. In this section we run through some techniques for making your text look simply stunning.

Special effects?

With Paint Shop Pro you can add a wide range of effects to your text layers. For most actions the vector text layer must first be converted to a raster layer – a warning dialog appears and Paint Shop Pro asks you if this is OK (if you don't want to be asked every time, click the 'Don't remind me' checkbox from the dialog that pops up onscreen).

Special text effects

Cutout

graphics

filter emboss

effect

liquid pixels

Over and above regular text effects, added via the Materials palette, it's possible to add tremendous three-dimensional power using any of Paint Shop Pro's filter effects. To do this you might have to convert the layer from vector to bitmap but still, the resulting effects, as seen here, are very impressive.

Select 'Drop Shadow' from the 'Effects>3D Effects' menu. The opening dialog offers a range of control options: try the randomize tab or simply grab the shadow 'tail' in the window and drag that to the desired point to create the right depth and shadow angle. Click OK.

Drop shadows make a tremendous difference to the appearance of the text. As a general rule, place the shadow under the text and to the right (there are obvious exceptions to this depending on the type of font chosen and its use).

Other 3D Effects for adding impact to text include: **Chisel**, **Cutout** and **Inner Bevel**.

Besides the usual formatting changes that can be made in any word processing program, these would be the most useful for adding impact to your text. If you need to add something slightly more esoteric, then try some of the filters from the 'Artistic', 'Art Media', 'Distortion' or 'Texture' filter

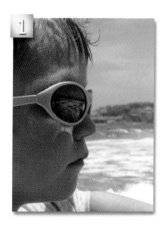

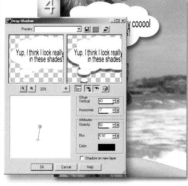
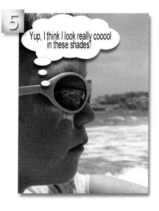

Adding a vector shape and text to a photo. (1) Open the photo. (2) Choose a suitable preset shape from the drop-down Preset Shape Tool menu. (3) Use the handles to reposition and rescale the shape if necessary. (4) Reposition, rotate or flip the vector shape using the Object Selection tool, then choose the Type tool and enter appropriate text in the text box. Press 'Apply' once happy with the size and positioning of the new text. Use Paint Shop Pro's Drop Shadow filter to add an effect to the speech bubble and save as a '.pspimage' file. (5) Alternatively, flatten those layers and save another version of the picture in the JPEG file format so that it can be emailed.

drop-downs. Any of these filters will work on the text layer as long as it has been converted into a bitmap (raster) layer first.

Using filter effects: a warning

Though almost all the filters under the Effects menu will have an effect on raster text layers, not all work well and some may not appear to do anything at all. The reason for this is that the filter action works across the entire frame and not just on the text on its own. If the filter has a global effect then it is more than likely to be seen on the text layer, but if it is of a more random nature, it might or it might not. To make it work correctly you must first select the text and then apply the filter action. Do this by choosing 'Selections>From Vector Object' or use the keyboard shortcut 'Ctrl+Shift+B' and then apply the filter. Most filter combinations will produce an impressive result.

STEP-BY-STEP PROJECTS

Technique: creating a greetings card

TOOLS USED

Layers Guides
Grid

To make a greetings card you'll need one large picture and possibly another smaller snap for the back of the card, an inkjet printer and a few sheets of A4 inkjet paper (preferably photographic quality).

Step 1. Firstly create a new document ('File>New'). Make it the size of the paper to start with (i.e. 210 mm × 297 mm). Select a background color. Most greetings cards have a white base color but that does not need to apply to you! Choose a resolution that's suitable for your printer. Most produce pretty good results at a setting of 200–250 dpi. Set the document in a landscape format (i.e. wider than it is high for a portrait card, taller than it is wide for a landscape card).

Step 2. To make the layout easier, you can use Paint Shop Pro's **Grid** or its **Guides**. Do this by choosing Grid from the View menu. To get the guides displayed, first bring up the Rulers and then,

A4 fold line

Add smaller version of the cover shot on the back and perhaps a caption, address or even a contact number...

Scale picture to fit into this space

A4 layout

Another great photo card from
Amelia James Photography

To assist in the card layout, make extensive use of Paint Shop Pro's **Grid** or, even better, its adjustable **Guides** (shown here in red). Remember to leave room for the centre fold - and for a caption on the front of the card, if appropriate.

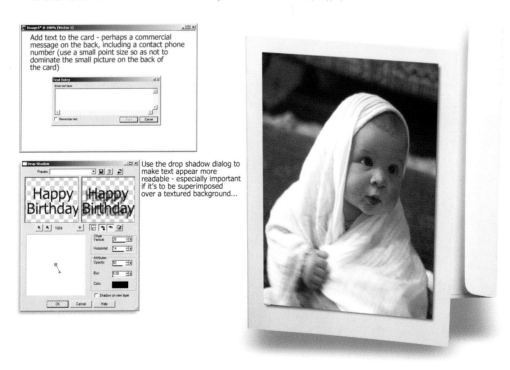

Add text to the card - perhaps a commercial message on the back, including a contact phone number (use a small point size so as not to dominate the small picture on the back of the card)

Use the drop shadow dialog to make text appear more readable - especially important if it's to be superimposed over a textured background...

Paint Shop Pro has a range of tools designed to assist in the creation of projects like business and greetings cards. Guides especially help in lining up objects, text layers and pictures. The beauty is that though they are visible to the designer, they do not print.

clicking in the ruler margin, drag the guides one at a time onto the canvas. To change the color and the pattern of either, double-click the ruler margin to bring up the tool dialog.

Step 3. Now open the main photo and, if color and contrast are to your liking, select it all, copy it, click once in the new document and paste the clipboard contents into the document as a New Layer. Your new document should now have two layers in it (open the Layers palette to check).

Step 4. Open the second, back of card picture and repeat the actions in Step 3, pasting the second image into the master file. Save this as 'card01' or something similar.

Step 5. Set the guides so that you have an edge marked out, a center line and a top for positioning purposes. Remember, neither grid or guides will appear in the print. They are there for assistance only and remain invisible to the printer. Choose the Deformation tool and adjust the size of the main picture elements so that it fits the right-hand half of the document. Repeat the deformation action on the second photo. This is there as a signature image – it can be your portrait or an image that is common to all your cards and invitations or you can change it with every creation. Most top-of-the-line greetings cards have a similar design, although you can of course make your own should you wish.

Step 6. Now that the two pictures are in position we are ready to add text. Choose the Text tool and add the copy to the main picture. This might be a simple Happy Birthday or Thanksgiving or you might want to add a more personalized, humorous or just plain silly header (I usually go for the latter!). Easy enough to do but hard to keep readable if it is laid on top of the photo. To fix this, either make the main picture smaller, the text larger, add an effect like a drop shadow or, as a final touch, you might want to drop the text into a flat-colored box to separate it from the background.

Step 7. Once satisfied with the main copy, add your own text to the back of the card, such as 'Another great masterpiece from the camera of Robin Nichols' or something equally modest, and run it in small text under the postage stamp photo on the back.

Step 8. Now that all the components are assembled into the one document, save it and print it onto a sheet of regular photocopy paper to check the positioning of the card. If it is possible, set the printer to print the image in the center of the paper. Also check the driver and click the fit to page setting to make it print to the edges. I find that printing on photo-realistic paper works especially well, but for the 'genuine look', try one of the many textured inkjet papers on the market. These produce a far nicer result (in most cases) and can be folded more easily.

Now all you have to do is find an envelope that fits!

Technique: combining text and photos to make a calendar

Making your own calendar requires a higher degree of skills level because we are not only using a greater number of photos but we also have to use, and layout, text in a very precise manner. In this exercise we'll be using Paint Shop Pro's **Grid** and **Guides** tools.

Step 1. Create a new document to the required size of the calendar. (As most of us only have an A4 printer this is a good place to start – although you can make equally good mini-calendars to A5 proportions.) Set the optimum resolution for your inkjet printer (this might be anything from 200 to 250 dpi) and choose a white background (this can be changed later to another color or a texture if you wish).

The trick in making calendars is to assemble all 12 months into the one (large) document and then to print only selected layers at a time (a group for each month).

Step 2. Choose Rulers and Guides from the View menu and drag guides to the required layout positions. To make this function better, make sure that the 'Snap to Guide' function is 'on'.

Note: It helps to have all 12 monthly pictures sized to the same resolution and proportions before you proceed (although it is possible to resize each on its own layer using the Deformation

Create a blank white A4 canvas. Choose a suitable typeface for the months and days in the calendar.

Enter the dates, adding spaces and returns to tabulate the data for the correct layout.

Enter the days of the week as a separate layer so that a drop shadow can be added.

tool). As the final file size will be large (and therefore the computer might slow down noticeably), you might want to resize before importing pictures to the master file.

Step 3. Open the picture slated to be the January pin-up, select it all ('Selections>Select All' or 'Cntrl+A'), copy it into the clipboard ('Cntrl+C') and then paste it into the new document as a New Layer ('Cntrl+L'). Double-click the layer as it appears in the Layers palette and rename it 'January picture'.

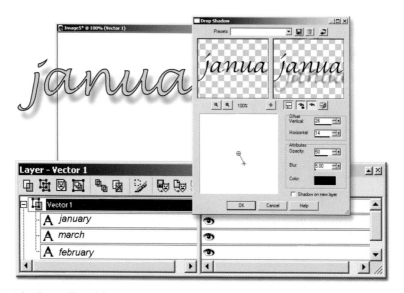

Add the drop shadow effect (if required).

Step 4. Repeat this performance for all remaining months, creating a new layer for each month.

Step 5. Now design the calendar dates. You have two options: either make a scan from an existing commercial calendar (this shouldn't infringe copyright unless the specific design or images are copied as well). All we are interested in are the numbers. If there's any doubt, don't make the copy and proceed to the second choice, which is to enter the text dates yourself.

Step 6. Use the Grid feature to position the days of the month into a regular grid layout on a new vector layer placed into the appropriate layer group for that month. Use the **Kerning** feature (in the

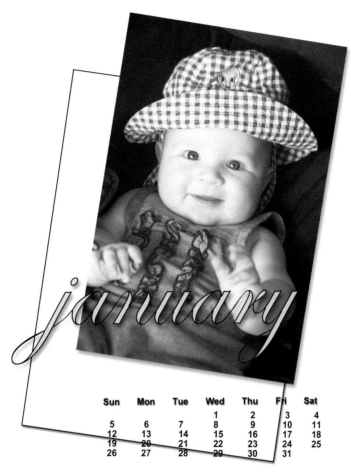

Sun	Mon	Tue	Wed	Thu	Fri	Sat
			1	2	3	4
5	6	7	8	9	10	11
12	13	14	15	16	17	18
19	20	21	22	23	24	25
26	27	28	29	30	31	

Open the photo for that month and add that to the document. Repeat for all 12 months and save as a '.pspimage' file in case it requires editing at a later stage.

text options palette) to spread the numbers further apart from each other and the **Leading** feature to add space between each new line. Although these formatting changes don't physically appear in the text box, they'll appear 'live' in the document so keep an eye on the positioning so it can be repeated for the next month, and so on.

Step 7. On a separate vector text layer in the appropriate layer group, add the month using another typeface or point size, depending on the design required.

Step 8. Repeat this performance for all 11 months with the appropriate layer names. You should now have 12 groups of layers for each month: a January picture layer, a January text layer and a January dates layer (one raster and two vector layers). It's important to name everything, otherwise you'll become confused when printing the calendar months.

Step 9. Using January as the 'base' month, switch off all other layers by clicking the visibility eye icons in each layer. Now check that the alignment is consistent with all layers by switching each month on and off to see if it sits directly over the layer (January) beneath. Use the Move tool to rearrange the position of any layer that's not in its right place.

Step 10. Now comes the fun bit! Even though you have all 12 months stacked into a very large 'master' document, Paint Shop Pro will only print those layers that are visible. Switch everything 'off' and print the month of January (i.e. all three January layers together).

Step 11. Switch January off, switch February on and print that. Repeat this procedure for all 12 months.

Step 12. Use an office services bureau to coil bind the calendar for the final touch. You might want to add a cover sheet with all 12 images displayed as thumbnails and a front page. Service bureaus normally supply a choice of backing and cover sheets for a minimal extra charge.

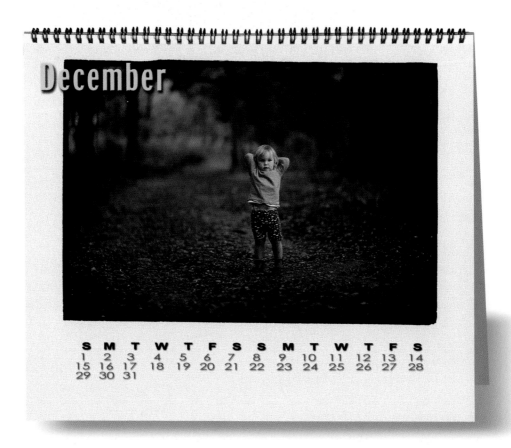

Most local office supplies businesses will be able to add coil binding to the calendar for the final touch.

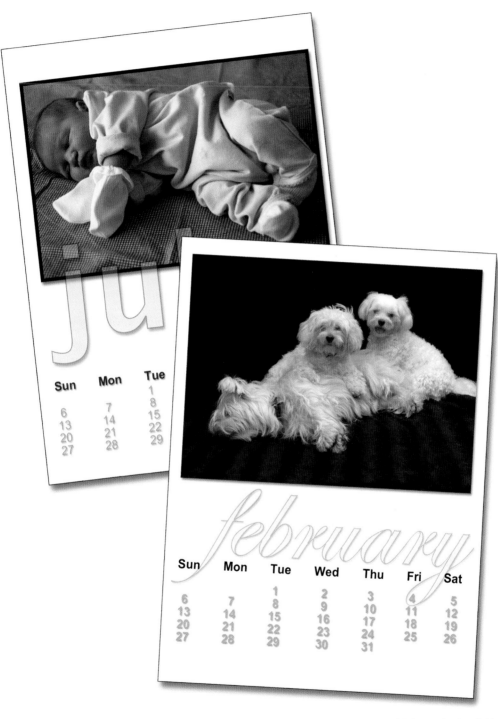

The easiest way to make a calendar is to print it using an inkjet printer. Use high-resolution inkjet paper, as this is very fine-detailed, yet still quite thin so as not to add weight to the product, especially important if the calendar is to be posted.

7

Manipulating Images:
Creating Special Effects

n this chapter, learn how to add special effects to your digital photos with a range of powerful, easy-to-use tools.

TECHNIQUES COVERED

Applying filter effects
Creating paint, sculpture and cartoon-like filter effects
Using digital lighting studio effects
Having fun with the Picture Tube
Improving the appearance of downloaded web pictures

Making a panorama using layers and tone adjustment controls
Preparing photos for cutting out of a background
Special negative image effects
Using the Materials palette
Using the Color Replacer tool
Working with the edge frame dialog

TOOLS USED IN THIS CHAPTER

Balls and Bubbles filter
Color Replacer tool
Deformation tool
Desaturate brush
Expand command
Flatten (command)
Halftone filter
JPEG Artifact Removal filter
Layers
Lighting effects
Magic Wand (selection tool)
Match modes
Materials palette
Merge (command)

Move tool
Opacity
Offset filter
Page Curl filter
Picture Tube
Picture Frame
Polar Coordinates
Saturate
Sepia Effect
Selection Modify tools
Seamless Tiling filter
Soft Focus filter
Spherize
Tolerance adjustment

Creating a panorama

Panoramas are a great way to stretch your creativity, both through composition and all-over picture potential. So, what exactly is a panorama and what special gear is needed to make them?

A panorama is essentially nothing more than a group of pictures joined together, seamlessly, into one wide (or high) picture. Panoramas generally begin with more than two frames but can be constructed from up to ten or more individual photo elements. How many you use for the panorama is dependent on how much detail is required in the frame. Once the components have been shot, they are then stitched together using Paint Shop Pro and then its tone adjusted for maximum picture impact.

Tips on shooting panorama components

- Use a **tripod** or other stabilizing device for shooting your panoramas. It's important to keep the camera absolutely level at all times, otherwise the panorama segments won't stitch together correctly.
- Lock off the camera exposure meter (using its AE Lock feature) so that every component is exposed at exactly the same value.
- Lock off the focus (using the AF Lock function) so that each frame is focused to the same distance point.
- Overlap each panorama frame by about 20–30% to ensure that it all fits in the master document.
- Remember that a panorama need not be horizontal – you can also make neat vertical panoramas.
- Because of their wide, all-encompassing nature, panoramas need to be composed very carefully to include sufficient foreground interest.
- It is possible to hand-hold the camera when snapping panorama components but extra care must be taken to get the level right.
- Ensure that the camera rotation is around the **nodal point** of the lens, where possible. (Check the Internet for further information on estimating the nodal point for your camera model.)

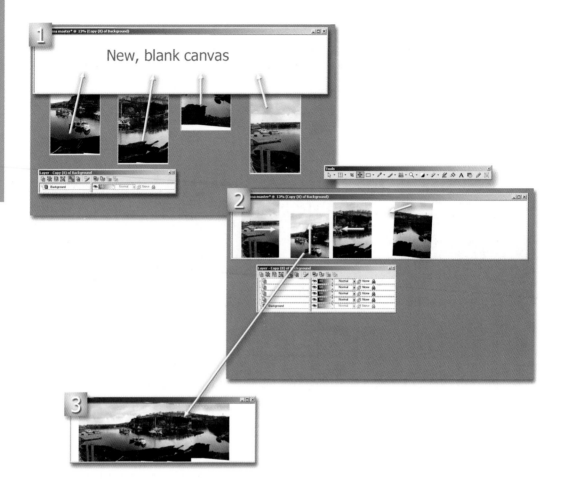

Step 1. Once you've made all your exposures, import the lot into the computer, open Paint Shop Pro and create a new, blank canvas to the desired panorama proportions ('File>New'). It doesn't matter if it is too large – it can be cropped at a later stage.

Step 2. Find and open the panorama components. Copy each one and paste it into the new document. Try to keep the order of pasting the same as the order in which the elements were shot (i.e. left to right or right to left).

Step 3. Choose the layer on which the left-hand panorama segment sits and, using the **Move** tool, drag it over to the left-hand side of the frame. Choose the second-to-left layer and, after reducing its opacity (in the layer palette), move its left edge slightly over the right-hand edge of the first frame to get an exact fit. Jiggle the opacity slider so that you can see through one layer to the layer beneath to make this process easier and then, once it's in position, return the opacity to 100%. Repeat this

process for all remaining panorama components. You may find that some have been shot on a tilt, especially if the panorama camera was hand-held and not mounted on a tripod. If this is the case, use the **Deformation** tool to straighten out the uneven horizon on that particular layer.

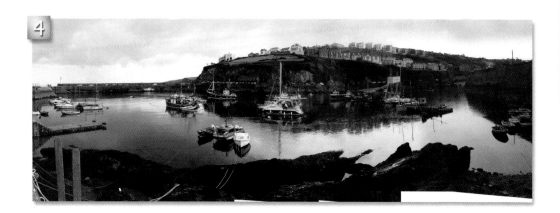

Step 4. Once the entire set of frames (components) have been overlapped successfully and all opacities are the same, save the file as a copy (i.e. keep one file as a 'Master file').

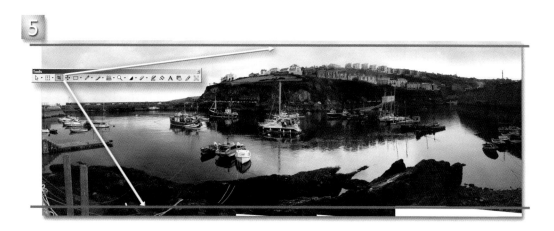

Step 5. Check that the density and the color values for all layers are the same, otherwise you might find that, even though the exposure was 'locked off' at the shooting stage, some frames are still darker or lighter than others. Use the **Color Balance** and **Histogram Adjustment** tools to make these tone corrections if necessary. Choose the **Crop tool** to cut off the extreme edges of the frame if there's a noticeable mismatch with the component segments (as in the bottom of this illustration).

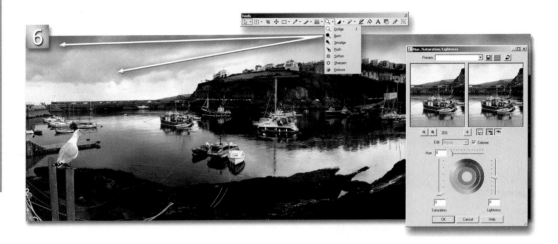

Step 6. Flatten the layers in the copy ('Layers>Merge>Merge All'). (Note that doing this loses most of its editability.) Now you can use the photo-editing program to adjust the global color and contrast values in the panorama to get the entire photo that way you really want it to look. Consider, at this stage, using one of PSP's darkroom tools to increase (or decrease) the density/color in selected parts of the scene using a brush.

Step 7. Save the panorama.

This is the final, cropped and color-balanced panorama.

Cleaning up web pictures

TOOL USED

JPEG Artifact Removal filter

All digital pictures suffer from **artifacts**. These are imperfections caused by physical shortcomings in the technology used to create, save and store digital pictures.

Artifacts are introduced to a photo when it has been over-compressed. Why do this? Most digital cameras save pictures in the JPEG file format. This operates by compressing digital photo data so that, among other things, it can be downloaded quickly in a web browser or so that more pictures can be crammed onto a flash card. On saving a JPEG file, the software often discards too much data in order to make the picture physically smaller for storage or transmission. When it's opened (expanded) again, the technology fails to rebuild the original picture data perfectly. The result can be blocky lines in flat areas of tone and often an ugly halo around contrast edges. It can be most unsightly, especially when this open and resave process is repeated a few times.

If you work with files that display this kind of image defect, Paint Shop Pro has a specific filter designed to reduce this kind of distortion, called the **JPEG Artifact Removal filter**.

How does it work? Select the filter from the 'Adjust>Add/Remove Noise' menu (or from the Photo toolbar) and adjust the Strength (of the filter) and the Crispness values (amount of remedial sharpening applied). You might not have a clue about these settings, so use whatever comes to mind, or try the Randomize button.

The beauty of this process is that there's always plenty of room to experiment. Note also that enhancement filters always soften the picture. Because of this it's often necessary to reapply some

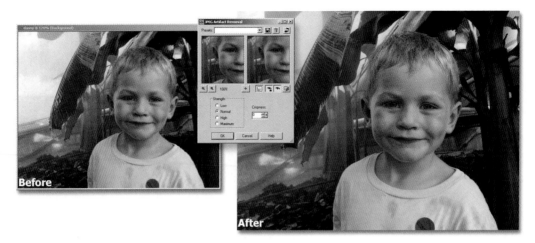

The JPEG Artifact Removal filter is excellent at smoothing out some of the more obnoxious artifacts and 'jaggies' that JPEG compression introduces into web photos. Used too much and the picture appears very soft. Care must also be taken not to add too much 'crispness' as this also adds its own noise problems. A good balance between the two can save an otherwise damaged file.

of that sharpness, either using the Crispness field or even by applying one of PSP's specialist sharpen filters.

Though this is an excellent filter tool, too much ('Strength') might over-soften the image and too much sharpening ('Crispness') might reintroduce an ugly grittiness to the final result.

It's up to you to find a good balance for each individual picture.

Replacing the background in a photo

TOOLS USED

Magic Wand	Expand
Match modes	Selection Modify tools

In this section we look at Paint Shop Pro's impressive selection of modification tools and how these can be used to make pictures ready for publishing in the printed page or on the Internet.

Deep-etching or making a **Cutout** is a printer's term used to mimic, with film, the process of cutting an object from its background for the purposes of placing it in another background or picture. In the old, pre-digital days, this was performed lengthily with negatives, positives and a lot of very messy red opaque masking paint. Now it's easier, quicker and considerably less messy using Paint Shop Pro's Selection Modification tools.

Product photography selection problem
areas: background too dark; shadows too
deep; dirt, tears and marks on background
paper, etc.

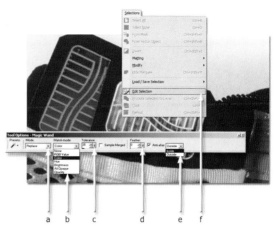

Using the Magic Wand tool, check the Options
palette to modify how the tool works. (a) Replace
mode. (b) Match mode. (c) Tolerance. (d) Feather
amount. (e) Inside/Outside selection area. (f) Check
the Edit Selection mode to highlight (and further
edit what the Magic Wand has 'grabbed').

Select Color Range allows you to
make a selection based entirely on
its color.

Remove Specks and Holes. If the
initial selection leaves 'holes' in the
mask, use this dialog to clean them
up – or fill them in. It works a
treat.

Smooth Selection. If the selection edge is a bit rough and ready, use this dialog to straighten it out. Again, set a small pixel value and watch as it smoothes out jaggy lines.

Expand Selection. If the selection is too tight onto the subject, use the Expand dialog to enlarge it.

This is the final, selected and cutout version – showing the Feather and the Contract Selection dialogs. Feather softens the selection edge using a diffusion or 'feather' value, while Contract reduces the circumference of the selection by a controlled pixel value.

Refining the Magic Wand tool

Paint Shop Pro's **Magic Wand** tool is one of the most versatile for deep-etching pictures because its options are highly controllable and the resulting selection can be completely edited using the program's **Modify** features.

The Magic Wand tool's edge-seeking properties can be fine-tuned through its options palette using a number of variable selection parameters called **Match Modes**. These include: 'RGB Value', 'Color', 'Hue', 'Brightness', 'All Opaque' and 'Opacity'.

To refine the edge-seeking action, you can also have fun using the adjustable settings for how sensitive its pixel search is (called the **Tolerance**) and how hard that selection line appears (called the **Feather**), as well as an **Anti-alias** mode which softens the zig-zags in 'straight' lines.

The Magic Wand is easy to use, though somewhat harder to use well. If you click anywhere in a photo with this tool it will automatically make a selection based on the parameters set in the options palette. Initially this might be OK; however, more often than not, it'll only be partially accurate. Generally what happens is that too many, or too few, pixels are grabbed, resulting in only a partial selection.

Tip

If your first click-selection is only partial, hold down the Shift key and click on an unselected area. **This adds to the current selection**. You can also select 'Add' from the options palette if you don't want to hold the Shift key down with every mouse click.

Tip

Save your selections regularly ('Selections>Load/Save Selection>Save Selection To Alpha Channel'). An alpha channel is a black and white channel used specifically for storing mask data. Selections can be used again and again and can even be transferred from one document to another ('Selections>Load/Save Selection>Save Selection To Disk'). Choose 'Selections>Load/Save Selection>Load Selection From Alpha Channel' to activate the saved selection once again, either in the same document or 'Load Selection From Disk' for using it in another document entirely.

The skill required for pushing this tool to its maximum performance is in identifying the type of tone that's going to react best to the selected Match mode. To put it another way, if you have a red packet of soap powder shot on a pure blue background, you'd select 'RGB Value' and a reasonably high tolerance value to get a one-click selection because the tool can easily lock onto a single color. Of course nature, and advertising, is never so convenient – another good reason why Jasc supplies an adjustable tolerance value to enable you to be more critical about the degree of color

'hunted' when choosing a selection edge. If the red packet had a large white logo bleeding off to one side and a pale pink top, for example, you'd have to adjust the tolerance values down to bring those extra tones within the selection parameters.

Once you have tried this technique it becomes easier to judge a picture and to assess the correct Match mode and tolerance levels required to make the best single-click result. Inevitably there's never a one-click answer for any picture unless it's been specifically shot for deep-etching. If you can restrict your selection techniques to only a few mouse-clicks, results will be faster and more accurate.

Once you have the subject perfectly selected, save it and press the Delete key. This removes the pixels in the selection and replaces them with whatever is selected as the background color in the **Materials palette**.

Once the product is deep-etched you can add a different background. This might be a flat color, a texture, a combination of both, or another picture. It can also be copied and pasted into a second document ('Paste as Layer', 'Paste as New Selection' or 'Paste as New Image').

Tip

If the background is cluttered, making it hard to create a clean selection, consider selecting the subject rather than the background. Once the subject is cleanly selected and saved, **invert it** and again remove the background ('Selections>Invert').

Tip

Most photographers can make the deep-etching process less painful by shooting the product on a plain, featureless background. Plan ahead and you'll significantly minimize the time spent sitting in front of a computer.

Selection lines, regardless of the tool that produces them, are razor sharp. While this might work OK for some instances, it won't suit all. You can soften the selection line by using the **Feather** controls in the tool options palette. The default feather value is zero. Change this to a value of five or higher and the selection line becomes slightly blurred (over a five-pixel width). Change this to a higher value and the selection becomes warm and distinctly fuzzy! You can use feathering as a simple vignetting device when cutting and pasting elements from one picture into another. It can also be simply used to camouflage the fact that any digital black magic has been going on in the picture!

Pressing 'Shift+Cntrl+M' hides the selection marquee so that you can concentrate on the effect being applied, rather than seeing that off-putting 'marching ants' selection line. Don't forget that the selection is still active when you try to do something else – and it doesn't work!

Fine-tuning your work

Selections can be modified at any time. If you are deep-etching a product to place into another picture it's common enough to see a dark or light line around that selection. This is caused by not having the tolerance value set low enough, or even by the lighting used to illuminate the subject originally.

Paint Shop Pro has a fantastic range of Selection Modification tools that make the job of perfecting a selection simpler and far more professional than most other products.

Click 'Selection' and choose from one of the many 'Modify' commands in the following drop-down menu. These include:

- **Expand.** This expands the entire current selection a pixel (or more) at a time.
- **Contract.** Works in the same manner as Expand, but in reverse. Very handy for reducing the impact of a white or black line around a selected object.
- **Select Similar.** Adds similarly colored pixels in the image to the selection.
- **Select Color Range.** Permits you to elect a color that's then added to the selection currently being worked on.
- **Feather.** Spreads the selection line over a preset pixel width, with the effect of dramatically softening the normally sharp selection line.
- **Inside/Outside Feather.** Another sensational addition to PSP's Selection Modification tools. This controls whether a feather is soft inside or outside of the line, or (as is normal) both.
- **Unfeather.** Allows you to modify the feather back to a previous, supposedly lower feather value.
- **Shape-based Anti-alias.** This modify tool is used to further soften the 'jaggies' often associated with linear selections.
- **Recover Anti-alias.** Reverses this process.
- **Remove Specks and Holes.** This has got to be the best Modify tool of the lot! Especially if you have used the Magic Wand tool and the entire canvas is covered in tiny selection 'holes'. Dial in the right tolerance level and everything that shouldn't be there vanishes. Modification magic!
- **Smooth.** This is a really useful way to fine-tune the finicky selection line that seems almost impossible to get really 'neat' and, well, smooth.
- **Select Selection Borders.** Used to separate one part of a selection from another with a border that has an adjustable width.

If these tools aren't enough, Paint Shop Pro gives you a number of other options that include **Defringing**, **Remove White** and **Remove Black Matte** (from around the selection).

Editing the matte

If you are into making selections you'll love the **Edit Selection** mode, accessed through the 'Selections' drop-down menu or by clicking the appropriate tab on the Layers palette.

If you have started a selection but feel that it needs reshaping, click the tab and note the red opaque layer that covers the currently selected area. This is similar to Photoshop's Quick Mask mode (although there's no corresponding keyboard shortcut).

The red mask is a flat color representation of the selection area. Use any paint or drawing tool to add to the red mask or choose an eraser tool to remove from the mask. Click the Edit Selection tab again to return to regular selection mode. The trick with this feature is to flick between modes using the various paint tools till the selection is correct. It's a fast and an accurate way to edit your work.

Using the Materials palette

TOOL USED

Materials palette

One of the most used palettes in Paint Shop Pro is the Materials palette. This is where you go to change the colors used in any of the program's paint or drawing tools. In this section we look at how the Materials palette can be used in the creation of special effects and how it's used for mixing colors.

Choose the Materials palette from the 'View' menu. There are two modes in which to work with this tool: Colors and Swatches.

Color displays a continuous tone color palette, while the Swatches tab displays colors in easier to click squares or tabs. Use the former as a default but use the latter if you prefer to work on the

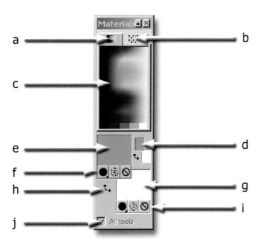

(a) Color toggle. (b) Swatches toggle. (c) Color picker. (d) Click here to swap foreground with background colors. (e) Current foreground color/texture/material/gradient pick. (f) Click the black circle to change the Color/Gradient and pattern selected. Click the middle circle to change the texture and the right-hand tag to add transparency. (g) This is what is chosen as the background fill color. (h) Swaps foreground and stroke properties with background and fill properties. (i) Click the black circle to change the Color/Gradient and pattern selected. Click the middle circle to change the texture and the right-hand tag to add transparency. (j) Check this to apply your changes to All tools.

Web and Internet. If I'm working on a limited palette, I find Swatch mode simpler to use (choose from) because you can make your own swatches. In many ways it's faster and more accurate to work with.

The two smaller squares to the base of the palette (or side, depending on how it's docked) influence the **foreground** and **stroke** colors, while the lower palette represents the background and fill colors. On these two palettes there are three drop-down choices: Color, Gradient and Pattern. To these three modes can be added texture **or** transparency. Selecting any of these with a brush means that you can add any of those features to the canvas. The combination possibilities thrown up by these options are enough to cover every painting combination possible.

Double-click either of the larger squares to open the color picker. Use this to choose more colors, to edit the displayed colors and to modify the gradient or texture.

■ Use the swap tabs: the two tiny squares indicate colors currently selected as foreground and background. Click the two-headed arrow to swap between the two.

Top left: Click once in the color picker to set the foreground color and paint. **Top right:** Click again elsewhere in the picker to change the color in the brush. **Bottom left:** Clicking the circular tab at the base of the foreground color checkbox accesses the gradients, all of which can be edited. **Bottom right:** Use the central circular tab to choose a texture for the brush.

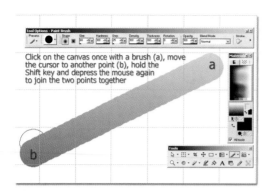

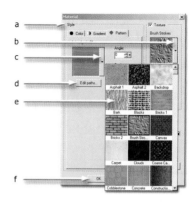

To draw a line between two points, mouse-click once, move the cursor to the end point and, holding the Shift key, mouse-click again.

(a) The newly integrated Style palette. (b) Click this menu to view the texture choices displayed (e). (c) Click this tab to choose new patterns. (d) This allows you to define the path to the pattern files. (e) Textures available. (f) Once happy with choice and edit status, click OK.

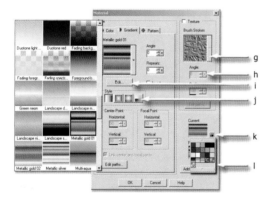

(g) Clicking here displays the textures on offer. (h, i) These give great edit power if the selected pattern/texture is not right for the drawing involved. (j) Change the gradient style here. (k) Click this small tab to bring up the color palette (l).

This is what a brush stroke looks like with a wood grain texture applied.

- Click any of the three tabs at the base of the foreground/background color boxes to choose Color, Gradient or Pattern.
- Click the spotty tab to add texture to the paint strokes.
- Click the right-hand tab to add transparency to the brush.
- If you are happy with a particular combination in the palette, click the 'All tools' checkbox to lock it off and to apply the settings to all the tools.

Color gradients are also easy to add and draw.

Add a texture to give an extra dimension to the brush power.

Applying filter effects

TOOLS USED

Filter sets

Photo-editing software is used to improve the look of digital pictures. Most contain **filter sets**. These are pre-recorded visual effects that can be applied to a picture at the press of a button (OK, at the press of two buttons).

This is what the filter Effect Browser looks like. You can make it display a thumbnail of every filter in Paint Shop Pro, or you can be a bit more specific by choosing filters from individual subsets. Double-click the window that you like the look of to apply that filter to the picture open on the desktop.

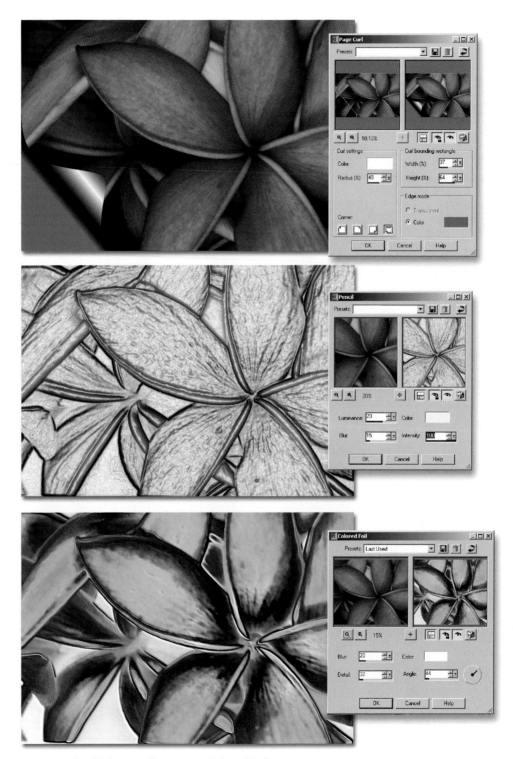

Top: Page Curl. **Middle:** Pencil. **Bottom:** Colored Foil.

Paint Shop Pro has many filters, designed not only to improve the quality of your work but also, in some examples, to radically change the nature of the picture. For example, you can increase or decrease color, contrast, hue, sharpness and even black and white tone in a photo at the press of a button. These filters are regarded as 'standard issue' for most photo-editing products. Paint Shop Pro also has a range of creative and esoteric filter effects that are used to change the nature of a picture from a photo into the appearance of something different, like a drawing, painting or even a sketch. In fact, with a bit of patience, you can create almost any type of special effect you'd care to think of, such is the power of the software filter set.

Tip

Many criteria come into play to influence the success or failure of a software filter effect. Factors include the quality, focus, color and contrast in the original snap. Don't use a filter to mask the fact that the snap is no good – because the filter effect will invariably be no good either!

Paint Shop Pro has dozens of filters. The program is also compliant to a range of plug-in type filters. These are manufactured by third parties, like **Flaming Pear** and **Auto F/X**. These are loaded into the Effects menu just as if they were original Jasc-designed products.

Most of Paint Shop Pro's filters are subdivided into types under the Effects menu. These include:

- 3D Effects (6).
- Art Media Effects (6).
- Artistic Effects (16).
- Blur Effects (5).
- Distortion Effects (12).
- Edge Effects (8).
- Geometric Effects (8).
- Illumination Effects (2).
- Image Effects (3).
- Reflection Effects (4).
- Texture Effects (15).
- 'User Defined'.

You'll also find more filters under the Adjust menu. These include:

- Lens Correction (3).
- Noise (10).

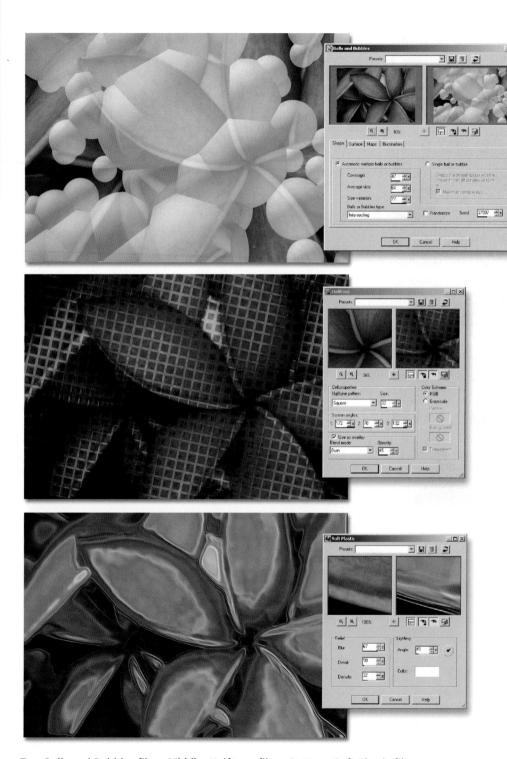

Top: Balls and Bubbles filter. **Middle:** Halftone filter. **Bottom:** Soft Plastic filter.

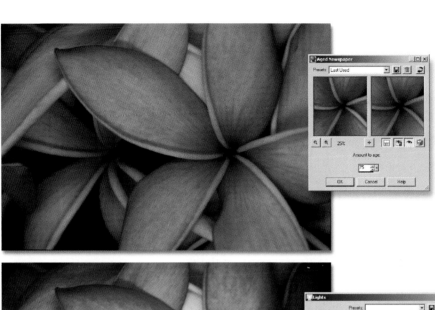

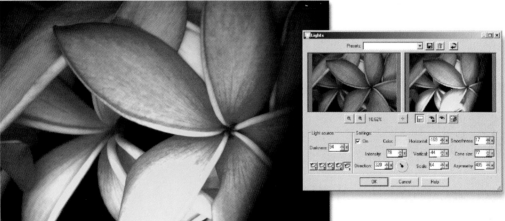

Top: Aged Newspaper. **Middle:** Lights. **Bottom:** Black Pencil.

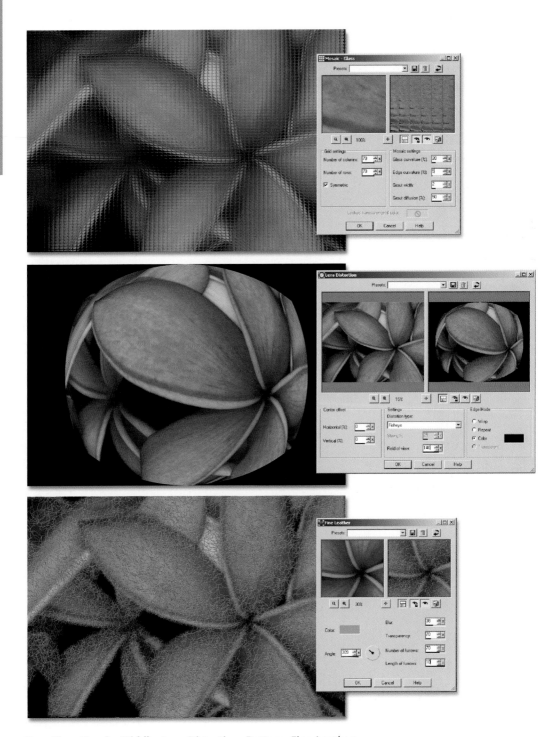

Top: Glass Mosaic. **Middle:** Lens Distortion. **Bottom:** Fine Leather.

- Blur (5).
- Sharpness (3).
- Softness (3).
- Red-eye Removal.

There's also a powerful filter **Effects Browser.** This previews all the filter effects as thumbnails so that if you've no idea of what to use, you can make an educated, illustrated guess.

Each filter subfolder contains specific effects that can be applied to any picture **globally,** to a **layer** in that document or to a specific **selection.** For example, Art Media filter effects include: 'Black Pencil', 'Brush Strokes', 'Charcoal', 'Colored Chalk', 'Colored Pencil' and 'Pencil'. Select any of these and the dialog that appears offers further refinements to the filter action. Some are quite straightforward while others have a comprehensive range of controls.

Tip

Because Paint Shop Pro has so many possible filter combinations, its preset button is there to record the values from any effect so that it can be replayed on other images at a later date.

Tip

When using software filters, try to avoid eliciting the 'Oh, he's used a filter . . .' type reaction. Don't over-apply filter effects. If the picture is strong enough, it should not be necessary.

What's the 'correct' use of a filter? I try to go for the subtle use although, in some cases, blatant can also work quite well, especially if you need to change the nature of the entire picture.

What pictures work with filters?

The simple answer to this is all pictures. You can turn sweeping landscapes into Turners, Still Lifes into a van Gogh and sleepy interiors into illustrations for a Guggenheim catalogue. Well almost, but you get the (unfiltered) picture.

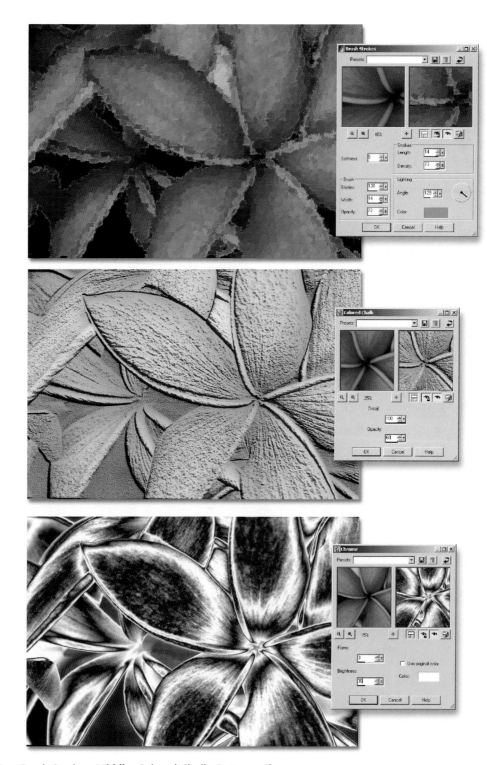

Top: Brush Strokes. **Middle:** Colored Chalk. **Bottom:** Chrome.

Hot filters to try

- Balls and Bubbles.
- Brush Strokes.
- Cutout.
- Charcoal.
- Halftone.
- Trace Contour.
- Offset.
- Glass Mosaic.
- Soft Focus.

New to Version 8

- Balls and Bubbles.
- Drop Shadow.
- Halftone.
- Lens Distortion.
- Offset.
- Page Curl.
- Polar Coordinates.
- Seamless Tiling.
- Soft Focus.
- Spherize.

STEP-BY-STEP PROJECTS

Technique: having fun with the Picture Tube

TOOL USED

Picture Tube

For the professional photographer Paint Shop Pro's **Picture Tube Tool** is one of the weirdest around. What does it do? The Picture Tube literally 'pours' pictures out of a tube onto the canvas.

Using graphics and photos as 'liquid paint' rather than flat color is an interesting concept, but it's one of those esoteric type tools that's almost impossible to find a proper use for. Unless, of course, you create your own specific Picture Tube files.

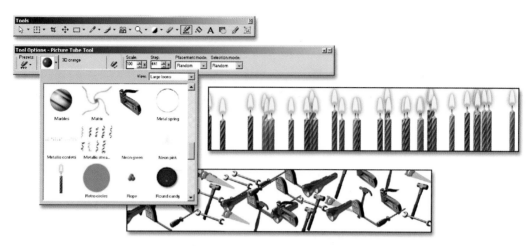

Use the Picture Tube to have fun, create borders and even to decorate artworks destined for the inkjet printer.

Picture Tube applications

- Creating fun effects.
- Cool edges and borders for pictures.
- Making unusual picture frame effects.
- Entertaining your kids (and yourself).
- Creating textured backgrounds.
- For adding specific, custom views to a picture (such as image grain, noise and even textures).

The Picture Tube icons can be different sizes and randomness. Shift-clicking creates a point-to-point straight line.

How to create a Picture Tube file

Step 1. Open the pictures chosen to be in the set, ensuring that they are dust-free and clear from JPEG artifacts (use PSP's **JPEG Artifact Removal filter** to do this). Ensure that all pictures are a similar resolution and physical dimension.

Step 2. Create a new document ('File>New') with a transparent background to accommodate the picture elements. For example, if you are making a four-image picture tube, set the fields to 800 pixels wide and 200 high. Choose 'transparent' as the background color and then click 'OK'.

Step 3. Open Paint Shop Pro's Rulers palette ('View>Rulers') and drag the guideline to the 200 pixel mark. Drag another to the 400 pixel mark and a third to the 600 pixel mark.

Step 4. You should now have a document with a transparent background (a checkbox pattern indicates transparency) with colored grid lines dividing a long wide frame into four sections. Copy and paste the four pictures into this document. At this stage it's a good idea to save a copy of the file in case the resulting tube is no good. Give it a unique name and save it as a '.pspimage' (layered) file for later use.

Step 5. Merge all the layers ('Layers>Merge Visible') that Paint Shop Pro has created (don't flatten this as it will produce a default background color which is not required at this stage). Once merged, the four pictures should be sitting on a single layer that has a transparent background.

Step 6. Select 'File>Export>Picture Tube' and another dialog opens. Enter the amount of cells that you have made for the tube (in this case, four). Make a unique name for the tube and click 'OK'. To test the tube, create a new document with a white background (any size and resolution will suffice) and select the Picture Tube Tool. Open its options palette and, after pressing the image selection tab, scroll through the preset tube files to find your alphabetically-placed file. Select this and paint away to test the tube.

You'll soon discover whether the selections you made, the scale of the images and their colors are attractive or not. If you are not happy with the result it's simple enough to open the '.pspimage' version again, make changes, save it over the previous tube file and try again.

Tip

In the Picture Tube Tool options palette, you can control the **Scale** of the picture tubes, its **Steps** and the **Frequency** of their placement and selection modes (how they are placed from the file).

You can use the Tube to create cartoon-like effects. Download new tubes from Jasc's website.

Another use for the Tube is to create 'edgy' backgrounds for website projects. Lower the opacity on the layer so that text can be read more clearly over the top.

By setting the randomness to a high value and reducing the frequency you can use the Tube to paint individual objects one at a time over the canvas.

Further fun

While a few photo-purists might swear at the Picture Tube, there are still a heap of devotees that swear by it. So many that there are entire websites dedicated to its use offering heaps of free tubes for fun applications. Start by visiting Jasc's site for further resources and downloads at www.jasc.com.

Technique: painting, sculpture and cartoon effects

TOOLS USED	
Art Media filters	Artistic Effects filters

Besides supplying tools for beefing up visual impact in a picture, Paint Shop Pro comes with a wide range of cool filter effects designed specifically for changing the appearance of the displayed pixels in such a way that it takes on the appearance of another medium.

To this end you can change almost any photo into a picture that looks like a Disney-style cartoon, a sculpture, a sketch and even a painting. To do this you'd choose from its **Art Media** and **Artistic Effects** filters. Here are some tips on how to get the best results form these filter sets:

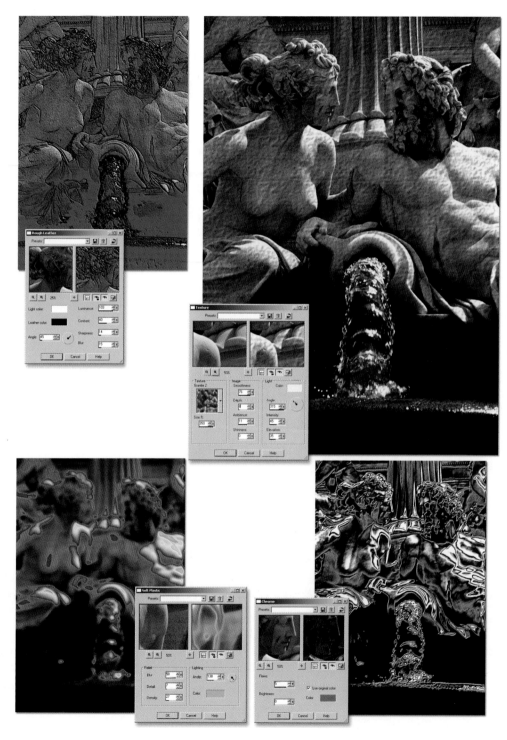

Use Paint Shop Pro's filters to create out-of-this-world textures and tonal effects like these: (clockwise from top left) Rough Leather, Texture, Chrome and Soft Plastic.

- Filters often work best on clean, simple compositions. Too much detail might diffuse the filter effect.
- You can of course use more than one filter on the same picture. A combination of filters might produce a better result.
- If you enjoy the results one particular combination produces, save it as a preset for use later.

Art Media filter effects include:

- Black Pencil.
- Brush Strokes.
- Charcoal.
- Colored Chalk.
- Colored Pencil.
- Pencil.

Included under Artistic Effects are:

- Aged Newspaper.
- Chrome.
- Colored Edges.
- Colored Foil.
- Contours.
- Enamel.
- Glowing Edges.
- Halftone.
- Sepia.
- Solarize.
- Topography.

Like all of Paint Shop Pro's filter sets, they operate through a dialog that gives you complete control over how each reacts to the pixels in the photo. Most have a simple 'Amount' plus an 'Opacity' setting. Amount controls the quantity of filter effect lavished on the picture, while Opacity controls how much of the original remains visible through the effect.

Most of these filters work best when some of the original image shows through – so try to keep the opacity slider under 70–80%. Of course, this can change depending on the depth of the required effect and the nature of the original.

Don't use these filters to disguise the fact that it's an 'average' picture to start with. If you use substandard pictures, even with the most exhilarating of filter effects, the result will remain substandard.

Note also that many of these effects are quite radical in their operation, so you'll need a bit of computer grunt behind you to get them to work quickly.

Technique: adding edge and framing effects

In what seems to me a great step forward, Paint Shop Pro now gives you the power to not only add frames to any picture you import into the program, but also to add a great range of frame edges to the file as well using the **Picture Frametool**.

In the past you'd have to load a specialist plug-in to make these types of effects. Paint Shop Pro now supplies these ultra-cool edges for free!

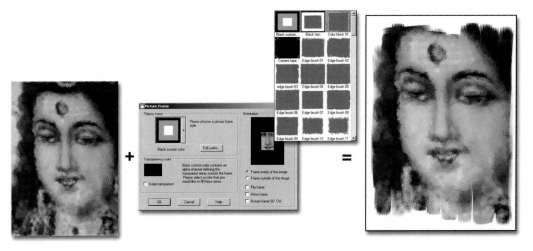

Paint Shop Pro's all new Picture Frame tool is fantastic, providing a great range of paint style edges (among others) that normally would take hours to create or several hundred dollars to buy (I wish I'd known about this before I spent the money!).

Why use edges? Photographers live in a rectangular world so it is great that we can now change that to recreate the look of a painted or sketched edge, film, crayon and heaps more edges. If you habitually work with the program's specialist filter effects, you'll find this new addition worth the upgrade investment alone.

How to add an edge to a picture

Step 1. Open the frame and choose 'Image>Picture Frame', and choose a frame or a picture edge from the dialog's many options. (There are not as many frames in this version as you'd get with an

expensive third party product; however, all the frames and edges here are changeable – you can flip, mirror and rotate each, making up to 60 extra choices and designs from which to choose. Not bad for a freebie.)

Step 2. Once the frame dialog is open, choose a frame or edge that you like the look of and click OK to add it to the full-resolution picture.

Technique: flipping from positive to negative

It's not rocket science; however, swapping a photo from its positive state to the opposing negative state can produce some startlingly good results. Simply do this by choosing Negative Image from the Adjust drop-down menu.

If the colors aren't quite right first try, use the Hue/Saturation/Lightness tool to make slight or drastic color changes (by sliding the Hue settings) like the ones seen in the example here.

Technique: using the Color Replacer tool

One of the unsung heroes of the photo-editing world, Paint Shop Pro's **Color Replacer** tool allows you to select a specific color in a photo and change it to another. You can choose another color from an adjoining section of the picture or it can be selected off the Materials palette.

Fine-tune this color selection using the tolerance values in the Options palette. This increases the range of colors selected and replaced (those more or less of a similar tone). Keeping a low tolerance value permits you to click-add color a bit at a time over the colors that have been elected as 'replaceable'. In some instances this is an awesome tool to use, being able to change colors almost at the click of the mouse, while other images are not so easy to do – which is why you have the Options palette.

Control-clicking chooses a color to replace (it displays in the Materials palette) while left-clicking replaces the chosen color with the foreground color. Right-clicking replaces the chosen color with the background color.

Technique: adding lighting effects

Paint Shop Pro has a very powerful feature that allows you to add real studio lighting type effects **after** the shot has been taken. It's a pretty cool filter-type effect that, when used with care, can add snap, pizzazz and depth to an otherwise flat or lacklustre picture.

Paint Shop Pro offers several light sources, exactly as you'd have in a real photo studio. Click on one and you'll be able to edit its behavior – widening or narrowing the spread of light has the effect of increasing or spreading the flood of light onto the picture. A narrow beam intensifies the

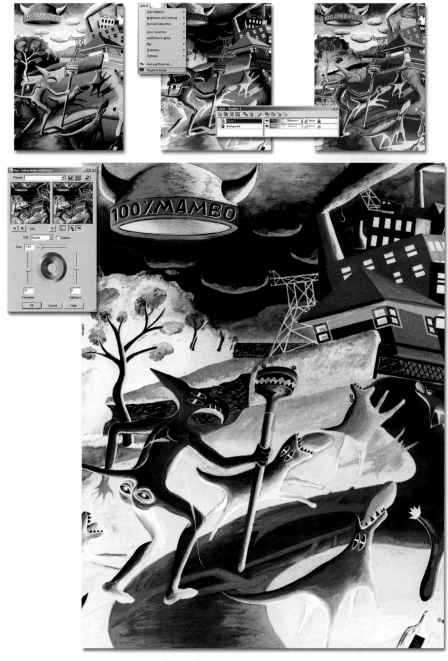

Simply by swapping the original colors (top left) to a negative image (top center) can be enough to make a new picture. It's a style often picked up by TV and film as an added out-of-this-world type effect that often proves effective in print. I have refined the effect by messing with the blend layers (you have to have a duplicate layer, otherwise the blend modes will not work!). As a final refinement use the Hue/Saturation/Lightness dialog to grab selected colors for emphasis. Exaggerate this technique by desaturating some of the other colors.

Tolerance controls how much variance there is in the selected pixels
If it's too high, you'll smother the area with too much replacement
colour

Ctrl + Left Click to set Source (replacement) colour

Ctrl + Right Click to set Target Colour

With subjects like this one, color swapping is a relatively easy task – providing the Tolerance levels
are kept under control. You are unlikely to be able to finish the entire job on one or two
mouse-clicks. Like the Clone tool, resampling is the name of the game and the more adept you
become at this simple task, the smoother and more convincing the end result is going to be.

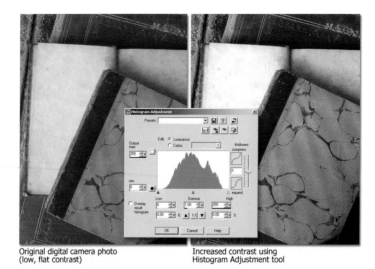

Original digital camera photo
(low, flat contrast)

Increased contrast using
Histogram Adjustment tool

Lighting effects allows the image-maker to add lighting effect to the shot **after** it has been captured. This is done via a clever combination of directional contrast and brightness enhancements, simulating the effect of a floodlight or a spotlight. If you don't want one of the lights on, simply reduce its effectiveness to zero and it goes 'out'. Though you should never use this as a substitute for shooting a frame properly, the addition of a lighting effect like the ones seen here can make or break a picture that is not as strong as it possibly could be. The first step is to use the Histogram Adjustment dialog to improve the tones and contrast in the photo.

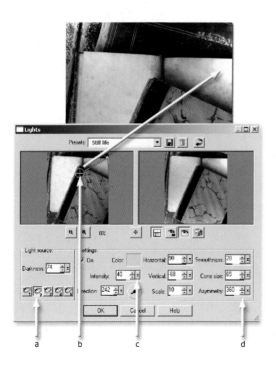

a b c d

(a) Click one of the lamp tabs to edit that specific light source. (b) Move the crosshairs that appear in the preview window to align the lighting effect to the correct part of the subject. (c) Reduce the intensity setting to zero to switch the lamp off (it's less hassle than pulling the plug out of the wall!). (d) Smoothness, Cone size and Asymmetry control how the beam appears in the picture. Use them like the dimmer, barn doors and snoot that you get in a 'real' photo studio.

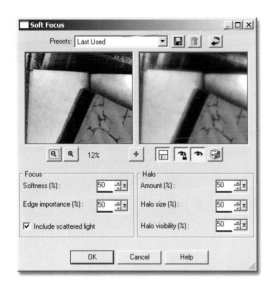

In this example I have added a Soft Focus filter effect to blow out the highlights created by the lights, giving this very pleasing look.

This is the final result – a snapshot with all the flair of a professional photo studio!

concentration of added light so take care not to 'overdo' this, otherwise you'll end up adding overblown highlights that take away from the subject matter. A little, in this case, will always produce a better result. The great thing about this tool is that its five light sources are infinitely adjustable. If you only need one or two lights, switch the others off by lowering their intensities to a zero value. Take care though, because you might end up spending a lot of time moving the 'lights' around the studio floor (i.e. the canvas). Keeping it simple will produce realistic and genuine improvements to any picture.

8

Print Preparation

his chapter is all about preparing your work for printing using desktop inkjet printers and commercial print lab technology.

TECHNIQUES COVERED

Batch processing techniques
Copyright issues
Emailing photos
Inkjet printing: basic considerations
Inkjet printing: advanced considerations

Printing directly from Paint Shop Pro
Resampling pictures
Resolution settings for different printers
Using stock and clip art

TOOLS USED IN THIS CHAPTER

Batch Convert (command)
Batch Rename (command)
File size (command)
Gif Optimizer (wizard)
Histogram Adjustment
Image Resize (command)

JPEG Optimizer (wizard)
Print Layout tool
PNG Optimizer (wizard)
Send (email)
Unsharp Mask (filter)

Inkjet printing: basic considerations

Start at the beginning

Begin with a photo that's sharp, displays good color, contrast and has a pleasing composition.

Paper choice

Use the correct inkjet media for the job. Don't undervalue your picture. Use quality media only. Paper varies from regular photocopy paper to some really exotic surfaces that include heavyweight, high gloss, dead matte and a variety of art-based, textured papers. If you want inkjet prints to feel like 'real' photos, print on photo-quality inkjet paper only!

File size

Ensure you have the correct file size set for the print output dimensions. This means that the digital picture must have a corresponding amount of data for it to be printed accurately. If you print a

Top left: Tiff file (6 Mb original uncompressed remains at 6 Mb). **Center:** 6 Mb JPEG file compressed to 390k. **Top right:** Screen resolution file (150k compressed to 29k) enlarged to match the physical dimensions of the two images to the left. Note that the Tiff and JPEG files appear to give almost exactly the same resolution (sharpness and clarity) – although the JPEG version obviously saves to a radically smaller physical size on disk. **Small picture inset:** A screen resolution file, such as you'd download from the Internet, for example, contains fewer pixels and, therefore, once enlarged appears significantly softer (less clear) than the other two. Printed to its recommended 300 dpi proportions, however, it produces an equally fine-detailed image – albeit a much smaller one!

picture larger than the amount of data it contains, the picture quality will break up – it'll look soft. If you print a photo smaller than its recommended data contents, you won't suffer any quality loss because there's too much data, not too little, but it'll take proportionally longer to print.

Determining correct output size

Have a look at the resolution in the 'Image>Resize' dialog. Digital camera pictures invariably appear on the desktop at 72 dpi. This means that the corresponding output dimensions are usually huge (i.e. the pixels are spread thinly in the frame). For example, for a 9 Mb Nikon Coolpix 880 file, at its highest quality settings, this equates to a picture that measures 72 cm × 54 cm, almost 20 in × 30 in! Too big to print and, if you did, it would be very soft! (Note that we only ever use 72 dpi pictures on the Internet.)

If you click the 'Resample using' tab to off, type '300' in the resolution field and click 'OK', notice that the picture resizes to 17 cm × 13 cm (or 5 in × 7 in). What it's doing is packing those existing pixels into a smaller, but denser, image structure, giving you the approximation of a continuous tone (non-pixellated) print.

Typical uncompressed RGB Tiff file size requirements for continuous tone prints

- A6 (148 mm × 110 mm) – 6.5 Mb.
- A5 (210 mm × 148 mm) – 12.5 Mb.
- A4 (210 mm × 297 mm) – 24.9 Mb.
- A3 (297 mm × 420 mm) – 49.8 Mb.
- A2 (420 mm × 594 mm) – 99.9 Mb.

OK. You've checked the file size. If it's the correct dimension, proceed. If it's not, you'll have to lower the resolution or add pixels to make up the differential. If the file is 12 Mb but you only want an A6 print, removing some of that data is not an issue, in fact it'll print faster. If you want to make an A3 poster from a 12 Mb file, you are going to have to try and get away with less than the recommended resolution, in which case it is going to look soft or you can add extra data to the picture by **interpolating** the existing pixels. Paint Shop Pro's interpolation feature is found under 'Image>Resize'.

If you want to make the picture larger, enter the new dimensions and click OK. The software examines the pixel distribution and adds extra to make up the difference. It seems like magic, and for most types of picture, interpolation works well, although you might notice it becoming a little soft. If this is the case, add a little **Unsharp Masking** (from the 'Effects' menu) to help compensate. This usually does the trick.

For exacting work there's no substitute for having the correctly-sized picture in the first place. If the file is originally from a scan, rescan the original at a resolution that matches the required output.

Printing resolution

It's not necessary to assign the printers' stated resolution to the photo file because of the way an inkjet printer adds ink to the page. Printing an A4 picture scanned at 1440 dpi, for example, requires several hundred megabytes of data, far too much for most computers to handle comfortably. What's also important to grasp is that, set at 300 dpi, an A4 print will not look much better than if it were set to 200 dpi. You might also get reasonable results from a file set to 175 dpi! Resizing files to this smaller size also makes printing faster, as there's less data to pipeline from computer to printer.

To work out the best resolution for your inkjet printer, make several copies and reduce their (file) sizes bit by bit and print them without reducing their physical output dimensions. Once you notice a drop in quality, use the resolution just prior to that quality loss as your default **best quality setting**.

In our example, a file of around 9 Mb will be just as efficient as 18 Mb.

Figure opposite. File sizes required for producing the best quality inkjet prints at 300 dpi and (in parentheses) at 200 dpi: A3 – 49.9 Mb (22.1 Mb); A4 – 24.9 Mb (11 Mb); A5 – 12.5 Mb (5.5 Mb); 4 in × 6 in – 6.0 Mb (2.75 Mb); 5 in × 7 in – 9 Mb (4 Mb); (note pictures not to scale).

Inkjet printing: advanced considerations

Though you can buy a photo-realistic inkjet printer for less than US $100, they have disadvantages over the more pricey, photo-realistic models:

- Slower print speeds.
- Smaller ink tanks (poorer value for money).
- Restricted to using dye-based, non-lightfast inks.
- Noisier.
- Vibration.

An inexpensive inkjet printer will produce surprisingly good quality from most photos.

Ink longevity

Ask anyone in the inkjet manufacturing world about print longevity and you won't get a straight answer (no disrespect meant). Little independent research has been made in this area – and what there is has not been good. However, products are improving and we are now seeing inkjet printers capable of making archival quality photos for the same cost as a photo lab.

Currently there's only one desktop inkjet that uses truly fade-resistant inks. This is the **Epson Stylus Photo 2100P**, which claims longevity of up to 100+ years. If you sell your work, this is a major consideration. Other manufacturers are catching up, with a current standard of around 15–20 years lightfastness (for other models from Epson and Canon, among others).

If you sell work within an art context, a 100-year longevity claim is the best option. No one wants to spend a considerable sum on an artwork to find that it has turned magenta in 15 years! Other commercial ventures, on the other hand, might get by printing work on models boasting 15–20 years lightfastness.

Other factors affecting fade rates

- **Media.** Some only guarantee longevity if it is printed on their own media products – even though you'll still get great, though less permanent, results with just about any brand of paper.
- **Display positioning.** While all paper tests are made under controlled conditions, most general-purpose situations are far from that. Even an exhibition space may have widely varying lighting conditions, so be aware of this prior to printing the job.
- **Storage.** For storage of materials, you also have to consider what the output is going to be stored in, or against. Typically, cheap plastic photo albums exude chemical vapors that attack the surface of photographic prints. Don't expect such storage conditions to preserve your valuable photos! The same goes for archivally rated prints (either photographic or inkjet). They are only archival as long as all the materials that they are stored with, in or against are similarly labeled!

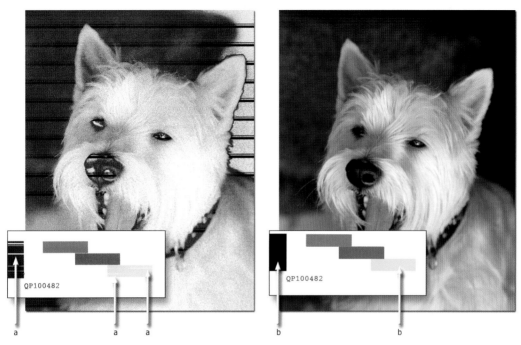

a a a b b

One of the commonest causes of print malfunction is a blocked inkjet. There are many reasons for this happening; suffice to say all that's required to fix it is to run the head-cleaning utility that sits in the printer software driver. You may have to run this several times if the printer hasn't been used for a long time – or if the blockage is serious (as in this example: the white lines indicate a blocked jet – a). Print the test pattern to confirm that there are no longer missing colors (seen as continuous tone – b) and reprint the original file.

Printing with Paint Shop Pro

TOOL USED

Print Layout tool

When you actually get round to printing your work directly from Paint Shop Pro, you'll find an exhaustive range of choices in terms of format, placement, attitude and extras.

 Having opened the picture, make sure that the quality is the best possible and choose Print Layout from the File menu. The **Print Layout** dialog shows the files selected for printing in the left margin. Click 'Open Template' to view your options. There are over 15 different templates to choose from as a starter. These cover most everyday options, but you can also make your own and save them for faster production work in the template library ('File>Save Template').

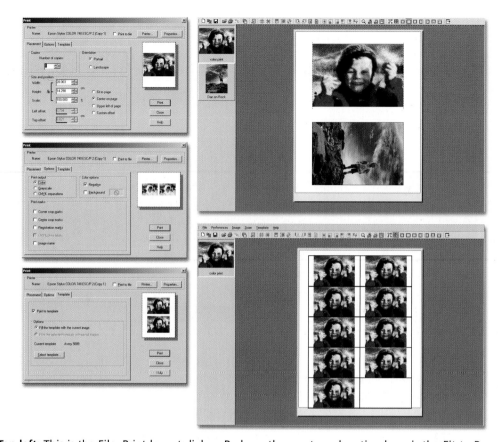

Top left: This is the File>Print layout dialog. Perhaps the most used section here is the Fit to Page function. Check this to ensure the file, regardless of its current resolution setting, will fit to the page size chosen in the Page Layout dialog window. Bear in mind though that this, and any Orientation mis-match, will extend the time it takes to print. **Center left:** Options include printing a negative image. I'd ignore most of this extra stuff, as you can do everything in PSP. **Bottom left:** The final tab includes template printing. This is where you can get some decent results for simple tasks such as printing two pictures on one sheet of (expensive) inkjet paper. Click the Template button and choose a template from the list or window that pops up. For example, you can choose the business card template and watch as PSP arranges 12 identical images side by side on the same page. It makes your printing life much easier.

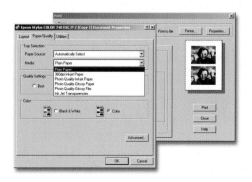

Don't forget to select the appropriate inkjet paper type. If you don't the color might not come out as you'd hoped.

What can you use templates for?

- Creating unique contact sheets.
- Making customized plates for specific jobs such as cards, receipts, invitations, business cards, etc.
- For making mini-stickers.
- For creating your own business labels.
- Address labels.

Once in the Print Layout you can either run the same picture in all the template's windows or you can bring more in. Simply open up a new picture and drag that into the place in the template where you want it to appear. Paint Shop Pro replaces the original picture with the new one. There are a number of assistants built into the menu bar. These are designed to make it easier to place picture elements centered, range right, range left and so on. Choose Options from the toolbar (or the Preferences menu) to adjust the template Placement if you find that some of the pictures don't fit the frames supplied. You can set it to 'Stretch', 'Fill' and 'Center', among other things.

It's a handy and quick way to make multiple print selections without the need for working out the complexities of layers, layer groups and selections, as you might with other programs.

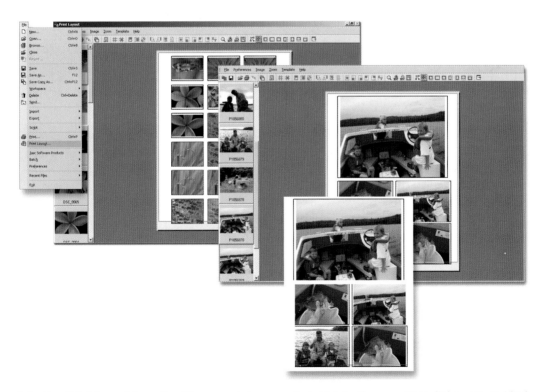

Selecting Print Layout from the File menu takes you straight into the new Print dialog. It's an ideal tool for making quick and easy images, and is very easy to use.

Emailing pictures

The rapid development in personal Internet use means that more of us are not only sending letters and memos to each other over the electronic superhighway, but we are also sending heaps of **pictures**.

Open the picture or pictures that you want to send via email. First check using the 'Image>Resize' checkbox that each is the correct size. If you don't do this, Paint Shop Pro will still compress and send the files in an email but, if they are too big, it might cause problems with the Internet Service Provider (ISP).

Once happy with the file dimensions, choose 'File>Send' and watch as Paint Shop Pro compresses the active file (the picture

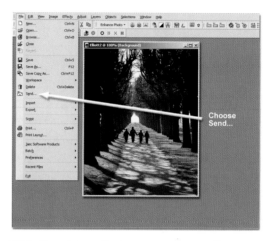

With the picture that you want to email open on the desktop, choose **Send** from the File menu.

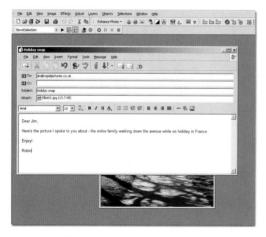

Paint Shop Pro automatically saves the file as a JPEG and slots it into the email message as an attachment. All you need to add is a message, a subject and the address. Simple!

that's at the front of the stack) and loads it into the email program that's been set as a default for your operation (for most, this is a program like MS Outlook Express). The file appears as an attachment in the email.

Enter the address, the subject and the body of the email, and click Send. Nothing could be easier. As a general rule, only send compressed files smaller than 1 Mb. As the email program uses the JPEG file format to transmit files this is not much of a problem. You can still compress an 18 Mb file quite comfortably to less than a megabyte and still get quite acceptable results when printed at the other end.

If all the recipient is going to do is view onscreen, send a physically smaller file. It will

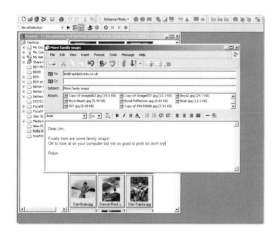

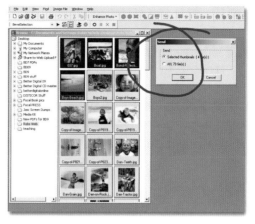

If there's more than one image selected in the browser, Paint Shop Pro adds all to the email. You can view the files that are to be sent in the drop-down window marked 'Attach' (Using IE5).

If you choose a folder, you have the option of sending the entire contents or just those frames that have been selected from within the folder.

be far faster. Unfortunately this helper is only capable of sending one picture at a time. If you want to send more than one, choose the Browser and select each picture to be emailed. Make sure that all are sized correctly and then right-click to choose Send. Paint Shop Pro asks if you want to send those selected or the entire folder contents.

Using stock and royalty-free clip art

From time to time there'll be a need for pictures that neither photographer nor graphic artist can supply, usually because of time constraints. This opens an opportunity for using **stock images** and maybe even **clip art**.

How do you use this medium? Generally stock, which includes original photography, illustrations, sound files, movie archives, animation, graphics and even art reproductions is a commodity purchased on a per use basis, for which you are granted a license. The cost of this license is generally influenced by the size of the print run. So, for example, a stock shot used for an ad in *National Geographic* would be significantly more than if it were for a suburban magazine with a small print run. Stock can be viewed, bought and downloaded directly off the Internet. Use a search engine like **Google** or **Yahoo** to find the image you are after. There are thousands of libraries from which to choose. Some are very specific while the larger ones, such as **Corbis** and the **Image Bank**, offer the visitor everything imaginable. Some stock is even given away free of charge with software promotional CDs, on websites or as 'freebies' with software programs. The free stuff is usually out of date or of poor quality. Even for small, one-off productions, stock shots can be quite expensive to purchase, in which case you might consider clip art or creating something yourself.

Clip art is available through similar outlets, including the Internet, although it is obviously less expensive to use. You might pay a nominal US $15 for an annual subscription to gain access to more than a million pictures! Finding the right clip art for your illustration might be another headache! Most of these sites operate a simple search engine to look for what you are after. You have to be quite specific in what's asked for. With a database of millions, it might take some time to sift through what's relevant and what's not. If you don't know where to start, start up your browser, enter www.google.com (or a similar search engine), type 'clip art' in the field provided, click 'Enter' and stand back as the window fills with hundreds of addresses for clip art resources. The response will be massive.

Never copy or duplicate stock shots without proper acknowledgement or payment. Though you might think it unlikely that you'll ever be caught, stock libraries are increasingly litigious in chasing errant users. Fines, to date, have been massive, even for relatively small license infringements.

Copyright issues

Copyright protection is an issue for designers, photographers and art directors due, in part, to the escalating value placed on 'the image' as a commodity in the growing Internet market. Content is becoming King and while e-business continues to grow, so does the requirement for image-based content.

Which brings us to the sticky issue of copyright. Who owns what, what can be copied and what is owned by another party? As a very general rule, all pictures are protected in some way by the owner's, or originator's, copyright. All photographs and most illustrations are covered by copyright so, for example, if you see a really neat photo or illustration in a magazine that you think would look

good on your company calendar, you have to get the **express written permission of the copyright owner** before it can be copied and used in a commercial situation. The laws governing the use of 'similar images' in a private, non-commercial situation are a little more blurred because (a) you might not be using it for financial gain and, more obviously, (b) private copying and usage is far harder to police.

Suffice to say I'd always advise **against** copying another person's work. Just because it might appear easy to do doesn't make it OK. Consider how you might react if one of your best works ended up on a highly popular cereal packet around the nation. You know that the company might be making tens of thousands by having such a good photo on the packet, so wouldn't you want a slice of the pie? Absolutely! The fact that this sort of copyright theft happens doesn't make it right. In fact, there are more and more companies taking offenders to court and winning huge settlements for misuse of other people's images.

As these successes continue so the courts turn to smaller claims, and while I suspect that private individuals who copy a photo for their own use are relatively exempt from being prosecuted, don't assume it'll never happen! If there's doubt over who owns a picture, find another or shoot it yourself!

Batch processing

TOOLS USED

Batch Conversion Batch Rename

For busy photo editors, Batch (file) **Converting** and Batch **Renaming**, like Scripting, is something of a Godsend. Why? Simply put, batch processing permits you to run an action over as many files as you have in one folder and convert the file type from its existing state to another file in another folder elsewhere in the system. If you shoot a lot of digital camera images and need to convert the lot from

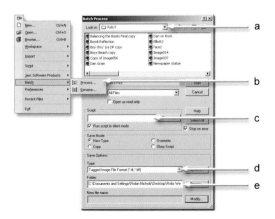

a

b Batch processing is there to assist and increase throughput for busy people. Use it to rename
c or to process actions on files that are located in the one folder. (a) Locate the files you need. (b) Choose between 'Process' or 'Rename'. (c) Use this window to find a suitable Script to run on
d the batched files. (d) Choose a file format for
e the newly saved files. (e) Elect a place to put the new work so that you can find them!

JPEG to Tiff for example, this is an ideal way to get some golf in rather than sitting there attending to everything via a one-by-one process.

Batch Processing sits under the regular File menu ('File>Batch Processing>Convert'). There's a second automated function and that's Rename. Again, for obvious reasons, if you shoot a lot of digital camera stuff there's nothing worse than having 10 000 files labeled 'DCS0000001' and 'DSC000002' (and so on) on your hard drive (don't laugh, I know people who do this – they get horribly confused when trying to identify one 'DCS' picture from another).

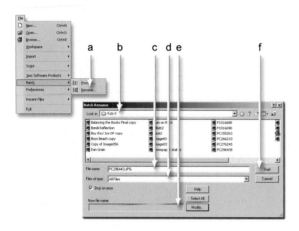

Batch Rename answers some of the frustrations for prolific digital photographers. (a) Choose 'Rename'. (b) Find the files that are to be renamed. (c) Check the file name here. (d) Choose a file format to save the renamed files as. (e) Set the new file name here (i.e. 'BaliHoliday'). (f) When you are ready click 'Start'.

Place all the files you want to convert into one folder and suggest a rename title. Before you get too excited, appreciate that no software is going to rename individual frames, so you'll have to contend with something simpler like 'Sports01', 'Sports02', 'Sports03' for that particular folder.

STEP-BY-STEP PROJECT

Technique: resampling pictures

TOOLS USED

Image Resize Histogram Adjustment
Unsharp Mask

Paint Shop Pro has many cunning software tricks up its sleeves. One of the most amazing involves sampling all the pixels in the file so that it can add more, effectively making the file physically larger so that it can be printed bigger. This is a process called **interpolation** or **resampling**.

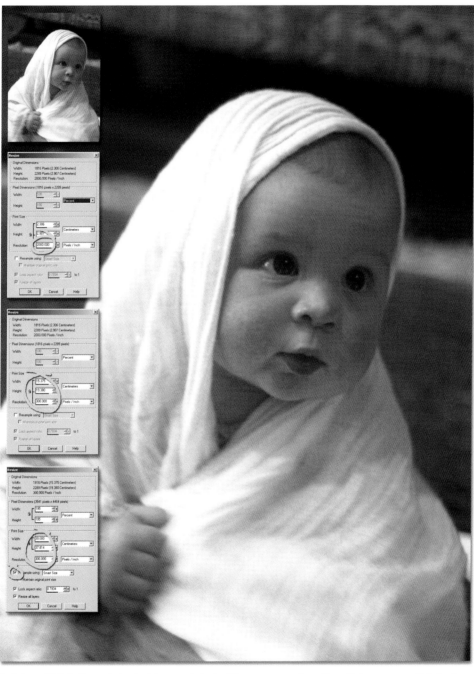

Inset picture: This is the original picture printed with no resampling. **Top dialog screen:** Original scan reads at 2000 dpi but with only a 2.9 cm × 2.3 cm print dimension. **Center dialog screen:** Changing this to read 300 dpi shows us the real print dimensions at that scanned resolution (i.e. 15 cm × 19 cm). **Lower dialog screen:** By clicking the Resample checkbox and entering a new print size, Paint Shop Pro resizes or interpolates the file (it adds pixels) to a larger 30 cm × 37 cm print dimension. The result is usually spectacular, providing the original photo was sharp and well exposed.

Resampling advantages

The advantages are significant – larger files and greater printable sizes.

Resampling disadvantages

The disadvantages of this software technique include loss of sharpness. Resampling can make the picture look softer, plus it can affect the color values in the image. In extreme cases you get odd-colored pixels where there shouldn't be any, making the overall color and contrast appear a bit weird.

This is sort of OK, though, because you can apply Unsharp Masking to fix its deterioration and, of course also adjust color and contrast with the appropriate tools. It just takes a bit more time.

Not all photos resample up as well as others. There's also a lower limit to the file sizes over which this technique works. If the file is less than 10 Mb, you might have trouble retaining the original image quality, but for most camera files and scans that are larger than this you should have no problem building large files for posters, banners, advertising uses and more.

Technique

Step 1. Open the file and choose the Resize dialog from the Image drop-down menu.

Step 2. Make sure that the 'Resample using' checkbox is ticked and enter the desired resolution for the file.

Step 3. Enter the new (interpolated) print or output dimensions. Press OK.

Step 4. Watch as Paint Shop Pro rebuilds the file quickly and efficiently. You may not notice any loss of quality in the new picture displayed onscreen, so don't be fooled. Once printed on a high-resolution inkjet, you'll see that a bit of softness has crept in.

Step 5. Choose the **Unsharp Mask** filter and add about 100–150% to the file. Leave the Radius to a value of one and a small threshold.

Step 6. You might also want to increase the contrast. Use the **Histogram Adjustment** tool or **Levels** to do this.

9
Working with the Web

TECHNIQUES COVERED

Creating animated graphics

Introduction to Jasc Animation Shop

Making navigation buttons

Making image maps, image swaps and rollovers

Making your first web page

Preparing pictures for use on the Web

Working with the Web

TOOLS USED IN THIS CHAPTER

Animation Optimizer (wizard)

Animation Shop (software program)

Banner Optimizer (wizard)

Gif Optimizer (wizard)

JPEG Optimizer (wizard)

PNG Optimizer (wizard)

Introduction

The World Wide Web has several specific requirements for displaying images and text. Pictures are usually displayed as **JPEG** files while graphics might be more suited to the **Gif** file format.

JPEG allows you to compress the data so that it can be transmitted and read very rapidly, allowing you to display a web page quickly. Graphics with limited color palettes can be better saved in the Gif file format, as this is ideal for limiting color data (and therefore making small files). The third picture file option is the **PNG** file format. This has many advantages over the JPEG file format and one large disadvantage: as this is a newer file format, not all web browsers might support the format.

Text, in fact the entire mechanics of the web, is written in **Hyper Text Markup Language** (HTML) that is simple enough to edit in many word processing programs. None of the above file formats can support selections or layers, so you have to flatten your '.pspimage' files and convert them to JPEG, PNG or Gif.

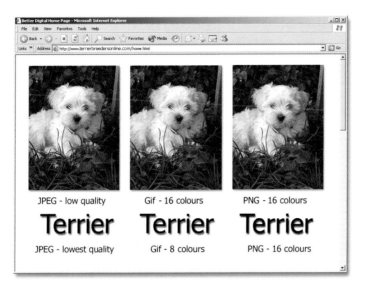

These three photos and graphics illustrate how Internet file formats appear in a browser. JPEG files are the most usual form of saving photos for display – but you can see excessive compression tends to create ugly haloes and artifacts that are hard to get rid of (try using Paint Shop Pro's excellent JPEG Artifact Removal filter to improve the look of downloaded Internet pictures). Gif files are generally far more suited to displaying flat tone graphics rather than tonal pictures. PNG files also look good, although some care should be taken as not all browsers support this newer file format.

This is what HTML code looks like. It's an open code language – which means that any web page can be inspected like this, copied and adapted for the inspector's use, where applicable.

Preparing pictures for the Web

TOOLS USED

Image Slicer	Gif Optimizer
Image Mapper	PNG Optimizer
JPEG Optimizer	Dithering

All web pictures are set to display at a resolution of 72 dots per inch (72 dpi). This is because it's the default resolution of the screen that displays web pictures. If you present a picture with a higher resolution than this, you won't see any quality benefit, all that'll happen is that the picture will display too big in the browser! Plus, it'll take ages to download – and that potentially sends viewers away rather than attracting them in droves.

If you plan to post images on the Web, the technique is to get your files as small as possible so that they display quickly, yet not so small that valuable detail is lost. This is a process called **optimization**.

Paint Shop Pro has just the tools on its Web toolbar. Here are picture optimizers for the three principal Web file types: JPEG, Gif and PNG.

JPEG files are generally photos or pictures containing lots of graded tones in them. Gif files are used for displaying flat graphics where there's little tonal range. PNG files are similar to JPEG but display better quality and support for transparency (though not all browsers support this as 'standard' where they do for Gif and JPEG files).

On the Web toolbar there's also an **Image Slicer** and an **Image Mapper** tool. The last tab on the toolbar is also useful: it allows you to preview the optimized file in a default browser so that you get instant feedback.

The **JPEG Optimizer** in Paint Shop Pro is quite good although, unlike some other programs, you first have to change the physical size of the picture before you open the optimizer. Use the program's 'Image>Resize' feature to do this. Set the resolution field to '72' first then, in the 'pixel dimensions' section, choose 'pixels' from the right-hand menu and enter the required width for the Web application. Hit 'OK' and PSP interpolates the image down to make a physically smaller file.

Once saved to the correct dimensions the file needs to be optimized. Choose the JPEG Optimizer from the Web toolbar and click the 'Use Wizard' tab. This gives you two pages of simple instructions from which to choose. Decide how much compression to give the file in relation to how long it takes to download at that size, click the 'Next' tab, choose the 'Chroma Subsampling' default, flick to the next page and inspect the previews. These give a good 'after' snapshot, making it easier to judge whether the amount of JPEG compression applied to the file is damaging the file by losing colors or introducing artifacts (ugly tonal 'blockiness'). The wizard allows you to flip back and forward through the pages till you get this balance of size, download speed and quality right.

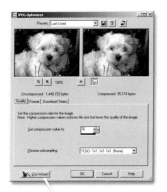
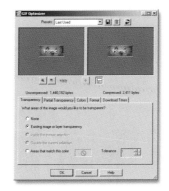
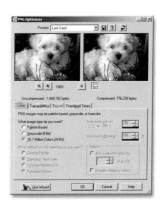

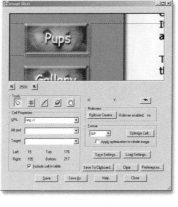
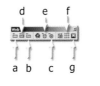

Dithered Gif
image

Non-dithered
Gif image

Paint Shop Pro's Web toolbar is very sophisticated, providing easy to use (and surprisingly professional) 'wizards' for saving JPEG files (left column), Gif files (center column) and PNG files (right column). The toolbar also has room for an Image Slicer tool (e), an Image Mapper tool (c) plus a range of other filter effects like Offset and Buttonize.

If you don't choose the wizard, the JPEG Optimizer simply displays the compression values and Chroma Subsampling on the same page. The second tab gives you the choice between 'Standard' file format (gradually revealing the file in the browser window) or 'Progressive' (picture appears almost instantly as a low-resolution version before it increases in resolution to the final size). Page three displays how long the compressed file takes to download using various transmission speeds. If you

do a lot of web work you'll know what the best page display rates should be for your subject and will be able to alter the compression rating accordingly.

Click the OK tab once happy with the previewed results. Ensure the file to be previewed is open on the desktop, choose the 'Preview current image in a web browser' tab on the Web toolbar and view it onscreen in the browser of your choice.

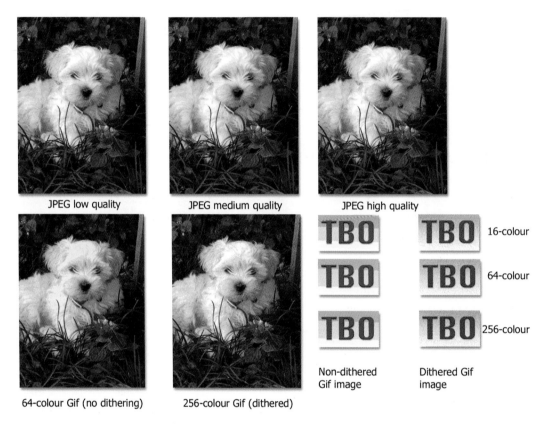

JPEG low quality JPEG medium quality JPEG high quality

16-colour

64-colour

256-colour

64-colour Gif (no dithering) 256-colour Gif (dithered)

Non-dithered Dithered Gif
Gif image image

These illustrations show the influence of high compression on regular photographic images compared to the action of dithering in a Gif file. Deciding on exactly which JPEG quality to go for is an art that the web designer has to develop.

The **Gif Optimizer** is a little more sophisticated. It's still necessary to size the image **before** it's imported into the dialog. The whole point behind the Gif format is that it's designed for small graphics that have little or no tone. Because of this you can compress Gif files significantly by actually removing the colors that are not in the file. For example, if it's a small web banner made from blue and gray you could restrict the colors to less than four, which gives a much smaller file size and a far faster download time. It's also possible to save transparency in a Gif file and to convert partial transparency to full transparency (or opaque). There are also two different 'Save' formats: non-interlaced and interlaced.

Dithering is a technique used to smooth out the tonal banding so prevalent when colors are restricted to the bare minimum.

The **PNG Optimizer** operates in a similar fashion to the Gif Optimizer. Both have easy-to-follow wizards and can work with (saving) transparency. This means that you can match colors in the picture with those of the web page background, removing sympathetic tones to reduce file sizes and to speed up download times (depending on the proportion of that color used through the file).

With PNG files you can choose the Websafe palette, grayscale or from True Color (16 million). The latter, though heaps better, cannot always be freely displayed on all browsers. It's a toss-up whether the risk of some pictures not being visible yet having higher quality is better than a general acceptance that all the pictures will display with no problems but at a lower quality level. If you are in any doubt about the audience and their quality requirements, go for the tried and tested JPEG format.

Making navigation buttons and tabs

One of the most important jobs when making your own website is its design. Poor design usually means that the site is not easy to navigate. It is hard to find things so you get bored and move elsewhere. Not good for the viewer and certainly not good for you! How do you make sure that this never happens?

Keep it simple, make it interesting and, above all, make it easy to find your way in and out of each page and section. One of the easiest ways of making sure your visitors remain visitors is to create interesting and fun buttons and tabs. Fun is just not enough in most cases – these tabs have to lead you in the right direction, and back again if need be. Paint Shop Pro has most of the tools for making all kinds of customized navigation aids. Here's how:

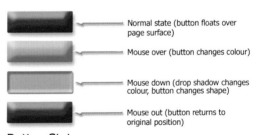

Normal state (button floats over page surface)

Mouse over (button changes colour)

Mouse down (drop shadow changes colour, button changes shape)

Mouse out (button returns to original position)

Button States

Button states are optional for most websites – you can choose to use the lot or only a few, depending on the effect that you are chasing in the site.

Step 1. Make a plan. Nothing fancy, but sketch, in note form, the pages and links that each page requires. This will be of immense help later.

Step 2. Decide on a style and layout for the navigation buttons. A button can be anything from a simple circle arranged along the top of the browser to a 3D, animated tab that changes color and name when moused. Start simple. Providing the website has been designed with expansion in mind, upgrading to a more sophisticated set of navigation graphics is easy.

Use the Pen tool to draw a circle, square or ellipse shape. For a quicker start you could also use one of the geometric marquee tools to draw the button shape, filling each using the **Flood Fill** tool.

Button states can be preserved in one .pspimage file

Buttons can be made easily in Paint Shop Pro using any of the preset vector shapes and the Buttonize filter. Use the program's **Hue/Saturation/Lightness** dialog to change the colors where necessary. Prior planning is essential to make sure that all the buttons in a busy site take you to the pages you want to go to and not something that is not clear in its layout from the start.

A third choice might be to use vector shapes from the **Preset Shapes** tool. OK, a colored circle on a white background mightn't appear to be the sexiest navigation button around, so to make things a bit funkier, use one of Paint Shop Pro's layer effects filters and apply to the button.

Tip

You might have to apply a selection (using the Magic Wand tool) to the colored area so that the effect hits the button, not the whole canvas.

Filter effects to try: Outer bevel, Cutout and Drop Shadow. All produce significantly different effects, turning it from a flat, boring color to something that jumps off the page.

Tip

Any navigation button must be made from at least two, and maybe three, parts: an 'up' state and a 'down' state. As the mouse travels over the button, it can also be made to change to a third state; color might change or the copy written on or under the button might also change. For example, the 'up' state might have a drop shadow. Its 'down' state has a smaller drop shadow, indicating that the button is closer to the surface. You can also change the color and the density of the shadow to make the on/off, up/down effect more convincing.

Tip

You can use your Layers palette to build an entire multi-button navigation palette, adding separate states to new layers as you go. Because layers can be switched 'on' and 'off', it's easy enough to add multiple button states without becoming visually confused. Save each 'up' and 'down' state with all other layers switched off, naming them 'top button up', 'top button down' or something similar to make identification easier.

Making image maps and rollovers

TOOLS USED

Image Mapper	Image Rollover

An **image map** is a photo that has invisible hot spots (or 'maps') in it that link the viewer to another location, usually to another web page.

Paint Shop Pro has a highly useful tool for creating image maps that comes complete with built-in picture optimizers, a rollover-making component plus the ability to save the settings for later application to a batch of other photos.

The process is simple and can add tremendous power to your website. Open the photo, size it to fit the image window (in the web page) then click the **Image Mapper** tab on the Web toolbar. The dialog that opens has a rack of tools for drawing various maps (square, round and irregular), moving the maps once drawn, erasing the maps or for reshaping the map.

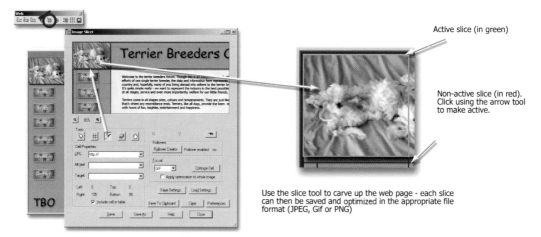

Active slice (in green)

Non-active slice (in red). Click using the arrow tool to make active.

Use the slice tool to carve up the web page - each slice can then be saved and optimized in the appropriate file format (JPEG, Gif or PNG)

Paint Shop Pro's Image Slicer tool is incredibly sophisticated, providing the web designer with all the tools needed to cut and slice front pages for distribution on the Internet. Options include a range of quality settings, adjustable highlight colors and more. You can also use this tool to create rollovers in a number of differing formats.

You then add the address of the web page (the page where the map is being added to), enter the Alt text details and the target URL address (to direct the viewer to the next page). Click the eye icon to view the image map in the browser of your choice and check if it's working.

On the same dialog you'll also see a drop-down tab for choosing the file format. This selects the optimizer if you click 'optimize image'. There's also a neat **Rollover** wizard.

Rollover? A rollover is a little different to an image map in that when the cursor moves over the hotspot, the picture in the background changes. Mouse down and the viewer is taken to another web page.

Of course, to use this feature you need to have a second picture prepared, ideally one that is identical in size and resolution to the host.

Paint Shop Pro's image mapping dialog is very powerful and provides almost all you need to make and add exciting features to your web pages.

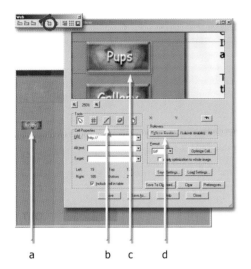

a b c d e f

To make buttons like the ones shown here (a), choose the Slice tool (b) and draw the slice around the button in the preview window (c). If this is to be converted to a rollover, check the tab (d) to bring up the Rollover dialog (right-hand frame). Enter details for the mouse states (e) and for the URLs that the Rollover takes the viewer to (f).

Introduction to Animation Shop

Users of Paint Shop Pro might be aware that this is not all you get in the box. Paint Shop Pro comes bundled with a software package called **Animation Shop**. This is provided so that you can animate still pictures for use on a web page, as a banner, an advert, as an eye catcher and as a promotional device. (Note that Animation Shop is in its third version (v. 3.04) and has not been updated to match the rewrite on its 'mother' package, Paint Shop Pro 8).

There are three ways to create an animation:

- from existing (still) pictures;
- by adjusting an existing animation;
- by creating your own images or frames.

The amount of frames in an animation determines how long it runs.

The easiest way to make an animation is to use the super smart Animation Wizard. Click the tab on the toolbar. Six steps and you have an animation! Use Paint Shop Pro to get the elements in the animation ready. Set the frame size and resolution. Place them where you can find them easily using Animation Shop (i.e. in a folder) and click the wizard tab on the toolbar. Once the wizard has finished you can click the **View Animation** tab to see how it looks.

Other features include:

■ The ability to edit animations.
■ Adding and subtracting frames.
■ Saving individual frames.
■ Previewing a printed animation.
■ Printing an animation.
■ Saving an animation as an AVI file.
■ Optimizing that AVI file.
■ Inspecting the HTML code in an animation.
■ Previewing the animation in a web browser.

Though the animation process often appears complex, Jasc makes it very easy. In fact, providing that you already have a few images ready and in the right format, you can create an animation in seconds using the wizard. The rest of the tools are there to make the process a bit faster and more sophisticated. (a) Animation Wizard. (b) Banner Wizard. (c) Export frames to Paint Shop Pro. (d) Browse. (e) New animation. (f) Open animation. (g) Save. (h) Animation Wizard. (i) Banner Wizard. (j) Paint Brush palette. (k) Displayed frames. (l) Paste as new animation. (m) Paste before current. (n) Paste after current. (o) Paste into selected frame. (p) Propagate paste. (q) Delete frames. (r) Duplicate. (s) Toggle onion skin preview. (x) Play animation. (y) VCR palette.

Creating animated graphics

Simple animated graphics are easy to make. All that's needed are three or four frames and **Animation Shop**. An animation can be nothing more than the same logo recorded in three or four different colors. These are then programmed to swap once the page is opened, or when the logo is clicked or moused over.

To make this work all you need do is open Animation Shop ('File>Jasc Software Products>Launch Animation Shop') and run the Animation Wizard. Providing that all your frames are identical in size, the animation can be put together in a matter of seconds – it's that easy.

(1) Start the Animation Wizard, import frames, decide upon size, transparency and looping, click OK and watch as the individual frames are assembled and built into a mini-animation. (2) The resulting animation can be saved, altered, edited or imported into the website directly. (3) Actions can be attached to the animated frame so that different things happen during mouse over/mouse down actions (i.e. looping, on/off, etc.). (4) Add extra frames to the animation (plus proper edit transitions like cross-fades) when needed using the Insert Image Transition dialog.

Very quickly you'll realize the potential this application has for your website. Animations, banners, logos and just fun stuff can be added with little effort. All animations can be resized once made and then saved in a number of formats, including AVI and Gif.

STEP-BY-STEP PROJECT

Technique: creating your first web page

Now that you are familiar with the concept of images on the Internet, you can consider constructing an entire web page. Web pages can be made in one of two ways: either as an HTML document (for which you need a specialist web building software) or by making the page to fit the entire screen area. It is then split or sliced into smaller bits so that it can be loaded in a browser faster. This is a process called **image slicing**.

Header: text layer with drop shadow and bevel effects

Site ID Picture: image map or animation that plays and takes you to the Home Page

HTML Text: copy imported from a regular text file and formatted for HTML use

Special Effects: Drop shadow created on each colour panel and flattened for convenience

Navigation Buttons: can be created either using the Buttonize filter and a series of mouse normal, over, down and up Rollovers - or by creating your own Image Maps. Both are used to direct the viewer to other parts of the Site

Slicing: Basic page sliced for faster loading in browser

Company Logo: created using PSP's vector text tools and optimized using the Gif Optimizer Wizard. Can be used as a link to the Home page or to the head office site, if there is one...

Photo Optimization: pictures are optimized using the JPEG Wizard and imported onto a new layer positioned and flattened for slicing

Websites are actually easy to design. One reason why there are so many sites on the Internet. The reason why there are so many **bad** sites around is usually that most 'designers' don't have a good grasp of basic layout and text use. Use fonts and text wisely and you are already 50% there. Paint Shop Pro cannot show the difference between good and bad design, but it can make either display quicker on the page!

Step 1. Create a page to the screen resolution required (i.e. 600 × 800 pixels). Select the background color that is to be standard throughout the site.

Step 2. Add the image elements. Use Paint Shop Pro's Grid tool to position these elements perfectly. You can also make use of its Guides to fine-tune the position of navigation bars, buttons, logos and more.

Step 3. From the Web toolbar, choose the **Image Slicer** feature. This has its own dialog that can be resized to fit the screen. Choose the Slice or Grid tool and draw section lines across the entire page. As a rule of thumb, you'd use this tool to separate the important bits from the less important parts in the page. Company logos and photos require different treatment to areas of flat color only. The idea is to apply different levels of image compression to each slice according to its importance. The good bits get less compression (so that quality is retained) while the unimportant sections can be highly compressed or converted to a Gif file to make them display faster. In this way it's possible to radically decrease the time it takes for any page to display. The Image Slice dialog has tools for optimizing these sliced areas (JPEG, Gif and PNG). You can even mix and match, retaining photos as JPEGs while graphics can be converted to Gif slices. This is a very clever tool.

Step 4. Once all slices have been made and the compression has been agreed upon, save the lot (Save Settings) and preview the effect in the Browser window (you must have at least one browser loaded on your computer before you can use the Proof button). If there's a problem with download speed, slice area or image quality, return to the dialog and adjust the compression, or image file type, to improve its appearance in the browser. Slices can be moved with the Pointer tool or erased using the Eraser tool. You can also apply this optimization process to all slices (click the appropriate checkbox).

Step 5. This dialog also permits you to add rollovers into the web page, great for fun or for a commercial site. Prepare the rollover components before entering the Slice dialog and click the tab. You then decide on the rollover style – on the action mouse over, out, click, double-click, up and down. Each can display a new effect, making this a very powerful feature.

10

Other
Considerations

n this chapter, we consider handling the tricky issue of color calibration. Getting what you see onscreen to print the way you want on an inkjet printer or at a commercial print lab.

TECHNIQUES COVERED

RGB-to-CMYK conversion
considerations

Color calibration
Monitor calibration

TOOL USED IN THIS CHAPTER

Paint Shop Pro Monitor Gamma
Adjustment

Paint Shop Pro displays a wealth of image information about the file, its edit status as well as the valuable EXIF data used to print the file on an inkjet printer or other commercial device.

Converting files for commercial print

Paint Shop Pro 8 is not designed as a professional pre-press printing tool – although it produces professional results! Accordingly, you cannot convert RGB color photos to press-ready CMYK files as you can in programs like Adobe Photoshop. You can, however, create your own specific CMYK profiles and print those as separated CMYK channels or 'plates'.

Choose 'Image>Split Channel>Split to CMYK' to see this in action. There are a number of opinions on whether this is relevant to the novice. I'd suggest that if there's any worry about CMYK conversions, talk to the pre-press professional who is going to print your job! They'll be set up to make those RGB-to-CMYK conversions and can advise on how to prepare files accordingly.

The pre-press company might even furnish you with an appropriate color profile that can be loaded into Paint Shop Pro. For most enthusiast applications this is not necessary. Talk to the print shop and get them to make these conversions for you. Remember that you can also ask for four-color test proofs. This is a relatively inexpensive process and a sure-fire method of checking the quality of any CMYK conversion **before** you commit to a full-on print run.

Color calibration issues

Color calibration is an issue that has many photographers reaching for the panic button. Getting the color that you shot to appear exactly the same onscreen **and in print** is a task beyond most of us. There are, however, some simple techniques to make color reproduction easier to manage:

Most color monitors are **not** color-corrected, which is why so many of us never get 100% accurate color on our inkjet or other print devices. The Paint Shop Pro Monitor Gamma Adjustment panel can fix that providing you can match the screen color with that of the test print. Don't try to match the print to the monitor as this will only work for that print only. Once you have a match then correct the color and brightness if it is needed and print.

Color is a subjective matter

Make life easier by positioning the monitor in a well-lit room but in a place where there are no reflections picked up onscreen. Also, never position the monitor where the light is in front or directly behind the screen. For example, don't try to calibrate a monitor that's sitting directly in front of a window.

Monitor calibration

Ensure your monitor is calibrated correctly. Jasc has a basic but effective **Gamma Adjustment** utility that makes the screen appear the right color and contrast ('File>Preferences>Monitor Gamma'). Print a photo and compare it with what you see onscreen. If it is 90–95% to that of the original file, allowing for viewing differences, there's **no need** to change the monitor.

If it is too dark, bright or is an odd color, chances are we can fix it using the Gamma Adjustment utility. Essentially this allows you to change the color and contrast of the screen to match that of the print. Once this is OK, save the changes and use Paint Shop Pro to bring the color back to the required hue and brightness.

Do not add or subtract colors onscreen to make the first print look better. This might improve the look of the first print but doesn't work for anything else. Match the color onscreen with the test print and you should get your color up to an acceptable 90% match.

PC calibration?

Windows also has an inbuilt color calibration utility for the graphics card but not specifically for reproduction color. To check if the graphics card profile is set correctly go to 'Start>Control Panels' menu. Choose Display and graphics card settings.

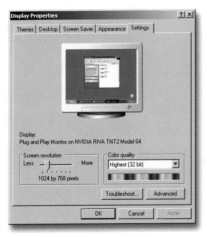 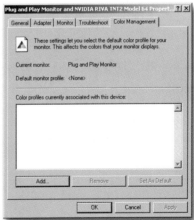

Windows has limited color management capabilities for the monitor and graphics card. If, after adjusting the PSP Monitor Gamma, the color is still less than 90% accurate, click the 'Advanced' tab in the control panel to view more options. Windows XP Home and XP Pro come preloaded with a range of color monitor ICC profiles so check under Color Management if this is displayed correctly. If not, click 'Add', choose a color space, click 'Apply' and then 'OK' to lock it in.

Environmental color

Reduce problems further by operating in a room that's not painted shocking pink. It might be extreme to paint the entire room neutral gray, but if the environmental color is bright it is going to have a detrimental effect on your color judgement. Don't wear that Hawaiian shirt!

Jasc (Color) Management

Another utility to try is Jasc's own **Color Management** dialog ('File>Preferences>Color Management'). Click the 'Enable Color Management' and check to see if there are profiles for the devices attached. Generally if there is an inkjet printer loaded it will have brought its profile with it – this will be visible in the drop-down menu. Likewise with the monitor profile. Check this every time you add or subtract a new printing device or if you are running more than one monitor. Choose 'Pictures' under 'Rendering Intent' for viewing photos.

The second option is to choose 'Proofing' for outputting to third party devices (i.e. your pre-press printer). This is where their device profile will appear when loaded into Paint Shop Pro. It should cross-match with your monitor and printer profile to produce color that's very similar

CMYK lithographic color profiles can be added via the File>Preferences drop-down menu. Talk to your printer and get the correct profile from them.

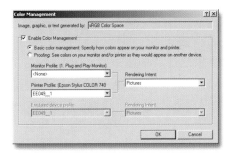

Paint Shop Pro's Color Management dialog allows users to set the correct profile for their monitor, printer and other devices connected into the digital workflow. If it is not available contact the manufacturer for a copy of the original profile data.

to how it looks once printed (it will never be **exactly** the same because of the different display technologies).

Note that paper types, ink sets and other non-specific factors might have a distinctly negative effect on color consistency. It pays to keep things simple and free from outside influences wherever possible.

Appendix 1:

Jargon Buster

Appendix 2:

Keyboard Shortcuts

Layers

New Mask Layer>Hide All	Shift+Y
Select All	Ctrl+A
Select None (Deselect)	Ctrl+D
Make Selection>From Mask	Ctrl+Shift+S
Make Selection>From Vector Object	Ctrl+Shift+B
Invert Selection	Ctrl+Shift+I
Hide (Selection) Marquee	Ctrl+Shift+M
New Window	Shift+W
Duplicate (Window)	Shift+D
Fit to Image	Ctrl+W

Keyboard hot-keys

Script output window	F3
Tool Options	F4
Materials palette	F6
Histogram window	F7
Layers palette	F8
Overview window	F9
Learning Center	F10
Brush variance	F11

Index

 Focal Press

www.focalpress.com
Join Focal Press on-line
As a member you will enjoy the following benefits:

- an email bulletin with **information on new books**

- a regular **Focal Press Newsletter**:

 - featuring a selection of new titles

 - keeps you informed of **special offers, discounts and freebies**

 - alerts you to **Focal Press news and events** such as author signings and seminars

- complete access to **free content** and reference material on the focalpress site, such as the focalXtra articles and commentary from our authors

- a **Sneak Preview** of selected titles (sample chapters) *before* they publish

- a chance to have your say on our **discussion boards** and **review books** for other Focal readers

Focal Club Members are invited to give us feedback on our products and services.
Email: worldmarketing@focalpress.com – we want to hear your views!

Membership is **FREE**. To join, visit our website and register. If you require any further information regarding the on-line club please contact:

Lucy Lomas-Walker
Email: l.lomas@elsevier.com
Tel: +44 (0) 1865 314438
Fax: +44 (0)1865 314572
Address: Focal Press, Linacre House,
Jordan Hill, Oxford, UK, OX2 8DP

Catalogue
For information on all Focal Press titles, our full catalogue is available online at www.focalpress.com and all titles can be purchased here via secure online ordering, or contact us for a free printed version:

USA
Email: christine.degon@bhusa.com
Tel: +1 781 904 2607 T

Europe and rest of world
Email: j.blackford@elsevier.com
Tel: +44 (0)1865 314220

Potential authors
If you have an idea for a book, please get in touch:

USA
editors@focalpress.com

Europe and rest of world
focal.press@elsevier.com